Fi

a memoir

Also by Alexandra Fuller

Fi

a memoir

Alexandra Fuller

Grove Press
New York

For my neighbors to the north, Jo Anne and Terry Kay.
Who, in the deepest of all my winters,
Brought me summer in a bottle;
With my gratitude and love, always.

And for my beloved fanana, CMW,
Who answered me in my own accent,
And used my own slang.
Muti in all the old ways, always.

Just Sit There Right Now

Just
sit there right now.
Don't do a thing.
Just rest.

For your
separation from God
is the hardest work in the world.

Let me bring you trays of food and something
that you like to
drink.

You can use my soft words as a cushion
for your head.

<div align="right">

Shams-ud-din Muhammad Hafiz
(c. 1320–1389)

</div>

MUSTH

i

FAIR TO SAY, I was in a ribald state the summer before my fiftieth birthday. I had intended otherwise: a book deadline, a couple of credits toward a master's in theology, more hours on my meditation cushion. Instead, I awoke in the early hours of Sunday, July 8, 2018, in the back of a diesel pickup somewhere west of Rock Springs, Wyoming, and turned to the woman sleeping beside me—in her midthirties, skin like alabaster, I'd thought it was only in Victorian novels—and said to myself, "This can't go on."

Or I said it aloud, and Till woke up, a light sleeper like I am.

"Why?" she asked. By the white glow of my headlamp, Till resembled the statue of Aphrodite at the Met in New York—the one from the imperial period in Gallery 162, you can't miss it if you've been. Aphrodite, the goddess of romantic passion and beauty and fertility, portrayed nude, as if surprised in the act of taking a bath. By now, though, the arms she'd used to cover her breasts, her pubis, those have long been broken off, not by her.

"Oh Till," I said; around about we'd gone all night. "Let me count the ways."

Was it better to face out of the prevailing wind or into the rising sun?

In the end, we'd compromised and had parked so that the back of the pickup faced southeast, canopy lid open toward a molten black sky, stars clear as Morse code, dits and dahs. The days of our lovemaking, the moon and Mars also had been coupled but preparing for opposition by month's end. Knowing about it, you'd think we'd have burned up, all that heat and war and us, gliding between them. Right now, the moon was a waning crescent, not in its full power, still a good two hours from setting. It looked exhausted, dragging that bellicose little planet along with it all night.

"You haven't given us a proper chance," Till said. She started to cry.

"I know," I said. "I'm sorry." I rubbed her shoulders, a runner's physique, built for distance, endurance. "But still, no." I'd tried not to rush into Till the way I'd rushed into all my previous relationships: like a tornado, lovers have told me, hair awry. But a cyclone doesn't know it has a name— or that it's hitting Florida. And Till was a severe weather advisory of her own: drugs, depression, also red ribbons of proud flesh up both her arms. Now, having rushed into each other anyway, I had such a sickening feeling. All I could think of was my own bed, alone. Till hadn't been a

crime—we hadn't—but the timing was awful. So yes, the timing had been the sin.

"You're homophobic," Till wept.

"I know," I said. That is, I'm not. I am not afraid of women who have sex with other women, or men with other men, or any configurations thereof. Whatever consensual adult relationship: free to be in my book. But I'd confessed to Till—in the way you do, sleepily, unguardedly, in the dark—that I am afraid of something inside myself that is tied up with sex and gender, childbearing and rearing, marriage and divorce, but that refuses to be hogtied by any of it. What's the mot juste for that feral thing? Whatever it is, it's forever dragging me off-piste, very insistent.

Also, I wasn't over a glassblower with whom I'd pledged forever—not forever. One moment, living with him in a yurt we'd put up together in the shadow of the Teton mountains: composting toilet, marigold petals, sourdough starter. The next moment, we'd flipped like an axe-head; I hadn't seen that coming. We'd been so inseparable, cloistered like a pair of monks; we'd even dressed alike, someone had pointed out, lots of wool and linen. Then, such an unholy breakup: disruptive, the way sudden things are, also loud and public. Not at all in keeping with the Tibetan prayer flags, the twin hammocks, the shared wardrobe. Why then—my friend Megan had been right to ask—had I not built an alligator-filled moat between myself and Till, at least until the dust had settled?

Instead, kicking up more dust.

Complete strangers will ask, "Wait, are you . . . ?"

It's a small town with a long main street, the Inter-mountain West, and for nearly three decades—since my midtwenties—I've lived in a dozen places in the two valleys on either side of the Teton mountains, both called Teton Valley, one in Wyoming, one in Idaho. Residents refer to the whole place as Wydaho, home to the annual Federal Reserve meeting, realtors, lawyers, climbers, ski bums, hunt-ers, knee surgeons, teachers, and people like Till and me. Also, my three children spaced out over more than a dozen years—Sarah, born in Zimbabwe; four years later, Fuller in Wyoming; eight years after that, Cecily, also Wyoming, same hospital. Same herds of elk in the snowy meadow outside the window, warm scents of salt, musk, and crushed vegetation.

"All the same father?" people have asked, staring at my children as if they didn't add up. Once, at the shared picnic table between the zebra and emu exhibits at the Idaho Falls Zoo, a mother of many had asked, flicking her finger between my kids, "Was that planned?" I'd pitied her, her big hair, her acrylic nails, her five under seven. For me, everything had been planned; certainty had been an entitlement. You could take that to the bank—or from the bank—back and forth. I'd still worried about the state of the world, though, and I'd advocated for causes I'd believed in. But I'd never thought life would serve me up something that could stop me dead. I'd assumed that I'd always have agency and options.

Fi

I was never going to need the loving arms of an Idaho Falls mom of many.

Life was never going to have me in such a noose.

I'd loved napping on the queen-size bed in the main bedroom with the kids after lunch on hot summer afternoons, books tented over our faces. Then projects—art supplies and newspaper and brushes spread all over the dining room table, classical music. Sergei Prokofiev's *Peter and the Wolf*, of course, also Benjamin Britten's *The Young Person's Guide to the Orchestra*. Then a cup of tea and a brisk walk with the dogs and often also the horses—rain or shine. After their fourth birthdays and until they could outwalk me, I'd expected my children to be able to walk their age in miles—not daily, but when needed—at roughly my pace, no whining, no stopping every two seconds for a snack or water.

When you eventually read your Jane Austen, I'd admonished them, you'll see. Even a Regency-era heroine—albeit Elizabeth Bennet, so the feisty one—thought nothing of walking three miles cross-country on an empty stomach just to visit her sickly sister. You can read for yourselves—people were forever catching colds and dying and putting their lives on the line for love because things were as mentally ill back then as they are now. The kids and I would put our hands to our foreheads, like heroines, and say, "It won't rain!" and plunge out into the world, whatever the weather. "Hold on Jane!" we'd cry to our imaginary ailing sister, "I'm bringing *broth!*"

7

I'd taught them the art of storytelling then on our daily walks along river and creek bottoms, meandering through aspen groves or up and over the little forest pass south of our house—announcing ourselves to wildlife, "Here moose! Moosie! Moose-moose-moose!" And all of us stopping now and again to inspect and fortify our many fairy houses and goblin hovels along the way—half a dozen on each of our favorite trails, hours of absorbed upkeep. Me finding a moss-covered log in the meantime and reading half a short novel.

I'd had zero tolerance for sulking, and it'd been understood that whatever we were doing, the children were expected to participate in that activity enthusiastically. Enthusiasm, from the Greek *entheos*: possessed by gods, *in* gods, gods within, like that, we'd played with words, and in words. I'd told them life is too short for a bored child or a boring sentence. And I'd told them there are no bad words but rather only bad ways to use good words. Also, phone manners, we'd practiced those on our walks. "Hello, this is Fuller, to whom would you like to speak?" That had been our son age five, future congressman of the egalitarian Utopia toward which we seemed inevitably to be headed.

We were approached in airports, restaurants, after church: "What a beautiful family you have."

"Thank you," Charlie and I would always say. Charlie, eleven years my senior, handsome in a long-suffering way: Baron von Trapp getting us safely over the Alps. We were

very theatrical, the kids and I; we'd been able to perform musicals or play charades for hours, stuck in a bus depot, or in a train station, or in a humid departure lounge on one of Charlie's expensive budget holidays, mostly around Central America and Mexico. Forced Family Fun, we'd called these adventures. Count Your Spots, a game for long car rides along winding coastal roads: carsick children, prickly heat, bedbugs. Backpacks filled to bursting with board games, art supplies, crafts, calamine lotion, Imodium.

Meantime, Charlie and I, both of us sleeper cells within the marriage, not on the same side, it turned out. They leave it so vague in the Anglican confessional, the authority under which we'd been cojoined in the horses' paddock on my family's farm in Zambia, 1992: "We have left undone those things which we ought to have done; / And we have done those things which we ought not to have done; / And there is no health in us." Up at 4:30 to write before breakfast, kids, a string of menial part-time jobs, ten novels—all rejected. Finally, believing it'd never be published, I'd written a memoir, mostly a love letter to my wild childhood starring my wild mother. My mother had hated it; my father and sister had refused to read it, hating it on principle. Charlie had resented its success; my dreams at the expense of his, he'd said.

It hadn't been my intention to infuriate my family, alienate my spouse. I'd thought I'd written a flattering, funny, light-hearted take on my childhood. But critics and my immediate family agreed: my brand of honesty was brutal. Why could

I not have been more like Elspeth Huxley? She'd written very nice books about growing up with her family in Kenya: flame trees, mottled lizards, sepia. I'd felt wounded, misunderstood; so, too, had my family. But a writer worth her salt is both the pointer and therefore also the disappointer. In the service of truth, a writer must court eviction from her tribe—and from any tribe that would claim her.

Charlie had withdrawn; I'd wandered.

The Bo Chi Minh Trail, my longtime editor at *National Geographic* had called it. Bo, because it's my childhood nickname, short for Bobo, slang for baboon. And the rest of it, because obviously. By the end of the marriage, I had been frantic. A bluebottle trying to get out of a jam jar—drinking, riding alone as fast as I could, just my mare, Sunday, and I, often until after dark. Also, dalliances. My heart had rarely been in it, these extracurricular flings, certainly not my soul. But having started down that road, I could neither see the end of it nor how to turn back, this very public business with Till, for example. "Did you really just say 'mot juste'?" Till said, sitting up and knocking over our lamp, plunging us into darkness.

"Ferfucksake, Till."

"Sorry."

The enteric nervous system, that's the gut brain.

The gut brain can't measure the diameter of a circle or write a book or do your taxes, but it knows everything else about everything else. The gut brain saw Till coming long

before I did. She was my own funhouse reflection walking toward me. How could she be otherwise? Till, simultaneously flighty and aggressive: Bambi with rabies. She'd studied my work in college, the early memoirs. She could quote whole passages of my life—as written by me—back to me. I felt both studied *and* misunderstood. "No way," she'd said, having made an allusion I'd not understood. "You've really never watched *Gilligan's Island*? Not even once? Not even by accident? It's like you were raised under a rock."

Then we'd talked about that and about how childhood casts a perspective on everything else that happens in your life, probably until you die, unless you're like the Californian New Age guru Byron Katie. She awoke, fully enlightened, at the age of forty-four, on the floor of a halfway house in Los Angeles in February 1986, a cockroach crawling across her foot. It'd been nothing but bliss for her ever since. I'd liked that about being with a woman, the more interesting and varied pillow talk. Also, taking it in turns to read poetry in the morning before turning on Wyoming Public Radio, KUWJ 90.3 on the dial. My children had been weaned, bathed, and ferried around to the voices of Nina Totenberg, Audie Cornish, Ira Glass.

So different from my childhood, theirs.

I'd been raised in Rhodesia, now Zimbabwe, in the 1970s and 80s; no one was ever calling my name. I was self-reliant, but we weren't allowed to be very self-preserving. "I celebrate

myself," the American Walt Whitman wrote in his late edition of that famous poem, "and sing myself." That had really struck me when I'd finally read it, in my early twenties by then. Imagine believing in a self, any self, *yourself* that much. Not us. We'd had none of Whitman's adoration of self-reflection and frank curiosity. It hadn't been in our national character—or in the national interest—to ponder what it was to *be*. We were *all* Rhodesians. We'd sung about that in one rousing voice.

One rousing settler voice I should say, even when we'd spoken Shona or Ndebele—and especially when we'd spoken Chilapalapa—we'd whitewashed everything: God, language, the bottom of trees, rocks, police stations. Pamwe chete; together only, we said. Wafa wafa, wasara wasara; you die you die, you live you remain, we said, very severe, very severed. For my part, I'd been a keen Rhodesian as a child—a quick learner, an enthusiastic if confused little racist. White, dependent, brainwashed from fetalhood—there was, as far as I could tell, no otherwise.

But I'd also been observant, sensitive, bright, and curious, a white settler minority child raised in a Black indigenous majority land. I hadn't noticed the inhumanity of war or the wrongness of racism or the insanity of both any more than I'd have noticed inclement weather had I been born in a hurricane, but I did notice that the world seemed bent on tricking the goodness out of everyone. And I'd been unable to help blurting it out: the inconsistencies, the outright lies,

our hypocrisy. I'd named names. "There's always one little traitor, usually a child," my mother would say—she'd level her gaze at me. She also is not subtle.

"Loose lips sink ships," she'd say, landlocked as we were.

I'd been unable, almost from the start, to adhere to the settler virtues of sweeping things under rugs, of being seen but not heard, and of ramming down—and screwing up—my feelings. I had known my place, however, in the rigid Rhodesian hierarchy: roughly on par with a puppy-mill poodle, a bit inbred, crooked teeth, but at least you can teach it to hunt, not like a Pekingese. An English alcoholic aunt of my father's—most of his aunts were alcoholic, as was his mother and her twin, but the way they drank, you can't say it enough—had kept a brace of Pekingese on the dining room table and a dule of doves in the bedroom. It was normal for people in our circles to prefer their animals over their children and to die young—of gin, guns, and other accidents of the soul.

Certainly no one we knew outlived their hips or knees; we'd been raised in the expectation of short, colorful lives. Kids from the rural districts, my sister Vanessa and I, had been sent off to boarding schools the year we turned eight. Our dormitories were old army barracks, steaming in the summer, freezing in the winter. Our matrons were widows, spinsters, usually mid- to late-stage alcoholic, mustachioed. They'd patrolled the halls, punished us for whispering after lights out, and dosed us regularly with anthelmintics for

intestinal parasites. Other than those first few weeks—while it had been dawning on my seven-year-old self that I'd be incarcerated like this for most of the next thirteen years—I'd loved it all: the camaraderie, the carbolic soap, everything extreme.

We rural kids had run in packs, certain of our farmbred superiority, tougher than townies.

Over our heads, Alouette gunships flew Rhodesian special forces on raids into Mozambique. "Our men," we'd called them; boys, really, some were still growing. They'd been the older brothers and cousins of kids Vanessa and I were at school with; we'd seen them sometimes on leave. They'd had pimples up close, sunburns; the boys vowed to be them, the girls vowed to marry them. That's who'd been jumping out of helicopters. It had all been so familial, it touched everyone; the newest baby was born already kissed with our conflict. No one comes away from a war with their innocence intact.

What to do in the event of excessive bleeding?

On Tuesday afternoons, there were junior first aid classes run by the Rhodesian Red Cross. I'd signed up right away; we were all in this thing together. What about bone fragments? What if someone is unconscious but still breathing? A couple of times liberation forces from across the border had launched mortar attacks; no one had gotten any sleep then, crammed under mattresses praying out loud for our soldiers to prevail against them. "Ah Father, who art in heaven," we'd chanted. That'd shaped me, too, I can see

now. All the violence, and all the God, and all the rush of being alive, staying alive; everyone armed to the teeth—all the settlers, that is.

Meantime, not in the highveld and the tree-lined suburbs but in the lowveld and the borderland rural districts, settler kids had been expected to be able to fire over their parents' dead or dying bodies, should the occasion have arisen. During target practice, my mother had sung, "Olé, I am a bandit" and had emptied half an Uzi magazine into the treetops. She'd been an eager but terrible shot. Also, deadly serious. By the time I was five, all the settler-owned farms above ours, those abutting the Mozambique border, had been taken out in attacks by the liberation forces—gooks, we'd called them, terrs, spooks. We were jumpy and armed but also casually violent and callous, as you must become in war—or die.

Curtains, toast, scribbled, snuffed, slotted, donnered; we'd had a hundred words for murder. Children grow toward the light and away from the shade, mostly. It's not personal; it's just the place you land. The more a child is blocked from the light, the more crooked she'll grow in her determination to reach it. I'd landed squarely in the impenetrably dark umbra cast not only by civil war but also by the death of an older brother from meningitis nine months and twenty days before I was born. The happiest day of my mother's life had been his delivery, she'd told me afterward; the worst was when he'd died, one of them. One of the other worst

days of my mother's life had been when my toddler sister drowned the year I turned nine.

January 1978: Olivia floating face down in a neighbor's duck pond, rainy season. She'd been put under my watch, and I'd wandered off, distracted. The Red Cross course I'd taken at school wasn't joking: dead is dead. You could feel it. I could, her lips so blue, so irreversible. The pain of her death—the awful truth dawning and dawning until I was staring into the full sun of it—shocked me into a state of hyperwatchfulness, the birth of my inner stenographer: a nonstop tickertape, this person's movements, that person's absence, exits, entrances. Afterward, on the weekly hair-washing nights at school, I'd lain underwater, trying to atone. Also, to assuage the terrible pain; it was like I was being stung to death by wasps.

One wasp at a time, but soon the whole vespiary in my head.

Then, like Carl Jung said, "Until you make the unconscious conscious, it will direct your life and you will call it fate." My not telling anyone about that whole vespiary in my head wasn't me being resilient, or stoic, or even me sticking to the script of silence, it was me coping, but the stinging was still always there, an agony so terrible you imagine it should kill you, except that it didn't. Dumb, guilt-sharpened pain sat with me and inside me, until one hot morning, back on our farm for the Easter holidays, I'd been crushed by my horse—a proud-cut bush pony called

Burma Boy—very deliberately it'd seemed to me and after that I'd just been in pain.

A sea of pain, in which I was swimming, everywhere I turned, more pain lapping. I hadn't been grateful when it came, but I'd been relieved. I'd been expecting something of the sort, penance. Also, the horse was a homicidal creature and it hadn't been the first time he'd peeled me off, bucked me off, scraped me off. But I thought for sure he'd killed me this time. He'd never, having dumped me, thundered back to finish me off, a sort of solo stampede up and down my spine. I'd been able to feel my lungs emptying of air and failing to fill up again. There'd been also lots of dust, blunt heavy hooves, and the sound of him grunting as he'd delivered the blows.

Breath was life; I'd wanted it.

I'd made one last high-pitched plea for air, like a winded cicada, then waited for death.

Only then had the horse given up and wandered off to graze.

"No, no, no, Bobo. You want something with a bit of spunk," my mother had reassured me when we'd bought him two years earlier. The horse had savaged me when I'd attempted to groom him and had lain down in the dirt when encouraged to trot; he'd bolted, bucked, bit, and kicked. "Three hundred Rhodesian dollars, that was a lot of money back then," Mum said decades later; she rarely forgets the cost of anything. After the accident, I'd been driven to

hospital from the farm in the back seat of our old Peugeot station wagon; minesweeper, army escort. By that stage in the war, there were curfews from dawn to dusk; the movement of all Black people was severely restricted and no white settlers from our valley could travel into town without military escort, too many landmines and ambushes.

The Rhodesian army officer in charge of the convoy had come to the window, Euan Kay; some names remain seared into my brain even now, decades on. Anyone kind, or very unkind, I never forget. "Jislaaik, my laaitie," Euan'd said. "Look at all this hunna-hunna just for you." He'd given me a wink, "You must be quite special, hey," then he'd banged on the roof, "Okay, Tim," and off we'd lurched. Dad at the wheel chain-smoking, loaded Browning 9mm between his legs. Mum, with her Uzi submachine gun sticking out the passenger window, checking her lipstick in the rearview mirror. At each bump and corner, I'd screamed. "At least her lungs are working again," Dad had said.

The Umtali Hospital was beautiful: white stucco over red brick, tiled rooves, Dutch facades, sweeping verandas, someone's sumptuous idea of a place to while away a bout of malaria. "How can you bring me a riding accident in the middle of a war?" The orthopedic surgeon had been furious with my mother. My skull had a hoof-size divot kicked into it, a couple of my young ribs were bent, but it was my spine that had really inspired Dr. Standish-White's ire. "She's too young to be this smashed up," he'd

said. He'd held up the offending X-ray—it looked like a bowling ball had gone through my torso—and said this thing I hadn't understood and that other thing I hadn't been able to follow.

Then he'd said if I was lucky, I'd be in a wheelchair by forty. I'd caught that bit.

"Gosh," Mum had said. "Well, Bobo. Did you hear that?" And she'd given me one of her rare but intoxicating smiles of encouragement, the same smile she'd bestowed on snake-bitten dogs or horses writhing with tetanus. She'd even patted me, not unkindly, on my upper arm, one of the few places left unbruised on my body. "Of course, you'll be lucky." She'd suddenly started speaking to me as if I'd lost my hearing and glancing fretfully at the exit. My father hadn't come into the hospital at all. "Knee-deep in dying people," he'd shuddered, lighting another Madison. But his parting words of advice, as I was ferried off on a stretcher, had been similarly boosting. "Don't listen to half the things they tell you in there, Bobo!" he'd shouted. "It's the formaldehyde talking."

At first, I hadn't been able to walk—or feel the urge to defecate. It had hurt to breathe and to be moved. Then one morning, I hadn't been able to stand the thought of being abandoned on a bedpan for hours, again. So, I'd co-opted the kid in the bed next to me. She'd accidentally poisoned herself with pesticide and had gone a bit mad. She'd kept bleating that she didn't want to be taken to the hospital. "Hey man, you're already *in* the hospital," I'd kept telling her. Anyway,

she'd helped me shuffle to the loo. Soon after that—pain blurs time, as does time itself—I'd emerged from the hospital pale but radiant, like Graham Faulkner as St. Francis of Assisi in *Brother Sun, Sister Moon*. I hadn't been able to help myself; I'd hugged the first tree I saw, a stately jacaranda. It was like falling into the arms of a beloved old relative.

I don't know how *Brother Sun, Sister Moon* had slipped past the Rhodesian authorities on any level—pacifism, nudity, voluntary poverty—but somehow, the Manicaland Province Under-10 tennis teams had been treated to a screening of Franco Zeffirelli's 1972 masterpiece after dinner at the little boarding school in Melsetter to which we'd been decamped for a tournament. This was shortly after my sister had drowned but just before the riding accident. Things were very vivid for me at that time, and Zeffirelli's movie was the truest piece of art I'd seen until then. It was all about war and God and a wealthy merchant's son who did his call-up then came back with post-traumatic stress disorder; although we didn't call it that. We called it *bosbefok*, literally bush-fucked.

I'd given my life to Graham Faulkner on the spot.

Also, my father, taciturn, British by birth, that posh accent never really rubbed off—orf, he'd said—I'd given my life to him, too. His chief contribution to Vanessa and my upbringing had been to find ever more remote pieces of land on which to settle and then leave us, as much as possible, to the mercy of that land. "Go on," he'd say, encouraging us

to hop out of the car and run the last few miles home on those long, ribboning dirt roads of our childhood. Vanessa had always demurred; she was a drum majorette, leading the Rhodes and Founders' Day parade down Umtali's Main Street. Blond ponytail, golden tan, unblemished skin. But I'd always had socks and shoes off—ready to go—legs spinning before my bare feet hit the ground.

"Be careful," Mum would sometimes say.

"Bulldust," Dad would respond. "Don't put ideas in its head. Fugga moto, Bobo, run!"

"I hope a terr doesn't shoot you," Vanessa would sing out the window.

I'd give a yell, a holler, a whoop; life was cheap, but ammo wasn't. I knew I wasn't worth a commie bullet. Then, in 1980, the year I turned eleven, the end of the war turned everything around in my motherland at the very moment adolescence was preparing to turn everything around in me. Peace fell upon us, as mysterious and unlikely as snow. There was universal suffrage; our government took a hard turn left. To celebrate our official transition to an independent republic, Bob Marley played a capacity concert at Rufaro Stadium in the capital. Prince Charles flew out from England to do the handoff. The very first official words uttered in Zimbabwe, after the new flag had been raised, were: "Ladies and gentlemen, Bob Marley and the Wailers." The police shut the gates on the thousands of fans still outside, there was a riot, everyone was tear gassed equally; One Love.

✳ ✳ ✳

My mother had gone mad. She'd hated peace and she'd resented racial equality. She'd drank until she'd come to believe that our neighbors on the remote ranch on which we were then living wanted to murder her. She'd also been heavily pregnant by then; her fifth child, a boy. Her heart would flutter with anxiety and she would become breathless easily. So, she'd been packed off to town and put on bedrest for two months in the maternity wing of the newly desegregated hospital. But the baby had died a week after his birth anyway. "Failure to thrive," the matron had said. He'd looked perfect to me when I'd been taken to see him in the hospital, a blue vein running along his temple under gecko-translucent skin. What a way to go, though, just giving up the ghost like that. It hadn't, until then, seemed like a viable option.

Just shrugging off the life force, I mean.

My parents, disinclined to make a fuss, had disposed of the body as hospital waste. When Vanessa told me the news, I went outside and lay down on cracked black cotton soil outside—a painful lump in my throat—and listened to the sound of an emerald spotted dove calling from a camel thorn tree like cool water being poured from a clay jug, *coo, coo, coo, cool*. Aqua-blue sky, blond dry-season grass, there was no horizon any direction I looked, only more colors, more sky, more miracles. A chameleon stalking, a snake's belly rasping. That was it. Nothing was coming for you; it was just coming.

God can only be drilled out of us, not into us. I can see that now, from a distance.

Meantime, the sun beat impartial rays; the dove called again, *coo, coo, coo, cool.* That was it. There was death, and everything else was life. You had to get on with it, whatever it was. "Laugh and the world laughs with you. Cry and we'll take you out back and shoot you," my father used to say. So, we'd learned to laugh at our misfortunes, to chalk them up, most of them. In any case, all the crying that had needed to be done in our family was done by my mother. Like the chorus in a Greek tragedy, periodically the action had stalled while she raked over the plot so far, weeping for all she'd lost. Vanessa and I tiptoed around her during these times, guiltily aware that we were the persistent, surviving children.

"Mum's having a bit of a wobbly," Dad would explain, that dangerous British habit of underestimating the gravity of any given situation until you were eating the last sled dog and writing your final diary entries: Robert Falcon Scott, Lawrence Oates, Ernest Shackleton. While Mum had floated out in her own sea of madness, Dad had sat outside on the veranda chain-smoking, nursing watery whiskies until the small hours. It hadn't been her madness he'd minded, her flights of mania, her slogs of depression. It had been her drinking he'd hated, especially once it had stopped being in full view and had become secretive: surreptitious bottles in the wardrobe, in the toilet's cistern, behind her books on all her many bookshelves.

"Stop pestering me. Go away," my mother would beg, pulling the covers over her head if we dared creep into her room for whatever reason. "Leave the dogs in here. Shut the door!" But after Dad had stopped going into the room, Vanessa and I felt we had better check that she hadn't drunk all the everything, swallowed all the pills. Once, Mum had parked the Land Rover on a remote piece of railway line—my family had moved to a farm in Zambia by then—and had waited for the train from Tanzania to come roaring through and take her out. But it had been running late that day, and it was hot in the old Land Rover, no shade. A pedestrian had stopped, peered in at the window; several other pedestrians had followed suit.

"How are you, Madam?"

"Oh, for heaven's sake," Mum had said, waving the man away. "Voetsak!"

"You are coming from that side?"

"Go away."

"And to what side are you going?"

"Bugger off."

"Must we push?"

"No." But there'd been half a dozen people by then—babies, chickens, firewood—waiting around the Land Rover, peering in through the windows, eyeing all that empty space. The chickens had sounded parboiled in their bark-string baskets, strangled clucks, gasping trills. The women and children had looked patiently resigned to whatever happened; but in

some ways their patience was worse than when they'd been clamoring, pestering, eyeing Mum hopefully. Some people had started to drift away from the Land Rover to look for shade, waiting for whatever had stalled my mother to resolve. "Oh, alright," Mum had sighed. "What's the point? Get in. Come on, let's go."

Like that, no real reason, all the reasons, it's difficult to remain neurotic among people who aren't. And what a force Mum had been when she'd gotten going. If you could keep up with her and also render yourself devoted and useful— entertaining, capable, enduring, patient, uncomplaining—it was quite an apprenticeship. She read insatiably, followed the BBC World Service minutely; she was always learning another language, saving up for a new translation of Homer's *Iliad*, listening and relistening to her favorite snippets of opera, "Micaela's aria." She was the real farmer in our family. There wasn't a horse north of the Limpopo that wouldn't do her bidding. She named her dogs after Formula 1 race car drivers, dictators, and revolutionaries—Jackie Stewart, Niki Lauda, Che, Tito, Papa Doc, Aung San Suu Kyi—but she called them all Darling.

Vanessa and I were alarmed if she called one of us Darling. "What's the matter?" Vanessa would ask. "Am I dying?"

Mum's dogs all had interesting, indulged lives, but very short; snakes, mostly. Also crocodiles, snares, wild pigs, poison, drowning, obscure tropical diseases—they died of things mostly not covered in Mum's well-thumbed 1971

edition of *Black's Veterinary Dictionary*. All our lives, all of hers, the death of a dog—or the massacre of a few—could trigger a wobbly. Then Mum would be under the bedcovers again for weeks or months—sometimes a whole year, gone—sorting through her cache of pain, like time had crawled backward to her darkest age. Mum's wobblies had preoccupied Dad, too, and then Vanessa and I had been alone: undefended girls, like chickens in a fox house.

No ability to breathe. Or breathe a word.

But everyone has always said that my mother's bouts of blackout drinking, her suicide attempts, her periods of insanity make sense. People have always told me that I should understand this; when a mother loses a child, her surviving children lose a mother. But I didn't lose my mother; she hung on, mothering away, dragging and coaxing and encouraging us when she could, how she could; ignoring us and poisoning herself when she couldn't. I didn't lose a mother when she lost my siblings; that *was* my mother, marinated in grief but also tough, glamorous, heartbroken, capable, creative, resilient, determined to have a ball anyway. "Let's have a *hilarious amount of fun*," she used to say. I loved her immoderately, utterly.

Lipstick, sunglasses, Uzi: check, check, check.

War, trauma bond, drama: check, check, check.

Try to not become addicted to that as a child.

ii

"I DON'T WANT TO FIGHT with my person," I said to Till, now. "And all we do is bicker."

"That's not true," Till said.

I got up, made tea. We split a piece of dark chocolate, warmed ourselves over the little camp stove. It'd be blazing hot in a few hours, but now everything was frost glazed. We started driving after that, off the high desert with its wind like an eastbound train pushing us toward the mountains, not talking, our camping trip abandoned. I didn't keep on saying how sorry I was, but I was; recklessness requires precision, not this. The timing, but also our baggage, both of us with heartbreak in our recent history; sorrow, alcohol, and madness in our starts.

"It means we understand each other," Till had argued.

"No," I'd said. "It means we both need to be houseplants for six months."

Unobtrusive, I'd meant, neglect tolerant, harmlessly and calmly staying alive, cleaning the air, respirating, and photosynthesizing. Till had kept trying to kill herself over men

and, less often but also, women, she'd said—not their actual bodies but their abandonment of her. Or, more accurately, the self-abandonment of giving anyone that much power over your life—and death. "Imagine it," she'd told me. One time, a stolen revolver with two rounds in the chamber. Another time, the steady intake of Tylenol, a crazy drive to the ER. Those were long hours of awakening, undead, near dead, undead. Talk about cycles: padded cell, disposable pajamas, liver drip. "It's addictive," she'd said. "Suicide."

"I know," I'd said. I, too, have had the edges of that soul sickness; the love hunger, the gratitude deficiency, the refusal to see that this life with all its glorious trials and triumphs was tailor-made just for me by me. Also, it was in my blood, a family habit on both sides of the tree. Not only my mother but also my grandmother, my sister, my aunt, a few great-aunts, a couple of distant cousins, an adopted cousin, they'd all tried—although only a couple had succeeded—to top their own carrots, as we'd said, as if suicide were a gardening accident rather than generations of interfamily hostility turned even further inward. "Nonsense," Mum said. "It's the *breeding*; we're very highly strung. We're good at bashing zee Germans. It's the little stuff that startles us."

A ripe mango dropping on a tin roof, for example, we'll all dive under the kitchen table.

The US Centers for Disease Control's Adverse Childhood Experiences—or ACEs—test was first published in 1998. It remains the largest study on the long-term consequences

of early trauma on a person's health. It asks respondents ten simple questions. Before the age of eighteen, did you experience an addicted parent, a mentally ill parent, death in the family, this, that, or the next thing? I had taken the test online as soon as I'd found out about it. "This can't be right," I'd told the glassblower. According to the test's results, I was 1,220 percent more likely than someone who'd not had my childhood to attempt suicide and a few hundred percent more likely to suffer from pulmonary disease, cirrhosis, cardiac arrest.

"How's that even possible?" I'd asked. "Is 1,220 percent more even proper math?"

The glassblower had scored zero on the ACEs test; zero adverse childhood experiences.

"Most people get at least three or four," I'd said. "You have literally no excuses for anything."

That had been our circular argument, the glassblower's and mine. His midwestern childhood had been too perfect, I'd argued: maple syrup, sports cars, rock 'n' roll. A person can't grow up if they have nothing to push against; they just keep spreading out like hop vines in a potato field, no urgency, not even the theory of hardship. But that ACEs test wasn't lying either; I knew my own truth. You can't be raised by a pair of love-avoidant dipsomaniacs in a constant state of violent extremis *and* pour alcohol on top of it all. Or you can, but you can't expect it to not end in a conflagration. I'd ordered, read, and reread the memoirs,

the ways to self-arrest, rail hop: *Drink*; *Dry*; *Portrait of an Addict as a Young Man*. Therefore, also, the 12 steps, step by step. Sobriety hadn't equated with serenity, though, at least not right away.

Dizzying—loss, upon loss, scouring my middle age.

In the space of three years, my inimitable father dead, my irascible mother and my only surviving sibling strangely estranged, my unaccountable banishment from the beloved family farm in the Zambezi Valley seeming complete, my writing unpublishable, my forever after with the glassblower going, going. I could feel his impatience with my decumulation. I'd wished it were otherwise. I'd kept baking bread, offering him wine, lighting candles, all the sacraments. And everything's harder for the diaspora; even Prince Philip had whined about it. Greek by birth but standing always in the Queen of England's chilly little shadow.

Who was I without my family, my country?

Few people where I've now lived for most of my life can pronounce my name or where I come from: Alexandria, they say. Alexander. Allison, I get that a lot. Also, New Zealand, England, Germany, Australia, South Africa, Boston—few people guess correctly. Zimbabwe; not even Zimbabweans would guess now, from my mishmash transatlantic accent, that once I was one of them: "Hey, mummy, mummy, where are you from?"

"Mummy, how are you?"

"Mummy, mummy, what have you brought for us?"

Fi

Nothing—just my heart, my humor, my worldview—but no passport, no currency, and none of the languages of my upbringing, except English. My childish Fanagalo, my smattering of Afrikaans, my tortured *peck-peck-peck* of Nyanja and Ndebele and Shona are tricks of the tongue lost to time and disuse. Meantime, my mind shaped in that wild, wilding Eden, my internal soundtrack laid down, coming to consciousness, as I did, to thermal streams of potato bush scenting twilight in the dry season. Rose beetles cracking against paraffin lamps at night.

How I missed it. More than ever after my father'd died and my mother and sister had retreated into their increasingly anti-me antipathies, I'd missed it, as if my father's death had closed forever the gateway between the world of my childhood and now. The middle Zambezi Valley, the Eastern Highlands, the suburbs of Harare, the places I'd called home, receding; I'd never not pine for Zimbabwe, for my childhood people, my earliest mouthfuls of dirt. In what odd skin has my soul found itself? I am not *this* unfitting thing. I'd considered all the pills then, the waters of the big frozen mountain river near our yurt. There are hotlines you can call, but I didn't. I'd have wanted someone to answer me in my own accent; I'd have wanted them to use my own slang.

Sewerage pipe, we'd also called it. Growing up, it'd seemed the whole country knew about the soldier playing Russian roulette in the downstairs bar at the Monomotapa Hotel in Salisbury, as it was then; for two days people had had

to jol on the roof while the carpet and walls were cleaned. No one had blamed the bosbefok soldier, though. Like musth, the periodic seeming insanity that troubles healthy bull elephants for a couple of months every few years, they dribble urine, their temporal glands swell and emit a thick secretion as if the animal's brain were weeping. They've been known to plunge their tusks into river banks in an attempt to alleviate the pressure in their heads. They become irritable, unpredictable, murderous even. Everyone—other animals also—avoids the elephant until the condition subsides.

So, when it happened to me, the urge to be gone, I hadn't called a hotline. Instead, I'd stopped to consider the problem of my remains were I to numb myself out in the frozen river. If I went under the ice here, where the river was deepest, and my body dislodged in the spring, a child might find me downstream; a child playing Poohsticks on the bridge where I'd played Poohsticks with my three children when they'd been toddlers. We'd done A. A. Milne's entire oeuvre. Roald Dahl, everything by him. Also, Beatrix Potter: "Peter gave himself up for lost, and shed big tears; but his sobs were overheard by some friendly sparrows, who flew to him in great excitement, and implored him to exert himself."

Obviously then, I didn't kill myself and abandon my perfect children; I didn't take a fistful of befuddling pills and sink beneath the ice-chunked waters of a glacier-green river where less than two hundred years ago there were neither pills nor bridges. They say it's the altitude that does it. Eight

of the ten top states for suicide are in the Intermountain West. I say it's the guns—that and the great high plains are as lonely as an ocean and we're not seamen. Also, sagebrush isn't sage in color for most of the year. It's battleship gray, same as the sky, seemingly no end to it. Space sounds like a good thing until you remember a person might easily just let go and drift away into it—indefinitely.

"We must make a relationship with loneliness until it becomes aloneness," said the Tibetan Buddhism teacher and monk Chögyam Trungpa; he also drank, smoked cigarettes, slept with his students, and got into a public tiff with the renowned poet W. S. Merwin on a meditation retreat; you can read about it on the internet, very messy and human. They were favorites of Till's—and mine—both the monk and the poet. "Gray whale / Now that we are sending you to The End / That great god / Tell him / That we who follow you invented forgiveness / And forgive nothing," Merwin wrote in 1967. Poets, monks, the really great ones, they're seers, often, and therefore, also sometimes drunkards, womanizers, depressives.

"Aren't you going to talk?" Till asked now.

"No," I said. We'd been driving a couple of hours, stopping only once to cry and shout at each other, women on the verge. Till wanting more, me wanting less, why couldn't we want the same thing at the same time? After that, we drove with the windows down for five miles, ten. A cool wind

battered us, whipped hair into our eyes, made conversation impossible. Then, we'd tried the radio, but I'd turned it off two minutes into the news at the top of the hour. Police in Fresno, California, were still trying to determine how a two-year-old had managed to shoot himself, fatally, in the head.

"*Jesus*," we'd both said.

You'd never recover. We'll never recover. We never *should* recover.

All our damage. Time heals all wounds in the end but only because time itself ends, in the end. Meanwhile, you can still see alongside the highway, as if it happened yesterday, the actual wagon-wheel tracks from the 1860s Oregon Trail: the sagebrush parted, such fragile high plains, little graves. You're near Pinedale by then—we were—wide open country, oil rigs, the Green River. The air here used to be the cleanest in the lower forty-eight; I'd fought on the losing side of the battle to stop the natural gas rush of the early to mid-aughts. Now, on clear sunny days, ozone from the gas fields turns the air invisibly deadly; the elderly, newborns, and those with preexisting conditions are warned to stay indoors.

"Okay then, friends?" Till said, her voice different, softer. She held out her hand to me; the tips of her fingers had been sliced off by a drone. She was like that from head to toe, a litany of accidents. The time she'd crashed a paraglider into a buck-rail fence, the time she'd totaled her car, other times. I took her hand and squeezed it; she ran cooler than

Fi

I. These are the details of a lover you remember afterward. You remember their body temperature in relation to yours, that and a scent: lavender, cigarettes, salt.

"Okay," I said warily. "But no Till-Creep."

"No Till-Creep," Till agreed, by which Till wore away at a person's defenses, tireless. Every time I'd tried to end our relationship, reshape it, the same thing. First, she was on my bathroom floor sobbing; I couldn't just leave her there. Then she was in my bed, in my favorite T-shirt, blond curls brushed out of her tear-washed eyes, ebullient, a little gleeful. The next day, it was her electric toothbrush by the sink. After that, two cups of tea on the counter in the morning, not one. Then a telemarketer called my phone and asked for her by name, not me, my subscriptions hijacked, my life under her nails in such a short time.

"Okay," I said. "Phew." I looked out the window again. Sagebrush gave way to aspen groves, the plains rolled into the mountains, and my chest eased. I was getting back on track, on the intimate relationship wagon; it felt to me a little like the day I'd decided to stop drinking, the relief, the resolve, the hope. I'm not cut out for partnership the same way I'm not cut out for alcohol; teetotal suited me. Solitary suited me, solo, like a cheetah and her three cubs and the seemingly empty, open savannah. I could be like that.

Then we popped into the canyon that leads to the big beautiful open valley on the east side of the Tetons. The canyon cuts cellphone reception; so do the mountains and

the plains. The whole of Wyoming, you'd think it could be pinging with service, all that open space, not too much else going on except drilling and mining and cattle and sheep, but it isn't. So, when we hit a signal and my phone beeped with messages and missed calls from Charlie to call him back immediately so, too, my heart stopped.

THE END

i

I CALLED CHARLIE BACK right away, but before he even picked up, I knew.

It wasn't just the unprecedented slew of texts from him. Nor was it the fact that I've always feared the death of one of my children with something like superstitious dread, because if our fates are twisted into the double helix of our very DNA, then this had always been my destiny. And it wasn't also the fact that I've bargained with God over my children's lives since before they were born. If only they'd live long and happy lives and die of peaceful old age in their sleeps, there was nothing I wouldn't do. And now there was nothing I *could* do, and it was Fi. "It's Fuller," Charlie said; he could hardly speak, the words sticking in his throat.

"My God, please, no," I might have said.

"He's dead," Charlie said.

"Oh Fi," I said. "Oh my God, Fi."

Fuller, we'd christened him, at the start. Fi, he'd named himself when he could first make words out of sounds. "Fi to rhyme with tree, to rhyme with tea, to rhyme with me,"

I'd singsong, tickling toes, counting fingers. He'd gone back and forth on the spelling, when it had come to that, from Fee to Phee to Fi, finally. Fi spelled like fidelis: loyal, faithful. Fi, sounds like qi, so unentangled. Not the dying-early sort. Not him before me, surely. Please, not that.

Stitching, unstitching the evidence. Trying to undo what I already knew to be true. Trying to make the case against Fi's death. My awful prescience notwithstanding. The family habit notwithstanding. A recent seizure notwithstanding. A seizure for which they'd run tests and more tests—and had found no reason for further concern. "They say it can happen to anyone once," Fi'd reassured me. "So, it's not going to happen to me again." Laughing at himself for being such a weakling and teasing me for being so worried. He'd been *so* alive his whole life, for years and years. How can he now be gone? Also, Fi is a careful planner; he was. He'd have planned something as big as this. He'd have let us know he was planning to die.

He'd have said, *What's there to say?*

He'd have said that thing, though, whatever the right thing was, is.

Three days ago, I'd walked with him along the Snake River—distracted. He'd been home only a few days from Argentina, where he'd had the first inexplicable seizure at the end of his semester abroad—stress of finals, late nights studying, packing up to come home. We'd talked about that, about his last few weeks in Buenos Aires, about his host

family's cooking, and about his flight north for a planned week of mountain biking when the seizure had happened. He'd said he felt fine now, a little tired maybe. He'd chattered on and on, unhurriedly, skipping over some things— "remind me to tell you later"—we could go back to that, we had time, another time.

I hadn't told Fi the extent of my looming problems: the book deadline overdue, my bank balance draining, my life a crazy paving of cracks. But I'd told him the relationship with the glassblower had ended, it was for the better, and that although I'd missed the yurt, the new condo was going to be good for us. Right now, carpets torn up, warped windows, but a *perfect* location for Cecily and me, bike paths, school bus, bookstore. "I'm so sorry," I'd told Fi. "First you wake up in an ICU in some town you've never heard of in Argentina. And now you come home to find your mother's down to a bedroom and a half. Do you feel thrown out of the maternal nest?"

"As long as I can still have Anatole's cooking," he'd inside joked, Bertie Wooster.

"Greedy worm," I'd countered, Aunt Dahlia.

We'd laughed then, linked arms, and, walking under the cottonwoods along the river, we'd noticed the pair of resident bald eagles seesawing back and forth across the sky on a wide thermal. So, we'd talked about them. We'd said what magnificent scavengers they are, bald eagles, and about how, to me, they looked and sounded and behaved so much like

the African fish eagles on the farm in Zambia. We'd talked about other stuff, too, none of it important but all of it precious, and I'd hugged Fi long and hard when we'd parted ways at the trailhead. He'd said he was off to an outdoor summer concert with friends. "You're a delicate plant, don't forget. Plenty of water, lots of sleep," I'd said.

Then I'd promised Fi his favorites—oxtail stew with grits and greens—as soon as I had an operating kitchen, my pots and pans unpacked. Also, baked apples, Epsom salt baths, peppermint oil foot rubs, hot water bottles, green tea, honey, lemon, ginger, and garlic in everything: I treat my children as if they're faddish Edwardian lepidopterists when they're tired, poorly, under strain. "I can't wait to feed you properly," I'd said. I'd told him how much I'd missed feeding him: all that gathering of ingredients, all those hours in fragrant steam, the piles of food, plates wiped clean. It grounds me to feed my children; they eat and I take root. "I'll start a new sourdough starter," I'd sworn.

"I'll take some back to school with me," Fi'd replied. Then, he'd told me his plans for the rest of the summer, where he would work and what he might do on his days off. But even as my beautiful son had been talking, saying his final precious words to me, I was thinking about the next things on my list: electrical fittings, the paint store, the wretched carpet people. And then Fi and I'd said I love you to each other, I love you more, I love you *most*. And now I'd never talk to him again. That had been it. He'd said his last words

to me, and I hadn't written them down the way I'd written down his first words.

His first word had been "Dada": "Dada-dada-dada."

Then dog: "Dog-dog-dog." Then he'd said not much at all. He'd been, instead of a talker, a silent and acute observer as a toddler, seriously and intently witnessing. And even when he'd finally started talking—a lot of things to say, it'd turned out, a lot of facts had accumulated during his early silence—he had needed speech therapy for years, his *l*'s and *r*'s all wrapped up in each other. Adorable, I'd thought. Honestly, I'd found nothing wrong with his speech. Love is deaf as well as blind. How will I ever survive his death? And then you realize you won't survive his death; I did. I knew, on the spot, that I was over; everything assailable would be gone, would have to be gone.

His life flashed in front of my eyes in fragments, then. It was like photographs and scraps of memorabilia falling out of a keepsake chest; my life, too. It's a lot to take in at first, too much, your whole world fluttering away, dissolving, like watching your ship go down only to realize you *are* the ship. "My God," I might have said again and again. Then there was a pain inside my chest so intense, at first it didn't register as a feeling but as a noise. The passenger door wouldn't open; I lowered the window and tried the handle from the outside. Then Till stopped the pickup and I tumbled out, already midstride, running toward the Snake River. The grass was yellow, dry, sharp when I hit it.

I smelled blood as if it were someone else's. I bounced and started to run again. The river was within easy reach, as the crow flies, but there were houses in the way, fences. Dogs were barking; my legs buckled.

Till was on me then, her whole Greek statuesque self. I lay between her and the hot ground, the Earth's unmoved and unmoving embrace, Till's arms pinning me, her cool skin warm on mine. I was frozen, freezing, under this ironing-hot sun; if only I could reach the water, I could unmake this thing from happening, this thing that had happened. I turned my head. Even with my face on the ground I could see the rocky bank, a fir tree clinging to a crumbling cliff. Fi'd been conceived on that river, upstream from here.

Pregnant the day—and hour—of my choosing.

On a boat, at midday, on June 6, 1996, eddied out in a beaver pond.

A baguette, a bottle of wine, a block of cheese, Charlie had brought a fishing rod, a cigar. I'd brought a book and my binoculars. After lunch, I'd wandered into the cotton-wood forest along the river shore and had almost tripped on a speckled elk fawn, curled tightly around itself in a puddle of sun. "If you're lost, find a river," my father had always said, a couple of brandies in, waxing philosophical. "Then follow that river to the sea." My father had loved a good shaggy-dog story. Follow that sea to its tides. Follow the tides to the moon. You're never lost under the moon. But under this blazing sun—what was it, eleven, how I hate

that time of day, all mystery and possibility flattened out of a place—I was lost.

"Let me go. Please." I tried to push Till off me. I begged, "Please, let me go."

"No," Till said. She held me down. "I'm sorry," she said. "No, no, no."

ii

WE LAY WITH HIM, his father and I, while Sarah and Cecily wept on the lawn outside. So pitiful they sounded, but I couldn't have left Fi. I must have phoned my nearest and most trusted friend, because Joan was suddenly there with me, and then with them, with the girls, the way she'd always been with us when we'd needed her. It didn't seem survivable, the pain—mine, theirs—instantly recognizable as the worst thing I'd ever felt. Unimaginable. Also, both deeply personal and yet ours, together. Like we'd been in an earthquake and each of us had been pinned under a different truss, in a different part of the house, able to hear one another but not to reach one another.

Dear God, nothing can prepare you for this.

Our friend Will, a deacon in our church, came and knelt by us, his summer hat next to his knee, straw, wide brim. Then other friends came, stood vigil for a while on the lawn, and left. Bit by bit, I could feel the news of this tragedy crackling through our small community. Fi had co-captained the

school tennis team, and he'd been passionate about lacrosse. He'd played hockey for Wyoming in his senior year. He had been student body president. He was smart, hilarious, earnest, self-aware. He'd hated not being outside—always outside and always moving. "The only thing wrong with the weather is I'm not in it," he'd say.

All the things he *used to say*—past tense.

Fi's bed was small, the three of us on it; Charlie's and my hands touching on his head, our fingers in his hair. We've lived within twenty minutes of each other since the divorce. We're not friends, though; we rarely talk. We didn't speak now; we couldn't make eye contact. Most of our lives, we'd been unable to agree about much of anything except parenting, and even then, we'd battled over the heads of our children and, after the divorce, right through them, unforgivingly, unforgivably. All the things you read about and vow to not do and vow you're not doing, we did. "Nothing a few visits to a shrink won't iron out," Fi'd always said, not-joking joking. Of course, I'd offered to go along. "Boundaries, Momma, boundaries."

"My boy," his father moaned now.

They had been such easy companions, Charlie and Fi, not just all the lacrosse and tennis and ice hockey but also their father-and-son travels. An arduous hike up a volcano in Mexico, for example. Another time, in Nicaragua, Fi clinging to the back of a moped with the backpacks and the old net bag with the snorkels and the flippers while Charlie negotiated

back roads and remote footpaths to some little-used beach a bartender in Managua had told him about. "No guys, guys, listen. I literally ate like a hundred pounds of dust," Fi'd said. It was Charlie's parental love language. It always had been, taking the kids places from which they'd return with peeling sunburns, stories for the campfire, many bites.

"DP," that'd been Charlie's familiar catchphrase, short for "don't panic." I'd always wished he'd panicked a bit more. It'd led to arguments when we'd been married: crowded buses, thronging markets, so many chances for their sweaty little hands to slip from ours. After the divorce, I'd had to hear about the family escapades secondhand. "Just when you want Liam Neeson in *Taken*, Dad turns into Jason Bourne meets *The Big Chill*," Sarah had complained the summer of her eighth grade. Panama City with Charlie, the power grid shut down across the entire country. "I thought we should stay in our hotel room with the door locked. Daddy thought we should find a bar that still had cold beer and karaoke."

Of course, I longed to reach out and touch this man now, this coparent, this precious person of my precious people. I longed to let him know I could feel what he was feeling, but even in the epicenter of our catastrophe, in those first few awful hours, we were too far gone from each other to be of comfort to one another. We hadn't weathered lesser storms together—our marriage, our divorce, for example— so we weren't going to weather this perfect storm now. Since splitting up seven years earlier, we'd lived on opposite banks

of the Snake River; we never bumped into each other buying groceries or hiking or at social events. So, we lay on either side of our dead son now and endured an identical hollowing unimaginable agony, alone, alone, alone.

"My boy," over and over he said it; Charlie's voice shook. It's the oldest lament in the English language: that thought came into my head even then, even in my worst pain. It's what happens when your internal compass is calibrated to stories. The way a pilot sees wind in clouds or a sailor reads currents in water, I look unconsciously for stories to remind me where I am, to remind me that whatever I'm going through, millions have been here before, are here now, will be here again. Tiny snippets of Beowulf broke loose in me, the grief of the grey-haired man, "no games in the yard . . . / there is too much room in castle and county." It was from the hefty tea-stained tome of *World Poetry* I've kept by my bed since the kids were tiny, reading in fits and starts, propped up on one elbow while they'd nursed.

"Oh Fi," I whispered, effortless tears, floods.

Our perfect son is dead; the perfect son is dead; a perfect son is dead.

Meantime, I needed towels, damp facecloths, lip balm, ice chips as if I were in labor; it's like that, the rasping breath, the chapped lips. I was in here for the long haul. I'd have done days if they'd let me. Breath after breath, I'd have been there with him until I'd figured out where he'd gone, and then I'd have followed him there. If not for our daughters

outside with Joan on the lawn weeping under that unblinking July sky, if not for them, I'd have stayed with my son forever, left with him. Instead, I vowed into Fi's cold neck, I'd do both.

Somehow, I'd do both; I'd find a way to be both where he was and also where they'd stayed.

"Ma'am?" the medics had been waiting; they kept gently asking to take the body.

"Not yet!" I curled myself around Fi tighter, inhaling every last molecule of his life. He smelled of mountains and lakes, petrichor and pine resin, forests and wild ice; his hair smelled like freshly baked bread. But his body, so cold, so unrelentingly unmoving was beginning to belong back to Earth, a block of perfect marble into which, even now, I tried to press my own life, exhaling, exhaling, exhaling. It's fruitless, you know it's fruitless, but you do it anyway, entreating your dead son to return to this perfectly usable thing, this beautiful, still body, so unblemished, so strong, so midstride.

You can give your child anything.

You can give him his life, even, but not yours.

And you can't give him his life back, once lost.

Also, his death made Fi no longer mine, no longer ours. For the first time since being born, Fi belonged now to the hands of others, entirely. To the medics, the authorities, the professionals. There was nothing more for me to do for his body, his beautiful body with its own rhythms

and tides—it's breath and heart and spinal fluid—in and out, stilled.

"I love you, I love you, I love you," I didn't stop telling him as they loaded him up into the ambulance. His sisters' cries muffled in Joan's embrace. I held his feet, cold and hard; a red blanket covered them, covered him. Then the ambulance doors closed, and in that moment the world flung me from its gravitational pull, and into some vast, unseen, unfamiliar current.

"I'm so sorry, I'm so sorry, I'm so sorry," I said to my daughters as they climbed into Joan's car; forlorn doesn't cover it. I put my arms around them, felt how diminished they were already, deboned. "I love you, I love you, I love you," I told them, too. It's all there is to say in the end. I didn't say I'd see them soon, or later, or tomorrow. In the end there's no future, and therefore there's no point in making any plans. And then the girls were driven away to Joan's house, and I was driven away to the condo, by whom? I suppose Till drove me, although I don't remember.

I don't remember the logistics of those first few days.

Mise-en-scènes, I remember, in which I am both a participant and the observer.

I knew I'd been struck a near-fatal blow and that I'd needed to be tended, attended, prevented from following my son to the grave. Till was there, the way a mother or a sister might have been. Or, if not sisterly, Till was at least somewhat familial, partly because even the most misguided acts of

sex, I'd warned my teenage children, can bond you for life to a person, making them known to you in ways your body will never forget. You've breached the ramparts, and so have they. And now they can walk in on you in the bathtub, for example, and their eczema might be something you know about. Also, their bodily fluids, yours, tiny traces of both, all mixed in together.

A time stamp of each kiss, each infiltration, I imagine you could count my sexual partners like rings in a tree. My cells subtly changed by how many? A dozen, maybe fifteen people: Till had become family in that way, with the flash-fire intimacy that sex engenders. But I wouldn't have sex with Till ever again partly because I thought I might never have sex with anyone ever again. The pain of losing a child is very physical, like the onset of a terrible chronic illness: the nausea, the cold sweats, the adrenaline. My whole body felt simultaneously jacked up and hijacked, buzzing with frustrated adrenaline, limp with crying, frantic with pain. A natural disaster, the world had ended for me—and for my girls and for their father, my God.

Till said she was good at managing disasters; she'd be here until I wasn't one. She'd be here until she didn't have to go around reassuring the neighbors. Very thin walls, within each block, we could hear each other's normal conversations. We knew what channels of television were favored; we could smell each other's cooking. I hated knowing that my early grief-howls like the howls I'd emitted during labor—nature's

911 call, unignorable—were reverberating through half a dozen units and into the ears of strangers. "Help me, dear God, please help me, you have to *do* something," I pleaded to myself, to Till, to my invisible mother, to my absentee sister, to anyone crying out over and over. "*Help* me."

That first night, as if I were lying embalmed in an open casket, a procession past my bed.

I didn't say anything. There was nothing to say. I was an upwelling.

Local friends said soothing things, a hand on my arm, filing out again, hushed voices in the kitchen downstairs. Then Michael Bernstein from Pittsburgh appeared by my side, his younger daughter with him, also his sister-in-law, Lori; I thought I'd hallucinated them, everything so shaky, so shattered. Anything was possible. But they'd been on their way to a concert in Vegas, had heard the news, and had diverted to Wyoming. They said to me, "You're not alone." Lori rubbed my feet; she's a bodyworker, knows how to hold a spirit in a body. "Stay with us," she said, like you do to a person who has a choice. "You're needed; we need you."

Fi had loved his Pittsburgh world. It's where Charlie had grown up, and once they were old enough to travel alone, we'd sent our kids for a few weeks each summer to their American grandparents, who lived in a picturesque township outside the city: golf and tennis, hamburgers by the country club pool, visits to the planetarium and the aviary.

Fi'd been accepted to the business school at Pitt, his first choice; touchstones and familiarity, maybe he'd live there after he graduated, he'd said. As part of campus life, he'd been in charge of a student campaign, a photo stand-in, to "put the *i* in Pitt." His beaming student face in the dot of the *i*, click. The Bernsteins had had front-row seats to Fi, the part of him that was leaving home, finding his adult self.

All those miles of walking: Frick Park, Mellon Park, Schenley Park. Also, his beloved Pittsburgh Penguins, his favorite ice hockey team. Until he was old enough to go over to friends' houses, we'd all had to go to sports bars to watch the Penguins games with Fi; I'd been so set against a television in the house. The final season of Fi's life, the Penguins had won the Stanley Cup for an astonishing second year in a row, and Fi'd held the trophy aloft, working his night job as a bellhop at a local fancy hotel where the team had gone for a celebratory dinner, his childhood dream literally unfolding. Fi could have touched Mario Lemieux; he'd been that close. He'd told us all about it. Also, Sidney Crosby, Sid the Kid.

5'11", 201 pounds.

Shoots: Left.

Born: August 7, 1987. Cole Harbour, Canada.

"Everything I know, I know because of love," Leo Tolstoy said. It's true. I'd never have known the vital statistics of a total stranger, if not for love. Our doctor, Bruce, he showed up beside my bed, too; over the decades he'd treated me for pneumonia, malaria, tropical parasites of one sort or the

other. He drives an ancient car, wears shiny old suits; his cowboy boots are worn at the heel, scuffed at the toe. He's a gentle workaholic with a passion for rivers, mountains, and wild places. He's rumored to be one of the characters in Edward Abbey's *The Monkey Wrench Gang* but you'll never hear it from him. "Oh boy," he said. Then he put the palm of his hand against my forehead as if trying to impress upon me. "You survive this," he said. His hand was big and warm, like something that could calm a flighty horse.

"And the girls?"

"They'll be okay."

But what did he know? I believed I'd prepared my children for everything. "When you're dying, hearing is the last sense to go," I'd told them when they were young. I hadn't wanted them to be surprised or offended by certain endings. The climate ruined, coastlines swallowed, no more polar bears, whales, or elephants. Also, in no particular order, our pets, their grandparents, the Ogallala Aquifer, roadkill. "Oh no, a dead porcupine." That had been Fi's spirit animal; he'd been distraught, eight, I think. "Does that mean I'll die?" he'd asked.

"Yes, Fi, you'll die," I'd said.

"When?" Fi'd wanted to know.

"One day," I'd said. "But not now. Not for ages and ages. Not until long, long after I'm gone." Then I'd made a grab for his ribs. "You hear that?" As if I were the boss of every-thing. "And when I *do* go . . ." I want the quickest, cheapest,

easiest thing for everyone. Stick me in the ground, burn me, compost me asap. But Fi and I could waste hours planning my elaborate imaginary funeral. The playlist quickly got out of hand: live performances by Sergei Rachmaninoff, Miriam Makeba, the London Philharmonic, also Paul Potts, winner of *Britain's Got Talent 2007*. Eulogies by William Shakespeare, the Queen of England, and Queen Latifah, ashes scattered on the summit of Everest and across the Mariana Trench.

"When you die," Fi'd asked, "how long do you have to stay dead?"

"Good question," I'd said. "I'll let you know when I get there."

"How?" Fi'd asked. "How will you let me know?"

iii

MY MOTHER had come over from Zambia to Wyoming for his delivery. Born in a storm, the barometer plunging, I'd been flattened by Fi's birth. He'd had a rough crossing, too, and had had to be hurried off to an incubator, wilted and wrinkled, a damp silkworm. I'd stood up and tried to follow the nurse; no one was taking from me my freshly delivered son, not without me in tow. The room had swung upside down, me on the floor. His head had been an effort, I can tell you. Stitches. There'd be no horseback riding for months, no bike riding for a while, no coughing or sneezing or laughing without consequences. I'd hauled myself up and flopped back on the delivery bed. "Dear God," I'd said to my mother. "What happened?"

"Mm." Mum had peered unhelpfully but gamely between my legs. "Oh gosh," she'd said. She'd emerged ashen; it takes a lot to make my mother blanch. "How about a cup of tea?" she'd offered. I'd felt gingerly in the direction of the pain. Mum had shuddered. "Oh dear," she'd said again. "Perhaps

something stronger. I know I need something stronger. This is a *nightmare*." She'd blinked distress and had begun to drift toward the door as if pulled by magnets. "It's enough one of us is miserable. And I suppose it'd be against regulations." She'd said "regulations" the way she imagined a Texan would. "And that's why they don't put pubs in hospitals. Perhaps I'll just . . ."

She'd licked her lips. It is true; she'd looked parched.

For two days and two nights, Fi'd breathed in a glass box, flat out on his back, like a jaundiced little frog, wires and monitors, not enough human touch. I'd stood outside the glass and had pleaded with the nurses for his release. My warmth is perfect, I'd reminded them. I can monitor his heartbeat. He needs his skin on my skin. I'd eked out his feeds when they'd brought him to me to nurse; plenty of milk I'd always had, as if expecting a village. "Drink slowly," I'd told him. Touch, I'd touched all of him, over and over, all over. I'd stroked every fraction of his skin, kissed it, wondered at his perfection. "What a dream you are," I'd told him.

I made that song by the Carpenters all his, about birds suddenly appearing and stars falling from the sky. Outside our hospital room window, thousands of elk crushed together on their winter feed ground. Biologists and scientists keep warning of an impending, inevitable pandemic, all those animals together like that on the national refuge, eating alfalfa pellets as if it's a drive-thru; it isn't natural.

Fi

All day, horse-drawn sleds take tourists out to cruise among the elk, milling like cows behind the fence along the highway north of the hospital, shaggy with spring coats.

Hale-Bopp—the most widely observed comet of the twentieth century—became visible to the naked eye in May 1996. Fi had become visible on ultrasound a few months after that, a hummingbird pulse attached to a yolk sac. By January, I was *all* Fi, a belly out to here. And Hale-Bopp was so bright anyone could see it, even from a light-polluted city; it was brighter than any star. All night and part of the day, that comet shone. You couldn't miss it—or avoid it—especially not in our wine-dark sky in the southern end of the Big Hole Mountains where we'd lived then. I'd never seen anything as wild as that comet.

A great silver ball with a pair of tails, a blue gas tail and an ocher dust tail.

The weather had grown wilder too. It snowed and it had snowed all that winter—and well into spring.

Massive dumps of snow—feet at a time—the roads kept closing in our part of the valley, not as traveled. Storm, bluebird, storm, bluebird. It's hard on an infant, all that barometric bouncing. Fi'd developed croup, always at night. They would stop plowing the mountain passes at dusk in those days; we'd been far from a hospital on either side of the mountains. I'd get our pediatrician on the line. "Please don't leave us!" I'd plead holding Fi's coughing little body

up to the phone. "No one go anywhere. Can you hear that, Dr. Little?" I'd had to take Fi into a steaming shower, then run outside into the cold. It'd jolted air into both our lungs.

Fat, moonlit clouds.

More snow in the forecast.

All month, Hale-Bopp had dominated the sky. I hadn't liked it, so much celestial influence around such an equivocal infant, an inauspicious start. And then Mars closer to Earth than it had been in the last sixty thousand years on the night of his death. I blamed the heavens. Fi, brought in on a comet, killed by a planet. If you miss signs from the natural world, then you miss everything.

In the days and weeks after Fi died, hummingbirds congregated around the girls and me everywhere we went; Cecily persuaded one to land on her finger. Or more simply, she stood still, finger outstretched and a hummingbird helicoptered lightly down onto it and then just sat there shimmering and metallic and perfect. Also, bald eagles and sometimes golden eagles—not just one or two, but flocks of them, five or six at a time—in the sky, on the ground, perched on fenceposts and telephone poles. Another friend reported being beset by owls, yet another by ravens.

Birds are messengers from God; you don't need to be a shaman to know. And augury—the practice of interpreting the will of the gods through birds—has been with us ever since we started casting around for meaning. The deeper you look into each moment, the more likely it seems that we've

been here before. Homer's Helen of Troy sees an eagle with a goose in its mouth and portends revenge. But don't we all invent augury—or at least discover it for ourselves—as children? I know birds talked to me until I was told they couldn't; thirteen, I was by then, I think. Now I stared at these birds intently from the porch of the condo, a lot of plump robins on a little hawthorn tree.

"Fi, is that you?" I asked them all. "Have you seen him? Do you know him? Would you take him a message?" God, I've never been so alone: talking to birds! Like a saint or a child or like any other ordinarily mad person. Till put her life on hold—"Well, it's been on hold anyway"—and ran around the condo with a drill and a nail gun and superglue; she slept on the sofa some nights, guardian in residence. Friends, colleagues, disaster moths flew to the porch; Till would ferry in a tray of tea, melt back into the condo, then the *shak-shak, shak-shak* of her nail gun would start back up.

"You will never get over it," a woman of my acquaintance assured me quite casually, as if pointing out to someone pinned under a bulldozer: *Oh*, that *won't budge in this lifetime.* She'd set up an appointment via phone to tell me this, as if it were her solemn but sworn duty. She'd offered me Buddhist texts for my spiritual solace, magic mushrooms for my depression, a lecture on the benefits of meditation. I stared down at her knees: they looked like a couple of angry ostriches, bobbing and pecking at each other in a sunburned vlei. *Old Ostrich Knees*, I thought.

"Thank you," I'd said. I didn't tell her: "Also, I'm not done thriving yet, my dear old ratite. I'm not ready to eschew my pain, wrap myself in prayer flags, and fade out with the bells. I am merely in the early learning stages of grieving my only possible son." One of millions of mothers to have lost a child every year, fifteen thousand a day. If none of us suffered, where would we be? Without wise women is where; suffering brings wisdom. So, a gift, this suffering, a promissory note for sagacity. Meantime, the actual suffering. I couldn't see my hand in front of my face, it was that dark.

"The first one is the hardest," an old Zimbabwean school friend wrote when she got the news. "Nematambudziko, Alex," another assured me. *We're devastated with you.* In the traditional, braided, intergenerational Mashona family structure from which some of my old schoolmates had come—upon a parent's death, younger cousins becoming small mother, small father, for example—you can never be an orphan or alone, always held by family, by clan, by ancestors. I envied that never aloneness in the midst of the most aloneness I'd ever known. I'd envied it as a child; I'd never stopped envying it. Majalaas, we'd called it at home.

"Grieve correctly," another Zimbabwean friend reminded me.

Cover mirrors, light candles; that went without saying. Remove his photographs, please. I couldn't bear to see his beautiful face now that I wouldn't see it in person again. Eat no meat, dress plainly, say no ill of the dead. Done,

done, done. My friends raised in Jewish families with Jewish traditions knew, too, sleeves up, hands on, gather. When death had happened in their families, they'd had rabbis saying what to do, and how to do it, and what to do next. But the Anglo-Africans who'd raised me were all about getting on with it, the cycle of life a beautiful violent blur: dead drunk, dead, dead drunk, repeat.

Now, where were they, my vanishing drunken people, my unsettled white settlers? My estranged mother, my estranged sister, everything and everyone attached to them estranged, too. Such a post-Blitzkrieg of silence. To be born to addicts, however, is to have been born to proud dragons; cold-blooded, also fire-breathing, cave-dwelling, lying in lairs, layers of lying. Instead of attending Fi's memorial, my mother inexplicably flew to Scotland; Vanessa continued to maintain a perfect silence. Still, I missed them, or I longed for some version of them that they weren't, but I'd taken alcohol and suicide off the table. Nonnegotiable, never again. Which is another way of saying I'd taken my family off the table, just for today, day after day.

"Should I phone them?" Till asked. Those first few days she kept asking.

"No," I said over and over. "I mean . . . No. It's okay."

Mitákuye Oyás'iŋ. All are related, the Lakota say. It's a philosophy and a fact.

Therefore, I couldn't shake the notion, born of unbearable longing: somehow, I'd gone astray in my understanding.

Someone was supposed to be here, surely. Not Till, certainly. Not my daughters. Someone else, other people, the village that it takes to raise a child should be there to grieve him. My mother, my sister. My father would have made an effort. He'd have said, "Bad luck, Bobo. I *am* sorry." He'd have written comforting weekly letters full of banana yields and fractions of millimeters of rainfall and fertilizer ratios. He'd have phoned me every Sunday morning to remind me to keep buggering on. Each other is a binding human contract, isn't it? Otherwise, who wouldn't give up with the loneliness of it all? And who wouldn't attempt to linger indefinitely in the womb—perfect temperature, all enveloping, weightless buoyancy?

Fi had been a womb-lingerer: two weeks past his due date, how impatient I'd been to get his life outside of my body. Then, how worried I'd been once he was out. He'd seemed more vulnerable than Sarah; she'd been a hearty baby, sociable, curious. Not Fi, he'd fretted unless attached to me. For two years, I'd rarely put him down; we'd breathed in tune, his heartbeat like a trapped butterfly against my chest. Then one day, the spirit of boyhood had suddenly vaulted through him: ice hockey, tutus, animal communication. A Renaissance child, he'd tried everything life presented, as if knowing it'd be just the one short run for him.

I know it took Fi off guard, dying.

I could feel his confusion. *My* confusion. The suddenness of it all. Becoming Fi's mother had taken me nine

months, plus all these years, my full cooperation; unbecoming Fi's mother, how to do that so suddenly, so unwillingly? Fi would've hated to find out that he'd died: a miracle, he'd always said. One and a half million people, each rolling a trillion-sided die, all landing on the same number; those were the odds of any of us being born. The odds of losing a child before you lose yourself—I looked it up after it happened to me—by age sixty, in the United States, is about one in ten.

RUNAWAY
BUNNY

i

I NEVER DID FIND OUT what took Fi, not exactly. I wouldn't look at the autopsy report or read the health records from the last weeks of his life, nor did I sit in on the interview with Charlie and the doctors and the specialists and the medical examiner. It's not only that I didn't want to know the details of what the experts could only speculate had been the cause of Fi's seizures and therefore the cause of his death; it's mostly that I didn't have time for guesses. I wanted to know for certain: where, now, is my only begotten, beloved son?

Not what, or how, or even when.

But where?

I wanted to go there.

The opposite of birth is death; we all know that. But there is no opposite to life. Life is eternal, so where had Fi's eternal life gone? No one could provide a satisfactory answer. Whatever the medical experts could tell me about what had stopped my son's now stubbornly unbeating heart, they couldn't tell me what had happened to him. Yes, his body

was in the Valley Mortuary, but his life was missing, gone, into the actual heavens, absorbed into the universe. Talk about looking for an atom—a cluster of atoms, a wrinkle of atoms, a riffle of Fi-energy—in the universe; there was no time to waste, therefore. I needed to start following after him, calling his name, now.

He was the issue, not what had taken him. After all, you don't ask a soldier shot on the battlefield the caliber, make, and manufacturer of the bullet that has shot him down; it's enough to know he's been hit. Details later. The same goes for any newcomer to a place; you don't dwell on the means of his sudden arrival to your shores—it's a fleeting thing in nearly any case—ship, road, train, plane. And you don't ask people of your fresh acquaintance: vaginal or caesarean? What took you from uterus to world?

"*How* did he die?" people asked, kept asking, still ask. Insistent.

I couldn't answer; I can't. I'd have to hold up a hand like you do on a plane. No more turbulence, please! My son died peacefully, in his own bed, by the hand of an impartial God, taken. A heart denied its next beat, its next two billion beats. A potential denied its promise, no one to blame except God and even that could wait. What mattered to me—the only thing that mattered to me—was that Fi'd left the limits of my understanding, and now finding him had become everything to me.

Fi

I worried that if I didn't hurry, I'd forget the cadence of his laugh. If I didn't hurry, I'd forget the music he'd listened to, his favorite color, the mole on his back. If I didn't hurry, we'd forget all the ways we'd always said we'd find each other if we were ever separated, if he'd become possessed, disoriented, kidnapped. Tell me something only we would know. It'd amused us to hear how quirky we'd sounded under examination, how culturally mashed: Southern Africa, Britain, the States eastern and western.

How do I know you're not an alien in Fi's body?

"Because," he might have said, "balsamic vinegar," his favorite dressing. Or which fictional character would you want to be in real life? P. G. Wodehouse's pampered aristocratic cerebral featherweight, Bertram Wilberforce Wooster. Name one artist we'd admired when Fi was in eighth grade: Ai Weiwei. Name another we were obsessed with at the same time. "That you were obsessed with," he'd have said.

"That I was obsessed with, yes," I'd have had to admit. Marina Abramović.

Tell me a line from a movie that is significant to you: "I tend to think of myself as a one-man wolf pack." Favorite color: yellow but blue, too, honestly. Actually, I don't really know. Do you think I am a tiny bit color-blind? I think maybe I might be. And then I'd remind him how he wasn't color-blind because he wasn't a kid who fell through the net; and as far as I could tell, for my children it was all nets and

71

checkups, vaccines and allergy challenges, helmets and elbow pads. It was all so safe it could be a bit oversafe, I'd argued.

Lucky number: 37.

A week or so after he'd died, Sarah had had that number tattooed on the inside of her arm; she'd nearly fainted with the pain. Too young for a tattoo, Cecily had written the number on her wrist in Sharpie every morning: 37. Their pain swamped them, overwhelmed me to begin with. On the nights Cecily had stayed with me—Charlie and I split custody of Cecily, two weeks a month each—Sarah had decamped from her apartment and slept over then, too, on the sofa, or the porch, loath to be away from Cecily. I kept running baths that no one got into, making cups of tea that no one drank. I kept picking up my phone to call him, to tell him what had happened, to ask if he was okay.

"Maswera sei," we say at home. How are you?

"Taswera maswerawo." I'm well if you're well, we say back.

I'm not okay, I kept hearing myself think. I'm not okay. I'll never be okay.

"I thirst," Christ is reported to have said from the cross, shortly before he died. After that, he sucked wine vinegar from a sponge attached to a hyssop branch offered to him by his guards. Then, "It is finished," he's supposed to have said, and it was. It's about all you can do, honestly, in the end: basic needs, bare markers, the facts, the penance of a whole history nailing you down. The impossibility of the task is enough to collapse the most stalwart of souls. The

aloneness of it, alone, is enough to leave you nearly speech-less. Or Mary: I imagined her raging impotently at God, that filicidal maniac, how lonely her sorrow. That was me, scrabbling at the base of the cross for *how* to do this thing.

"Hang on," I kept telling myself—and the girls. "Hang on."

The rooted people, the people with ancestors, they still knew *how*.

Meantime, grief is hungry. It consumes the extremities at first: hands, feet, toes. They become swollen from all the sitting around. Also, the heart, that's pulped, obviously. Legs, bladder, digestion, these all falter immediately. The sheer weight I had to chest press just to breathe. I hardly left my bed for a few days. After that, a short walk along the river, then a slightly longer one the next day in the foothills, day by day, as if recovering from a heart attack. I worried about my girls but only insomuch as you can worry about anything from your own deathbed. "It's not going to be like this for-ever," I promised. But it felt like a lie even as I was saying it. "I've seen to the end, and we make it," I told them.

It was like training for altitude, at altitude; also, no way down but up.

Everything else has been bootcamp, I told myself; this was the real war.

Oorah, semper fi.

* * *

If I follow any religion, it's walking, the daily practice of which brings me to a fresh understanding of God, which is to say an ever-mutable, riotous entity; you can only have the God you can have. Fi had taken to walking every day, too. Pittsburgh is a highly strollable city; you wouldn't think it from *The Deer Hunter*. He'd also read a dozen books his last summer, coached lacrosse to little kids, interned at an outdoor apparel startup, worked night shifts as a bellhop. He'd had his first real romantic relationship, a nurse. I marinated in agony, each stage of his development, mourned. Every proof of his evolving excellence, bewailed.

Andy Warhol, Art Spiegelman, Matthew Shepherd, Shepard Fairey.

To whom would Childish Gambino sing now, if not Fi?

Backgammon, poker, raffles: Fi won, usually.

Where had all that luck gone? Also, where had all those tastes and preferences gone; where did all that life go? His instinctive diplomacy, his way of not only being comfortable with anyone but also of putting others at ease. I wanted to be taken there, to my son, to his irrefutable, eternal beingness. Anything short of that—dead ends, false prophets—and I raged with disappointment. I've been told by unsympathetic observers—my exes, mostly—that I underestimate my own force. I don't know what that means, exactly, but I know this: you don't take into account your own force when that force is directed at the missing life of your child.

Fi

Like the moon, the moon doesn't do gravity on purpose. But in her slow regard across our skies, she sucks the very oceans from their beds, night after night. It's the natural order of things. Fi's death, people told me, was *not* the natural order of things. There's a relatively new word for a person who has lost a child—like widow or widower—coined by Karla Holloway in 2009: *vilomah*, from the Sanskrit meaning "against natural order."

Is it though?

Is it against natural order for children to be born and then to die, all in the space of their parents' lifetimes? Says who? Gravity's not intentional, but neither is it a mistake. Who's to say Fi should have been born this day, not that; died in this year, not that? We're not in charge of who gets more or less time, not in the biggest picture. Natural or not, something takes your child—providence, a bullet, the state—and suddenly you, too, are taken. I was taken, overtaken by an instinct to find him, in whatever form. I was a whole ocean in a single woman's body, Earth's gravity pulling me toward, toward.

Toward what?

Any flicker of life or—more precisely—his life.

Some women can feel the moment of ovulation. Not me, I hadn't felt him land on Earth, and I hadn't felt him leave. I'd slept right through his death; it kept me awake for nights and nights afterward. How had I not been jolted

into shocked awareness at the moment of his departure? How could I have had this person inside my own body for nine months, more, and know nothing of his fate, his arc? I couldn't even know the love I'd have for Fi—for any of my children—until I couldn't *not* know it. All my capacity to love, bighearted like a horse, flooded out of me at them the moment they were in my arms; mother love, unwieldy at first, so big, something that might easily knock a toddler flat.

Oh, mother love, who knew?

✳ ✳ ✳

One week and two days after he died: Fi's cremation.

We'd never asked him, "So, if you die before us, how do you want . . . ?"

I felt I was battling a kind of reverse gravity, like at the county fair, the awful rides.

I was twenty-seven years and two months old when Fi'd hit my womb: a pinhead-size blastocyst, burrowing into me, hundreds of his cells delving into hundreds of my cells. I was forty-nine years, three months, and nineteen days when Sarah and I sat together surrounded by beeswax candles in the mortuary chapel adjacent to the incinerator listening to the sound that took Fi's mortal remains from us and made of them ash. It's a building you know about if you live in our town: opposite the hairdresser, the butcher, a Mexican grocery.

I'd looked at that building often, looked at it without seeing it, really. Blinking in the sunlight, all those hours with

my hair in tinfoil at the hairdresser, nursing babies under capes. Or hurrying past the mortuary on my way to buy beef liver, dog bones, tortillas. If I'd thought of the mortuary at all, I'd thought, *Ah, that's for dead people,* whoever they are. Now, though, life, life, life. The calendar had chased me down, days whipping past. Old women—the age I am now—feasting eyes on my babies in the line at the post office had reminded me, "Enjoy it while it lasts; it goes so fast."

I'd been just counting heads, getting everyone in the door, out the door.

Mittens, hats, boots.

On, then off, on again, off again.

I'd thought Sarah would end up on Broadway, and Fi would end up in the White House, and Cecily would be a paleontologist. If I hadn't thought those things, I'd thought, they'll end up okay, my children. Their lives have been stable enough, lucky enough, privileged enough. I'd also thought I'd be married to their father forever; I'd pictured my wildness and outrage and objections aged out of me. I'd pictured him less disappointed with me or, at least, more accepting of his disappointment with me. I'd pictured him at peace with whatever I'd done, and with whatever he'd left undone.

There'd be grandchildren; and we'd have made it, a life together.

Meantime, I'd written from all the edges I could find. And for seventeen years, I'd written a final letter to the

children—a new final letter each time—put it beneath the bathroom sink and then I'd leave for a month, two: South Africa, Mozambique, Haiti, Angola, Zimbabwe, the Pine Ridge Indian Reservation, on assignment. "Darlings, if you have found this letter, it means I've been gone long enough that someone has finally decided to clean under the sink." "Old Yeller", my editor had dubbed *National Geographic*. Each word of every story tested and retested. "Truth is timeless, or it's neither," he'd always insisted. Then, the management of the magazine had been taken over by 21st Century Fox and I'd had a bridge-burner of a row with the new editor.

After that I'd written for other magazines and published a novel after years of memoirs and reportage.

There's a lie that says women can have it all: work, children, love. But to have it all requires such speed, such sacrifice, such intensity, it burns up the experience as it's happening, scalds the kids. A blur, such a blur, no time to think really or to absorb every miraculous moment. Do the most required thing right now. Then turn slightly and do the next most required thing. Child by child. Meal by meal. Page by page. Assignment by assignment. Advance by advance. Deadline by deadline. And so on, therefore doomed to repeat my lessons and my mistakes, bigger, faster. Up at four, writing, cleaning, cooking, another load of laundry before the children awake, dogs, horses, garden.

Sometimes, in the fall, I'd pony the children's gray mare, Ghost, behind my mare, Sunday, and I'd ride from the little

ranch above the hamlet where they boarded—sharing pasture with elk in the summer and hay with moose in the winter—skirting the new developments and meeting the kids for school pickup. Then, down the road in single file we'd clatter, the dogs weaving in between the horses' legs until we'd reached the trail back up to the ranch. After that, whooping and hollering, cantering home through aspen groves, horses steaming, dogs panting. Rotting leaves, woodsmoke, sweet willows: October in the Northern Rockies.

If I could do it all over, I'd do it all again but slower—much slower.

Except walking, we'd loved to walk at a clip, all of us, talking at a shout.

Fi'd got his love of walking from me; fanana-fanana, as we say at home, same-same. You can look at your mimicking child and say, in this way—in his adherence to a daily walk—a part of me will not die, nor will the part of my mother that had put the love of walking into me, or the part of her mother, my Scottish grandmother, who had loved to walk, also, my father, his nanny and groom. And so, back and back, the great walkers of my family—miles and miles we've covered, countless generations, six continents—remembered now in the steps of my son.

And his children, they'd have walked, too.

The way Sarah now walks, and Cecily; and their children will one day walk.

The steps not taken.

ii

T HE SOUND OF AN INCINERATOR, it's a roar. Headfirst, he'd come out. Feetfirst, he went in. And then the doors closed. They're heavy; you can hear them slamming. I will not see his body again. Not the way he filled out some version of my lips and my bumpy nose, my almond-shaped eyes. Not the way he carried his father's shoulders and height. Not the way he grew into his grandfather's hands, my father's hands.

The mortuary chapel had the feeling of a 1970s motel conference hall, rust-colored carpets, pine benches, flat electric light. Sarah and I brought blankets, cushions, a thermos of tea, letters to Fi, flowers, music, candles.

"How are you doing?" I asked. You ask differently at times like this.

"You know," she said.

"I know," I said.

We hugged each other then, the way soldiers might before battle, with the understanding that what we were about to do might just kill us. Sarah's shoulders are so

powerful. I always register this. She is so *sisterly*. Also, other things: a scholar, a biker, a writer, a reader, a daughter, a friend, an artist, an activist, a cook, an athlete, a spiritual seeker. But if I'd had to come up with the single word that most defined her, it'd have been "sister." From the start, three and a half years older than he was, she'd hovered over Fi, anticipating his every need, then his every thought and word. "I have control of your mind," she'd told him. They'd have been about three and seven by then, Fi strapped into his car seat, wide-eyed, while I'd run into the post office. "The person who gets in the car will look like Momma, but she's really a kidnapper." And Sarah's tour de force: "And how we'll know, kidnappers are always the same. She'll say, 'Why is Fi crying?'"

"Why is Fi crying?" I'd ask, getting back into the car, bills, cards, letters from Mum and Dad, dinner on my mind. We'd laughed about that years later, when they were older, sitting around the table, reminiscing after dinner. Our hilarious escapades, hilarious only in retrospect, some of them. Like the time Fi and his little gang got drunk for the first time, age sixteen. They'd have gotten away with it had not Fi thrown up on the walls of Sam's parents' freshly stuccoed hallway. He'd had to phone Sam's mom the next morning, sheepish but not at all hungover, his nose a little pink and twitchy with embarrassment, though. *Rabbit nose*, the girls and I had teased. "Um, hello Mrs. D., this is Fuller. I am so sorry that I got drunk and . . ."

The kids and I had laughed a lot, and we'd been dead serious a lot.

We'd tried our best to blow each other's minds. There had been no taboos, there are none. Politics, social justice, religion, addiction, sex, gender, race—whatever was coming up in our lives or in the news—we talk about it all, hash out our ideas, our insights. We're always having *epiphs!* We know we're each other's safest but also most challenging audience, responsible for acting as each other's moral compasses. Are we facing toward the light? How about now? Then, after supper, usually cards, art, or a board game, someone always trying to cheat, someone else trying to catch the cheater. Fi picking up Cecily by the ankles and shaking Bananagrams tiles out of her pockets.

Where had all that laughter gone? Where had that easy physical grace come from to begin with? Sarah and I spread out the blanket, the cushions; we lit the candles. Charlie and Cecily had gone into the mountains where he may also have been, Fi. Half of us with his body, the other half with his soul, who knew? A gurney was rolled in and we—Sarah and I—said goodbye one last time to the body that had been Fi's. Then we played his favorite songs and waited for the mortician to tell us it was over.

"You're so brave," I kept telling Sarah: twenty-four, nearly twenty-five.

The age I was when I'd had her in a sweet cottage-y clinic in Marondera, Zimbabwe.

Fi

In photos from Sarah's infancy, I look barely adolescent; gangly, thrilled, my healthy baby naked on my lap in the little cottage a dozen miles or so upstream of Victoria Falls. That world, that person, those people, they're strangers to me now. I will never again have a memory that isn't also overlaid by what I didn't yet know at the time of that memory's making. Everything I know, recast in his absence. Like Sarah now, gray rings under her violet-blue eyes, the birthmark on her forehead flaring. She looked utterly worn out, haunted. Altering her whole idea of a future, one without him. They'd been each other's closest confidantes, best friends, most ardent supporters.

"What happens after the sky?" Fi had asked, as all children must, eventually.

"More and more sky," I'd said.

"And after that?" he'd asked.

Ashes, so dry. But none of *this* is real, I kept thinking; unreal pain, unreal reality. They tell you you'll want to wait until the ashes are completely cool before taking them from the kindly funeral director, sweating in the parking lot, the pavement melting and burning through the soles of our shoes. He wore a pink golf shirt, khaki pants, leather cowboy boots, the funeral director. I can't remember what I wore; gray, I think. Gray and white, probably. I have a limited wardrobe. In any case, there's no graceful way to do this, to take your son in this unwelcome form from a stranger. Also, the end is not how you imagine the end will

be; there is neither a hallowed silence nor are there bugles or choirs of angels.

Instead, the *beep-beeping* of someone backing up heavy equipment, a dog barking. Sarah driving off, alone, a left turn onto Highway 22 toward her studio apartment, merging traffic. Her early adult life, this. A trash bin being emptied. A child shouting. We're all only human after all. My boy, with both hands, I could hold him now, again, the way I'd been able to hold him in the days after his birth, the size of a loaf of bread then. And the same weight in ashes as he'd been as a baby, seven and a half pounds. It's all so sickeningly, dizzyingly, tightly circular, at the very edges of existence, I mean.

And those universal edges—birth, death—they're hard to take in completely, when they're happening. It's all going too fast, blood rushing to the head. Even the middling, middle bits—stable-enough marriage, healthy kids, good income—like the middle of a roundabout, you can think it's all going quite manageably no matter how wildly the edges are quivering. I did; I thought I had it all under control. A deadline every six months. No more than two and a half glasses of wine a night. Cigarettes only on assignment. Infrequent affairs and then only with people I'd rarely have to see, long distance, longer. Three perfect children. Above all, even if I'd screwed up every other thing, I'd still have three perfect children.

And now I see, that too had been an illusion.

Fi

✷ ✷ ✷

Four small urns containing a little of his ashes: one for each of the girls, one for me, one for Charlie. Sarah'd had some of Fi's ashes put in a brass locket to wear around her neck. The rest we took a few days later—late July now—to the grounds of the little episcopal Chapel in the shadow of the mountains. Sage, lupines. There, in dazzling summer sunshine, we laid our child, our brother, our man to rest, six of us, three women, three men: Fi's father, Fi's two sisters, Fi's best friend Tenzing, our Episcopal reverend Jimmy Bartz, and me.

Fi and T, Fuller and Tenzing, Funzing we'd called them.

They'd been joined at the hip since Tenzing's father had put skates on the boys, toddlers, preverbal, and had let them teeter around the little cowboy ice rink in the village. It had been as if they'd grown a secret language between them, speaking speed and intent in a single glance. And, when they had started talking, both late—Tenzing also battling with his *r*'s and his *l*'s; Fojo, he'd called Fi for years—they'd vowed there were certain things between them, best-friend things, that they'd never talk about to anyone, things that they'd take to the grave and now here we were, there already. *The boys*, I kept thinking. Our *boys*.

They'd intended to be each other's wingmen until the end.

Then when they'd been in middle school, Sam had come along, a transplant to the valley.

After that, it'd been the three of them. They'd finished high school together, and most of college, and Sam's cancer treatments; they were going to be in each other's weddings. They were going to go back to the remote mountain village in Nepal where Tenzing had been born. They were going to meet Tenzing's birth family—his aunts and uncles, his cousins, his brothers and sisters—Buddhist monks and nuns, many of them. "Not this, never this, we didn't plan for this." I held Tenzing, hugged him, but there's a point you can feel—I did—that I could begin keening there, against Tenzing's shoulder, and not stop, not ever. Be still my human heart; these griefs will be grieved in their time. Jimmy Bartz reminded us of this, a season for everything, even the unseasonable, he said.

But what struck me most then, what I felt most terribly, that awful morning at Fi's final resting place, was how alone we each were in our vigil of sorrow; another symptom of grief in a thanatophobic culture. Each person hit by this disaster as if it were hitting them in isolation. Tenzing had found out about Fi's death alone, his phone blowing up in the Hong Kong transit lounge from Nepal. Then, after that, flying the ten hours from Hong Kong to Los Angeles in shock and disbelief, Tenzing, surreally suspended between earth and sky, the way I imagine Fi had been also.

Of all people, therefore, trust Tenzing to have been up there, with Fi. They'd known where the other was by feel almost all their lives. By the time they were eight, they hadn't

even needed to look across the ice; so many pucks had passed between them already. And also, so many ways of passing— back pass, flip pass, flat pass—each one an unbreakable stitch in their brotherhood. Perhaps Tenzing had flown home with Fi, but it hadn't felt that way to Tenzing. He'd felt nothing but loss, and after that more loss. All their future plans, broken. Where Fi should have been, nothing. A yawning gap, a time-swallowing hole.

Nothing, now, between Tenzing and the net.

I felt through his remains, my son's, grainier than I'd expected.

Sarah sprinkled ashes, then Charlie, also Tenzing. Cecily read a letter to Fi. After that, she sat on a rock on the edge of the chapel grounds, her arms wrapped around her knees trying to not cry, trying, she said, to see Fi in everything, in the lupines, the sage, the bluebirds. "I once read," the Israeli novelist David Grossman wrote in *Be My Knife*, "that our sages of blessed memory had the idea that we have one tiny bone in the end of the body. It was the end of the spine. They call it the *luz*. You can't kill it. It doesn't crumble after death and can't be destroyed by fire. It is from this that we will be re-created at the resurrection."

Fi's luz, then: where?

A small purple cloud scuttled over and stalled above us in an otherwise remarkably blue sky, and rain fell, just on the six of us. A refreshing rain, a light rain, not a torrent. Then, as we were walking back to our cars, Charlie asked if

I'd consider giving blood, submitting to tests; there was a possible genetic component to what had happened, he said, maybe an inherited this and that. I've buzzed out the exact words of his requests embedded in which are further clues to our son's last moments. I was already talking before he'd had a chance to finish; he'd hated that about me when we'd been married. "No, no, no."

What am I hiding, you ask?

There's a pitch audible only to bats; I put my hearing there.

"I can't," I told Charlie, shaking my head. If I'd found I carried the gene, the poison, the error that had killed my son for certain, I couldn't. In any case—I'd protested against this, too—he'd already taken the girls to the hospital, they'd had their blood tested for this and that, but the results had told us nothing about when they'd die or how. I said, "No." I didn't want to know if my blood had killed my son; in any case, I doubted it. Inbreeding and insecurity, yes, drunks and lunatics on *all* branches of my family tree. It's not like I'd hidden that from anyone, as if you could; they'd all but named the local mental ward after my mother's side of the family back on the Isle of Skye, Scotland.

The rest of my family had gone mad—and bad—in the colonies, drinking and racism, mostly. Not seizures, though, we had no history of those in our swashbuckling blood. An obscure poem by N. P. van Wyk Louw, one of the so-called *dertigers*, Afrikaner writers of the thirties, had haunted me when I'd first read it. It haunted me again after

Fi

Fi died: "O wye en droewe land, alleen Onder die groot suidesterre . . . Jy kendie pyn en ensaam lye van onbewuste enkelinge, die verre sterwe op die veld . . ." "Oh wide and sad land, alone Under the great southern stars . . . You know the pain and lonely suffering of ignorant individuals, the remote death in the veld."

Had it been our remoteness that had killed him?

Our ignorance?

Our emotional chilliness, our multigenerational mental illness?

Vivisection, factory farming, Roundup, DDT, convict ships, the Trail of Tears, the Highland Clearances, imperialism, the Boer Wars, the Troubles, anti-Semitism, uranium, lead, mercury, arsenic: what or whom had I ignored? The sins of the fathers, what had I done—or left undone? Warming oceans, jellyfish swarms, the Amazon in flames. Our lungs and hearts and brains coated, they say, in Teflon and plastic and all of us, at least in North America, made up at least in part of high fructose corn syrup. I hadn't allowed it in the house; I'd thrown out Halloween candy by Thanksgiving, no sugary cereals, nothing processed. "Gruel," Fi'd told his dentist when she asked him what he ate for breakfast, usually.

We'd laughed about that the whole way home.

But I'd had a fever, pregnant with Fi—either influenza or maybe remnant malaria. Had that short wired something? And I'd craved oranges all nine and a half months—half a dozen daily. Perhaps I'd been deficient in folic acid? Or

maybe I'd been full of other deficiencies; something at the cellular level—or worse, at the soul level—the sins of our fathers *and* mothers. And the whole, long, big winter of my pregnancy with him, I'd skied the rough, low, relative wilds of the Big Hole Mountains and had once scared up a mountain lion.

Maybe it had been that, a shot of pure adrenaline to his developing little heart.

Then, had I fed him the wrong food as an infant: tofu, strawberries, salmon? And there'd been the dairy allergy I'd been slow to notice. Another time, when he was seven or eight, I'd made Fi walk four miles with—it transpired—a fever of 103 because I'd thought he'd been shamming. I'd been tough on my kids in other ways, too. I'd expected them to start volunteering by eleven, working by fourteen. We'd lived eight miles out of town in a rural county, no bus service back then. I'd refused to drive them anywhere, though. They had legs, I'd told them, and bicycles. Did they know, I'd asked, how far kids walked every day to school in some parts of Zimbabwe?

I hadn't wanted to hear their complaints and their war stories, warries we'd called them.

"Keep it fresh for your shrink," I'd said, holding up my hand.

And if they'd dared whine how much easier their peers had it—cupcakes, computer games, television—they hadn't tried it on me more than once. If my parenting was too

arduous for them, I'd said, there were plenty of orphanages in Lusaka that would love a couple of student volunteers for the summer. I'd be at a nearby hotel, quaffing gin and tonics by the pool with the complete oeuvre of Michael Ondaatje. Stuff like that, and the ways I'd found it so entertaining to embarrass my young children. Dancing down the grocery store aisles unable to contain my peals of laughter, poor Fi in actual tears of embarrassment.

It hadn't killed him to be raised by me, surely, everything so intense.

My intensity reflected back at me with such unflinching calm.

I'll never forget—or let anyone else forget—the Intermountain States Championship Ice Hockey, 2007. Sudden death: Fi, age ten, the tournament-deciding shot. He'd looked toothpick tiny out there, very much the David in this story. Also sharing the vast swathe of ice with Fi: a referee, a puck, and a goalie from one of the Utah teams. The goalie had looked older than a Squirt to me; Fi'd looked younger. His stick on the red line—puck dropped—whistle. A thousand miles, it seemed, Fi'd skated down the ice toward the goal: *shuck-shuck, shuck-shuck, hiss-hiss.* Then all of a sudden, there; boom, slapshot, goal!

It had been a miracle on ice, *the* miracle on ice. I'd nearly flung Cecily out of her BabyBjörn and into the bleachers, dancing with pride. "Those are my ovaries!" I'd crowed. Afterward, Fi'd been humble, gracious; he could afford to

be. I'd recounted the play in real time for days—years, I do it still—to everyone, anyone; my hairdresser of twenty years, seatmates on airplanes, people in the line at the grocery store. Fi had learned how to negotiate, quietly, around obstacles, real and imaginary, such grace, as if being carried by currents, thermals, and tides. Even this impossible thing then, this death; he'd done his part perfectly.

He'd left nothing undone: no resentments, no grievances.

It was we who were left to figure out how to do our parts. Survive, thrive, transcend.

God, which is the way to those things?

I'd always told my children to be wary of anyone who says they have the way to anywhere other than the local library. I'd said there is no *the* way. And whatever anyone tells you, your way is not marked because the marked ways are already somebody else's way, and everyone has to find their own way. C. S. Lewis knew; he knew grief, he knew love, and he knew love's source. He knew, too, that for some, the way to Narnia was through a wardrobe, but to others the wardrobe was just that, an applewood container of mothballs and old fur coats. Above all, he knew that it was all sacred: the lion, the witch, the wardrobe, the mothballs, the fur coats, and the mind that could conceive those things.

iii

THOSE FIRST FEW WEEKS after Fi died Till would show up most days if she knew I was alone—or alone with the kids. She'd also taken it upon herself to do the things of a life for me: shopping, cooking, cleaning. "You must eat," she'd said, kept saying; but I couldn't. I lay out there, staring up into the postcard patch of sky between the choppy condo roofs. When Sarah and Cecily were with me—they were with Joan sometimes and friends sometimes and sometimes with Charlie—we lay out there together, holding hands, waiting. They, too, couldn't eat. I thought, *This is what they mean when they say "grief maddened,"* wasting away, searching the sky perpetually for signs of Fi, upward gazing.

Give us a sign.

Hold up a finger.

"Sanka, ya dead, mon?"

"Ya mon." We'd taken that from *Cool Runnings*, the 1993 movie about the first Jamaican Olympic bobsled team. We'd watched that over and over. "Whatsa matter, you guys cold?

It's not so much the heat, it's the humidity'll kill ya." We'd said that to each other, too, when it was minus 10, colder with the windchill, scraping ice off windscreens. We'd been so insider—"so cider inside her insides," as Roald Dahl wrote—I'd taught the kids the value of developing stock punchlines. If richly employed language is the bathyscaphe of good conversation, laughter is the oxygen needed for the dives into the deepest depths, where the real shifts in consciousness and thought can happen. The shallows are fine for rest days and sick days and low days, but otherwise too easy—also, overcrowded.

"Fi," I asked now. "Are you there?"

And finding no answer, none: just the wind, storms, wildflowers, eagles, and hummingbirds. And at his memorial, a few weeks after he'd died, a *double* rainbow as I stood up to thank the families of my community for raising the perfect son with me, lamenting that they, too, would stare at his empty place at their table. He'd been such a neighborhood kid, such a local, such a mountain boy. "Are you there?" I asked the sky over and over. I worried he, too, was lost, missing us as much as we were missing him, needing guidance. Maybe he was doing as we'd always instructed the kids on our trips abroad; anyone lost in an airport or a museum or a foreign city, stand still—and if it's safe, stand out in the open—until we find you.

Oh my God, where was he, Fi?

My oldest friend from home flew in the day after Fi'd died.

Fi

Iris knows me better than anyone else, in many ways, not only because she has known me the longest but also because she knows exactly where I'm from; she can put my whole life on the map in a nutshell, in a heartbeat. Ear, that's her nickname, knows my family, my school, the landscapes of my life, the politics that'd shaped and misshaped me, but we're nothing alike on the surface. Iris is petite and very poised, cheekbones like Sade; she turns heads. Her husband, David—"Iris and David; you'll sound like an expensive florist," I'd said when they'd starting dating—is literally tall, dark, and handsome, so unflappable I'd posited that his initials, D. L., stand for Dalai Lama.

David and Iris live in a hypoallergenic apartment in New Jersey with a view of Liberty's backside; lots of crisp white linen, hand-poured candles, brunch at a vegan place on Sundays. Iris never says anything inappropriate; she's not outrageous. I can't prevent myself. If I'm Coriolanus, "What his heart forges, thus his tongue must vent," Iris is pure Portia, "Allay thy ecstasy. In measure rein thy joy. Scant this excess." And yet from the age of thirteen, when we'd met each other at a high school in Harare, the Pink Prison—one hundred acres of hockey, tennis, *Anglicana*—we'd found ourselves together in the same clearings of understanding over and over.

"You're going to be okay, Bobo," Iris said now. She knew not only because she knew bedrock me but also because she knew her bedrock self, and she'd known loss. First, her

brother-cousin, Henry, when we were fourteen, a motor-bike accident, then a baby nephew a few years later, and a year after that, her older sister, Julie, both from the virus that causes AIDS. That epidemic hadn't shaken us up; it had torn us down. One in four infected by the mid-80s: the tiniest foe, most deadly, dying for love. I was pregnant with Sarah in Lusaka by then, throwing up in the canna lilies at the Kabulonga roundabout, such morning sickness, everything so verdant, also cholera running rampant. Then, right after Julie died, the Zambian soccer team had crashed off the coast of Gabon: small aircraft, faulty instruments, tired pilot.

They'd been a great team, the best, Chipolopolo, the Copper Bullets.

The whole country had grieved then, funerals, funerals, funerals.

We'd known death, I'm saying. We know it, we know how it can pile on, and we know that we're built to grieve but not alone. At home, by which I mean where Iris and I are from, funerals are an exertion, an endurance. Especially in the rural areas, the farms I grew up on, and in the villages where Iris had gone to visit her Nsenga aunties, mourners are expected to break bonds with the dead—rolling on the ground, ululating, dust. I'd looked on at these funerals my whole childhood; I'd stiffly attended a few. I'd never fallen to the ground, but I could see now how you'd want to, a grief that took you to your knees, lower.

Fi

"How did you do it, Ear?" I asked Iris now. I'd pictured Iris at those funerals, her two cultures on display in extremis, in ways no one could have imagined at the start, when her parents—young, handsome, idealistic—had met in West Germany back in the 1960s. On one side, her Nsenga relatives: spectacular sorrow. On the other side, her German Tantens and Onkles staring into the middle distance: Teutonic to the core, as if lamenting the lateness of an expected train. Iris was sui generis; early on she'd perfected the art of both not letting it show, whatever she was feeling, *and* taking it all in.

"I didn't roll on the ground, but I *felt* it," Iris said.

Nothing like my toddler sister's funeral in the humid valley on Zimbabwe's eastern border with Mozambique: a jungle, a banana plantation, a clearing with a few gravestones in it. After we'd buried her—Olivia, my little sister's name—already in the ground by late morning the next day, Altham Sutcliffe, a banana and tobacco farmer, rest his soul now, too, had sung about Lucille leaving him with four hungry children and a crop in the field. It had been pretty much all he knew on the guitar, so sad, so drunk. No displays of real emotion—not really Teutonic stoicism either—just a generalized alcohol-enabled stiffness that sagged as the hours wore on, became a bit impenetrable and gropey; those dank farmhouse passages on the way to the toilet, we'd had to watch out.

Then, Vanessa and I back to boarding school.

It'd gotten so much worse after that, the body count.

First, my mother had tried to kill herself, all the pills, waving a gun; everyone was talking about it.

Then, my Kenya granny, my mother's mother—now retired in England and hating it—she'd also tried to kill herself. She'd taken all the pills, drank all the everything, then before she got too groggy, she'd slit her wrists and flung herself down the very steep stairs in the small semidetached nineteenth-century workman's cottage my grandparents had inherited from an English relative back in 1967. But *everyone* was fine now, my mother had said, very drunk, the next time Vanessa and I were home for the weekend. Everyone was fine and the less said the better, my mother'd told us, a phrase we'd heard a lot as kids: *under the table, under the rug, under wraps.*

It had been around this time Vanessa had started to pull out her hair, in a circle, like Friar Tuck.

"It'll be okay, Bobo," Iris said now, singsong the way you speak to a fractious child. "You're not alone. I've got you." I clung on to Iris and she held on to me and I pictured a place, not so lonely: a dusty cemetery, maybe, like the one on Leopards Hill Road in Lusaka, filled with fellow mourners collapsing around me, rolling on the ground, rolling, rolling, dust kicking up, ululating. All the accidents and incidents that had to happen—and had to not happen—to land me on Iris's shoulder right now. Proof, surely, that we're not just pointless pips of energy in a chaotic cosmos

but intended, if not for God or for the universe, then at least for each other. "You're really not alone," Iris said. "I promise you."

I wailed and I whimpered. You stop caring, I did, that you sound like a child.

"There, there," Iris whispered. At our high school in Harare forty years ago, when we'd started this eternal friendship, we hadn't thought ahead to this moment. We'd thought mostly of getting out of that place alive; it'd seemed to have it in for us. Our Latin teacher's name remains a synonym for evil. Mrs. Fryer would be ninety by now. Probably still at it, declining Latin nouns and hating all adolescent girls with their stubborn indifference to the Punic Wars. *Pubic Wars*—I can't have invented that joke but it had earned me hours of extra homework and Mrs. Fryer's eternal ire. Why not Mrs. Fryer instead of Fi? Why not a suffering elderly person, done with life?

Why not me?

I'd have taken a bullet for Fi. Of course, anything.

"There, there," Iris whispered again. The wind rustled at us through the aspen leaves. "No one ever told me that grief felt so like fear." C. S. Lewis wrote a whole little book on grief. "The same fluttering in the stomach, the same restlessness, the yawning. I keep on swallowing. At other times it feels like being mildly drunk, or concussed," C. S. Lewis wrote after his wife died. Debra Winger was in the movie about it. I felt not mildly drunk but completely bosbefok. I

pictured me with the girls, pushing a shopping trolley with all our belongings in it around the Walmart parking lot in Idaho Falls—no rhyme, no reason, no bootstraps, no boots.

"Mm," Iris said. "Come now, Bobo."

"But you can see how it'd happen," I said.

"No," Iris said. "I really can't."

"But if it did," I said.

"Mm," Iris said. "Mm-mm, Bobo. Shhh, now."

The aspen leaves clapped, little green castanets.

iv

"ONCE," begins the well-known children's book by Margaret Wise Brown, "there was a little bunny that wanted to run away." That'd been one of Fi's favorite books when he was little. We'd read *The Runaway Bunny* over and over until we could say together, pointing at the pictures: "'If you run away,' said his mother, 'I will run after you. For you are my little bunny.'" Iris returned to New Jersey; Ricky came from Hollywood, gorgeous and amusing, like a sympathetic Lord Sebastian Flyte in Evelyn Waugh's *Brideshead Revisited*, before he turns to drink, Sebastian that is, not Ricky.

"Oh Bobo, how can I help?" Ricky's also from Zimbabwe; a Born Free, as we say, born after the war, although not after the war's half-life. He's a movie star, for real; he's an action hero, *The Vampire Dairies, The Flash*. I've only watched the bits with him in it. But even if he weren't a movie star, he looks like one. It's ego enhancing to walk with him in Manhattan, anywhere, stampeded by fans, people cry they love him so much. We say one day we'll write something together, a

comedy, very dark. Very dark because even before we lost Fi, we'd been sorting through our childhoods together the way you go through a wardrobe; what belonged to us, what didn't. What still fit, what was outmoded. The things that were strangling and choking us. The things that never had been a good look.

Who'd have thought we'd go from the tobacco barns of Chegutu and the Burma Valley to any of this? We tease each other mercilessly, imitate one another, challenge, interrogate, and mock ourselves; we know how humble our roots are and also how tangled up in that rich soil. A red-chested cuckoo hatchling doesn't know that the nest in which it finds itself was intended for other chicks; nor that there is a connection between herself and the smattering of smashed eggs at the base of her nest. We talk about that a lot.

"I know you'll make it; you've got to make it," Ricky said, holding my hand, rubbing my shoulders, massaging my feet. "Okay," Ricky said. "I guess, let's just . . . Ahh-hhh." Ricky articulated his grief the way he'd been taught in drama school: head back, eyes closed, throat open. "We've got to let it out, Bobo. You don't want all this grief stuck."

After supper—I couldn't eat, Ricky couldn't—he sang me sad show tunes from *Rent*, *Les Mis*, *Miss Saigon*. Then—afraid to be alone, afraid of sleep, afraid of our dreams—we held hands and watched *Wild, Wild Country*—a documentary about a religious cult in Oregon in the 1980s—and decided we could be persuaded to join any cult that would have us,

easily. We were *that* desperate, suggestible, vulnerable. Anything short of mass murder-suicide in the jungle to beat this unanswerable misery. "Where do we sign up?" Ricky said resignedly. "Take us, we're yours."

Then, after Ricky left—his fan conventions, auditions, and shoots—Embeth arrived, also from Hollywood, also an actor. South African, a sister-friend. She brought biltong, rooibos, rusks. She wrapped me in cashmere throws, silk blankets, soaked me in bath salts. She brought bags and boxes of gifts for Sarah and Cecily. She's mothering in a Miss Honey sort of way; the children and I had loved her in Danny DeVito's adaptation of Roald Dahl's *Matilda*. She was a dancer once, you can tell, so strong, so light; the bones of the magnificent frigatebird weigh less than its feathers, thus their buoyancy. Into her arms, I fell. "There, there, Bobo," she cooed, same as Iris, the same word, over and over, rocking and rocking.

"Oh Em, I can't find him," I sobbed.

"Shhh," Embeth told me. "Shhhh darling, shhhhh. I know, I know." She knew; there had been her very public battle with the kind of cancer that eats women alive right when their children need them the most. She'd said goodbye and goodbye; she'd said all her goodbyes. And then she'd faced the disease and dissolved and dissolved—ego, vanity, herself—to survive. Bodies are meant to be lived in, battle scars. Embeth believes that, but she believes also in cures: the healing properties of gardening, pets, and the

sea. "Shhhh," she said now. "There, there," she said. Over and over. Until, at last, stillness. "Shhhhh." And into the silence, grace, just a glimpse of grace, but enough.

Be still and know that I am, three instructions, not one. First, *be still.*

Then simply, know.

That I am.

Fi'd died in the fatness of summer, in the fullness of youth, on the brink of manhood. "But for him, it was his last afternoon as himself." W. H. Auden wrote that after W. B. Yeats died, an old man in winter, "nurses and rumors." On the last afternoon as himself, Fi went up to the lake with Charlie, Sarah, and Cecily, boating and waterskiing. The girls told me afterward how they'd all been joking, leaning into the wind like figureheads. "I'm infinite," Fi had shouted, laughing, arms outstretched, hair blowing back. "Look at me, I'm infinite."

Infinite Fi.

"In the prison of his days / Teach the free man how to praise," Auden concludes that poem.

Life had been such a serious adventure for Fi, undertaken so lightly.

"Find me, find me," I whispered now. "Find me," I begged. And then it occurred to me he'd never find me here, in a torn-up condo, anonymously nestled among dozens of identically beige-colored condos, drenched in other people's smells and sounds and lights. Plus, the waxing moon, such

a wild, perfect guide, but not here; here in town, she was a beacon to nowhere: "The moon was once a moth who ran to her lover," so said Rabia, the Mesopotamian poet, more than a thousand years ago. "The moon was once a moth who ran to God, they entwined."

So, for the night of the first full moon after Fi died, twenty days after, I carried a backpack up to a high alpine lake, closest to the darkest sky I could find, away from people and development, each step like Robert de Niro's in *The Mission*, slogging. Fireweed brushed the south-facing slopes purple. Indian paintbrush flamed red. Sunflowers, buttercups, cinquefoils, all yellow. Purple sugar bowls, asters, magenta-hearted lilies. Pink sticky geraniums. *Stinky* geraniums, Fi had said when he was little; a family thing, it had stuck.

Nine months of snow, or ten, at nine thousand feet, there are patches that never melt completely. May is a miracle: rebirth, wet mud emerging from a tomb of ice. June, July, and August are a tumbling race to emerge, procreate, and fall dormant before winter returns in September, usually by the middle of that month, snow up high. There are only thirty frost-free days a year at this altitude; and between the two long freezes that herald the beginning and end of summer, life bursts out of bounds. You can watch in real time, I have, a flower, a beetle, a bee—*saturated* with being—drunk with so much existence, ricocheting with life.

I ate early: tea, honey, some crackers, soup. I packed up camp for the night, hung my food bag over a tree limb out

of the reach of bears, built a small campfire. Then I crawled into my sleeping bag near the shore of the lake and waited in the semidark for the moon to rise; I could have read by its light if I'd wanted when it came up at dusk. Fi's full moon, I thought of it, the first full moon without him. The first full moon with him *in* it. A moon full of sorrow.

In the eastern hemisphere—Europe, Africa, Asia—the moon had been in the longest eclipse of the century, hours in Earth's shadow, turning red. But here, in North America, nothing was eclipsed, everything silver burnished, clear, a light frost on my sleeping bag. Also, a lunar rainbow, they say rain to come, or snow. The Lakota call the July moon Canpasapa Wi, When the Chokecherries are Ripe. It's one of their three so-called warm moons, the moons that invite us to lie outside under her, moon-bathing silver into ourselves, forest-bathing summer night sounds.

"Fi," I whispered. "Fi, I'm here."

Nothing. I couldn't understand how all traces of him had vanished; he'd left, and everything about his body had left with him, even his scent, which I would know anywhere. How many times had I lifted his clothes to my face, sorting laundry like a tracker. Is this clean, is this? And when he'd left for college, of course, I'd gone up to his room like every other mother does and buried my face in his pillow. An empty nest isn't the same as a robbed nest, though. A robbed nest is everything, gone.

Is there anybody out there?

Fi

The wind stilled completely, the campfire stopped crackling and died. I fell first into that silence, and then I fell into a holy sleep, body tired and sore. In three hours, predawn birds began their chorus. *Chika-dzee-dzee,* a chickadee started it off. I opened my eyes; the moon was low in the west, ablaze in pink inkiness before sinking behind the peaks. Then, a mule deer doe and her fawn appeared from the north, *plink-plink-plinking* along the lake's lapping shore, right in front of me, unavoidably close, as if I were nothing but a rock to them. I slowly propped myself up on my elbow.

"Hi," I whispered.

Plink-plink.

The doe stopped and leveled her gaze at me: Fi had had such a look, an attentive curiosity. "Fi?" I said, slowly sitting up straighter, hardly breathing. "Hey you," I said. The doe didn't flinch; she looked and looked at me. A slither of recognition entered me—her eyes into mine, another beat, two—and she looked away. *Plink-plink,* and then she was gone, her fawn gone, too. Not running but bounding. Fi'd bounded in that way, always certain of his place, always certain of his timing, his landings.

"I love you," I told the space into which the doe and her fawn had disappeared.

All the mountain birds were singing by then: buntings, nutcrackers, jays. I shook out my sleeping bag and went back up to the campfire. I kindled fresh flames, fetched the throw bag with the provisions from the tree, and put a kettle on

to boil. Then I took bear spray, matches, toilet paper, and my shovel and walked a decent distance back into the forest; the way we'd shown our kids, dig a deep hole, leave no trace. After that, I took a quick, cold bath in the lake and dried in front of the fire while I waited for my tea to brew. You have to do something about the fact of a body in the mountains is the thing; that's its cure, part of it.

The mountain doesn't rise to meet you; you have to rise to meet it.

"What saves a man is to take a step," wrote Antoine de Saint-Exupéry. I'd copied it out in Fi's birthday card the year that he turned ten—such a big birthday, double digits—in case he ever needed sage advice in difficult times. "Then another step. It is always the same step, but you have to take it." From the north, the fawn and the doe had come. On an Oglala Lakota medicine wheel, the north represents endurance, hardship, discomfort, trials, and cleansing. The north is also where guidance comes from, the wisdom of the ancestors. *Take a step.* Perhaps, it wasn't an instruction so much as an invitation; the dance of life isn't always swans and nutcrackers.

Plink-plink. Plink-plink.

I know that the deer wasn't Fi any more than a clock is time, or a flame is a fire, or rain is a river; but the deer and Fi were connected, are connected, in the same ways as those things. Life is *all* possibility resolving into a doe, a dear, a rock-solid form. Arising, falling away, arising, falling away.

Life is the same simple sentence said over and over; it's a tide, in and out. I picked wildflowers for the girls along the trail on my way down the mountain and pressed them in wax paper between some heavy art books when I got to the condo: daisies, harebells, yarrow. Life in there, too, life caught in the once vivid, now paling blooms, in their fading scents, remnants of his life's final breaths.

THE AERIE

i

THE ONE-BEDROOM CONDO with tiny sun-porch and airless loft was all I could find after the glassblower and I had split. My heart had sunk, a peeling little box tucked between two larger units. "Oh, aha," my friend Megan had said. I had asked her to come and look at the place, to see if she could think of ways to make it less . . . To make it more . . . To make it something it wasn't. On a budget. This had been five weeks or so before Fi'd died. If only. Had I known I was going to look back at these awful days as my high point, as my last days as Fi's earthly mother, I'd have done something else instead. I'd have not been moping about a fixer-upper at my down-and-outest.

"Well, I could *really* commit suicide in here," Megan had said. Megan wears eight-inch platform shoes everywhere, even in rough terrain; she'd taken several teetering steps back. "What did the last people *do* in here?" she'd asked. "That stove looks like it cooked meth." Megan is a polymath; what she knows, the situations she's found herself in, are all vividly

retold in her hilarious memoir *The Book of Help*. But Megan also designs tiny spaces; she has been a climbing guide, a house cleaner, and a five-element acupuncturist. She once did an autopsy on a human cadaver. Her tiny poodle mix, Harper, is her doppelgänger. Also ridiculous, also tougher than she looks.

"But if you rip up the rest of the carpet and paint everything white. Maybe some curtains. And get rid of those fixtures, they absolutely *rape* the place." Also, try to think of the condo fondly, Megan had advised. Don't look at it as it is; envision it as it will be. She'd urged me to consider it a refuge, a nest, an aerie. And get mirrors, Megan had suggested, "A few. One here, one there, a big one in the hall. They'll trick in a little light. Oh Jesus, no one said anything about having to *look* in the mirrors," Megan had said; we both knew the shock of seeing myself—so broken-up—could only have made it worse. "You just need some light!"

"Me, or the condo?"

"Both!"

How had this happened? I missed the glassblower, I'd told Megan. I missed the views of the mountain from our bed. I missed my old routes. The glassblower and I had lived in one of fourteen yurts in a meadow of sagebrush, thistle, and knapweed abutting a national park, like little sailboats. In a storm, you really feel it, canvas walls flapping. There was a linoleum-peeling communal bathroom. Decades back it had served as the village schoolhouse. It smelled of dry

rot, damp wool, and dead rodents. Orange and black stains blossomed from the base of the toilets and showers. Megan and I had bonded over chlorine bleach—our secret use of it. The glassblower had been very much on the side of the microbes.

Megan and I had also bonded over our love of dogs, bike rides, walking, writing, British murder mysteries, and books. We'd developed a routine. On Monday mornings, when the other yurt park residents were off at their jobs—a wildlife biologist, a baker, a cook, a math teacher, gardeners, climbing guides—we'd met in the bathhouse for laundry day. While we washed and hung and folded, we'd also drank tea and read our latest writing to each other, discussed this line, that word. She'd been writing what would become *The Book of Help*. I'd been trying to write my way out of a slump. Perhaps I've written myself off the page, I'd told Megan. Maybe I should become an Episcopal vicar, like my spiritual crush, Richard Coles, the English priest, broadcaster, and honorary chaplain to the Worshipful Company of Leathersellers. He was also, back in the day, in the band the Communards, most famous for the #1 hit, "Don't Leave Me this Way."

I'd loved it all: the yurt park, the glassblower, my easy friendship with Megan. It had seemed both grounded and sustainable, humble; it hadn't seemed like a situation that would quickly shift, let alone evaporate. Also, I'd finally met someone who could understand me. We were artists, the glassblower and I, building the perfect tiny space together.

We'd taken down his small old yurt and had erected a bigger new one: a loft for Cecily, a built-in sofa for guests, an adjacent man cave for the glassblower. Original to nomadic groups of Central Asia, yurts have kept something of the steppes about their sturdy, circular construction. They are undeniably romantic. Wind rattles the canvas; the moon and sun blaze through the dome.

"Oh Jesus this is embarrassing," Megan had said. "Trust me, Alexandra . . . The moon and the sun blaze through plenty of places. Build a yurt of your own if you miss it all that much, truly. But don't lose your serenity over a breakup. I don't care who it is. No one's worth the stress. Do you know what stress does to collagen? Save yourself the wrinkles. I'm telling you." Megan had been so right. How had I forgotten? "Everyone needs a place. It shouldn't be inside of someone else." The poet Richard Siken wrote that. "I kept my mind on the moon," he wrote next. "Cold moon, long nights moon."

Where had I gone so wrong?

"You will be alone always and then you will die." Richard Siken again. The windows in the condo had swelled and wouldn't close: I'd taped garbage bags over them, like eye patches. Boxes had been piled up in the bathroom; I'd been sleeping on a mattress on the floor in the loft—upended life, floor nails exposed, paint in tins—when Fi had died, and the condo's torn-up, unfinished shabbiness had felt like a symptom, proof, a preponderance of damning evidence of

my multiple failures, most damningly, as a mother. It had been as if I'd taken my brood, distracted, into some strange, unsettling place, only to lose one of them.

"My little rats," I'd called them, my tiny rats, my smallest rats, my beloved rats.

My rat knot, untangled.

Oh, my precious rats, undone.

If only, that's the refrain of early grief, one of them.

If only I'd known; this is the reason to have your *t*'s crossed *i*'s dotted.

This is the reason to not leave your country of origin, one of them, or to not get divorced. Not a good reason, but a reason—the loneliness when you come undone. If only I could time-slip back a dozen years. A family holiday in South America, four years before the divorce, Cecily in her Baby-Björn. Fi and Sarah singing and dancing their way through Charlie's self-guided tour. "Oh, what an exit, that's how to go. When they're ringing your curtain down"—they pirouetted around the Cementerio de la Recoleta—"demand to be buried like Eva Peron!" Then Fi and Sarah had clasped each other—Evita and Che—"Tell me before I waltz out of your life / Before turning my back on the past," and had tangoed down the sidewalk to an outdoor café where we'd ordered liquors, coffee, and sweet pastries at four in the afternoon.

Meantime, Charlie consulting maps and his itinerary under a huge straw hat, cigar, camera, sunblock like warpaint.

He was always trying to find the beaten track and then steer us well clear of it. It had been Sarah and Fi—Sarah'd been going through her Broadway phase—who'd turned our whole South American vacation into a six-week nonstop musical extravaganza featuring only Andrew Lloyd Webber's *Evita*. Cecily laughing in her BabyBjörn, demanding to be bounced. Me bouncing the baby and bravo-ing the big kids' endless-loop performance all the way from Buenos Aires, south to Bariloche, then over the Mamuil Malal Pass to Chile when finally, halfway through a scenic volcano hike, Charlie had asked nearly tearfully if there was anything else in the repertoire.

I remember thinking at the time, not once but over and over: *I love this unit utterly, I love it more than I love life itself, this family is life itself.* I can't break up the band. We traveled well together, Charlie and I. For one thing, traveling gave our differences something to bite into, other than each other. Also, I'd had to follow Charlie; we'd all had to. The kids and I willing hostages to his determination to take us where only the most zealous of missionaries had gone before. I loved being out of our ordinary routes but also knowing where everyone was: Charlie always ten feet ahead of us, Cecily always strapped to me, Sarah and Fi always dancing and singing, "Forgive my impertinent behavior. But how long do you think this pantomime can last?"

One is none; two is one.

Three is not two, though.

And you can't be what you're not.

Also, all the rats in a rat knot die, entangled, and it had been my miserable mistake to tie them up in this way, to make them irreplaceable to one another, never alone. Somehow, therefore, it was now also mine to undo this knot and to make of that old rope a new net with which to catch my girls—working backward, forward, counting dropped stitches. I calculated and recalculated, tracked and retracked obsessively like this, as if to make our lives whole again by my tricky math, my thoroughness, my redoing. It's what the death-and-dying psychiatrist, Elisabeth Kübler-Ross had dubbed the bargaining stage of grief. Debt collecting, stocktaking, joining the dots, knitting, unraveling. Who was responsible for what? And by what means can I call attention to this celestial accounting failure?

Meantime, the reality was one boy down, two brotherless girls, my daughters, my precious earthlings, my survivors. Gray, life had drained from their cheeks. The shock of having had every future they'd ever imagined gone; they trembled, shoulders heaving, even when they weren't sobbing. The first hot, surreally awful weeks after Fi's death, when they were with me at the condo, they'd walked hand in hand to the neighborhood pool and had bobbed in the shallow end together like bewildered toddlers, clinging to each other in the relentless high-altitude sun and listening over and over to a song by a band called Birdtalker that we'd

never heard of before, as if everything was coming at us in not-so-subtle code.

- "Me and the Blue Healer, Blue, Blue, Blue, Blue Healer."

Sarah's hands seemed never to leave the tiny brass urn on the chain around her neck: a thumbnail scoop of what her brother had become. "I can't do this," I'd heard her whisper, lying on the sunbed on the porch, tears in shining streaks down her cheeks. "I *can't*." Her hand on him—her hand on his ashes, I should say—over her heart, legs wrapped around Cecily's legs. Also, "Why?" Cecily had asked, over and over, her words broken before they left her mouth; it's the universal question, it turns out, when the world ends.

No good answer then or now. None.

Except the age-old, "Why not?"

But who can hear that, alone on the battlefield, and not give up?

"Hold on, tiniest child," was all I could think of to tell Cecily; it'd been all she could grasp. "Don't let go." Meantime, fretting, fretting, fretting: I'd written Sarah and Cecily love letters that I left on the sides of plates piled with grapes, slices of banana, cheese. Do try to eat, I must have kept urging them. And then climbing between them, arms around them, they'd squirmed out of my embrace. I'd been like a spider in their presence, all spindly limbs stretching out: desperate to swallow them back into me, where they'd be safe, enwombed.

I love you; you can say it over and over, until it runs out of meaning, until it's impoverished with overuse, like Van

Fi

Gogh's sunflowers, everywhere. But if you start looking for an atom in a universe, you start to see love is exactly like those sunflowers. Love is everywhere; if only I can let it in, recognize it. That's the trick—I see that now, too—to accept the death of a loved one is to arrive at the knowledge that *love* itself cannot die or change or end. Love goes on and on, blowing your mind, blasting out of your heart, endlessly. And everything else that I've ever called love but that isn't now with me, that's been something else, a beautiful transaction perhaps, a met craving, a shared passion.

Love doesn't arise from loneliness assuaged.

And loneliness doesn't arise from love's loss.

Loneliness is the injury that results from a refusal to let go—and to let come.

Fi'd come to Sarah in a dream soon after he'd died. In it, he was shouting to her from the other side of the river. The Snake at high water after the spring snowmelt, tumbling whole trees, driftwood, not a river to be easily crossed. You'd need to be a skilled oarsperson; Charlie had taught all three kids to face the bow toward the obstacle and to pull away from it. But in her dream, there was no boat, and Fi, short of time, eager to impart his message, had been trying to let Sarah know he was fine, okay, he'd never been better. "Death's a complete misunderstanding," he'd shouted. She could somehow hear this over the roar of water. "Kind of like racism," he added, by which we knew it to be him.

Two summers before Fi died, Sarah had initiated an antiracism campaign in our little community. On the town square she'd given a presentation about white silence around issues of racial injustice. A couple dozen people had shown up: Sarah's friends from high school, a reporter for the local paper, a few members of our growing Latinx community. Most of the people who speak Spanish as a first language in our county are from Tlaxcala, in Central Mexico. That's the advantage of a small community; everyone knowing everyone else, we can ease our way into choppy waters. The time in our town, for example, in the summer of 1996, when, as the *LA Times* later reported: "Local police and federal agents rounded up 150 legal and illegal Latino workers, inked numbers on their arms and hauled them to jail in patrol cars and a horse trailer soiled with manure."

We need to air it all, Sarah had argued.

Dirty laundry, in public. Let's wash.

Sarah's the photonegative of me in many ways; she's gentle, approachable, sympathetic.

If anyone can get a bigot to lean in, it's Sarah. Her Standing Up for Racial Justice event had made the front page the next day. At Cecily's lacrosse practice that afternoon, I'd been stopped by a parent, a family friend. I must be so proud, she'd said. She was so proud herself; it's so nice to see our girls speaking up. But surely, we hadn't needed this sort of campaign in our community. Sarah was stirring up something where there had been nothing. Online, someone

had suggested Sarah be beaten to death with a baseball bat, and someone else had offered to buy a beer for whomever was the first to do so. Yet another person had posted our old address as her place of residence. Like that, it had gone; anonymous, all of it.

Then three middle-aged white men I'd never seen before had appeared at one of Sarah's regular events wearing oil-skin dusters. It had been a hot day, too, but none of them were sweating, like vampires don't. Also, dark blue jeans, still with creases. One had had a rifle slung across his chest. His cowboy boots had given him a good three inches God hadn't. Second-home owners, I'd bet, nothing Wydaho about them. I'd put myself next to the man with the gun, and I'd said, "Isn't that thing a bit overkill?" Cold bullets of sweat had run down my flanks. I'd had this whole witty speech lined out and ready to deliver about how I'd started out as the Uzi-toting poster child of whatever he was selling, but once I'd got close to him, my bravado had waned.

"Your daughter?" he'd asked.

"Yes," I'd said.

"Seems well-mannered," he'd replied, Southern accent. "And pretty."

"Hm-mm," I'd said, rising to the bait. "Also, very intelligent."

"Ah huh," he'd said, a big slow smile, slow talking, too. "Then why'd you teach her to fish in the wrong bucket?" You don't forget a nonsensical line like that; I haven't. We'd discussed that afterward—the kids and I—and Sarah had

said not to make a big deal of it and to ignore it. Nothing had happened, and blowing things out of proportion is the last thing we needed to be doing. Still, I'd put most of my parental panic there, honestly; the two years before Fi'd died, I'd worried it would be Sarah. It had all felt so eerily Rhodesia circa 1978. If my kids had behaved like this in my childhood, we'd have been jailed, deported, our writings banned.

You think you already know what you'd rather not know. I did.

ii

I LIKE TO THINK I oiled their feet, rubbed their backs, and stroked their hair; I don't remember if I did. It's what I'd have wanted to do for my girls; it's what I usually do when they're in distress. *In my deepest heart of hearts, I know we make it,* I wrote to my daughters two weeks after Fi died, a card with a hummingbird on it. I found it later, tucked into the front of my Bible. I wrote these things, said these things, did these things, but maybe they couldn't feel it; I don't think they could. You can't feel anything but your own suffering when it happens to you; you can't do much else other than come up with names for your suffering.

The name of my suffering, the word that circled and called, like a raven: *loneliness.*

Specifically, loneliness for my family. En famille, we'd aimed for that once, in war, bonded.

Now though, sans famille, it was a haunting, a recurring thought: *Fi is dead, where are they?*

But my Scottish cousin Cait—my sister-cuz, the blood relative to whom I am most connected—she took off work

as a religious-studies teacher and flew out from Scotland to be with us for three nights. She and her husband, Phil, had lost a toddler to fever fourteen years before we lost Fi, a little girl whom she'd called Olivia—names echo through families as much as tragedies. Now, Cait cooked and chatted away to herself in my kitchen. "Right, thirty minutes at 350 Fahrenheit, I wonder what that is in new money? Maybe I'll just pop the kettle on. I think we all need a nice cup of tea. Anyone for a cup of tea? Anyone, everyone, tea, yeah?" She left the fridge stacked with quiche and more quiche, a complete meal, she said: a slice of quiche, a green salad, and a cup of tea, sempre tea.

She said, "You won't remember any of this."

I said, "I will."

"No," Cait said; she and I share an insistent nature. "You won't."

"I am pretty sure I will," I said.

"I felt like my brain was hijacked for about a year after Ollie died," Cait said.

"Are you over it now?" I asked.

Cait and I have never seen the point of lying or equivocating; this often gets us into trouble but never with each other. "Well, it depends on what you mean by 'over it.' It was two years," Cait said. "Before I didn't think, 'Oh my God I want to fucking die,' multiple times a day. And it was another . . . Well, it took me a long time to feel joy again. Also, when a child dies, well . . . It's just incredibly fucking

hard, my darling. But we made it. That's what I want you to hear. I don't think it was completely healthy or particularly great for anyone, but we muddled through. Also, I think we trusted each other to muddle through. That's what saved us."

"I wasn't there for you," I said.

"You were pregnant with Cecily," Cait reminded me. "You were here dealing with your kids; I was there. And I had my family around me." Phil's family, she meant, English but warm and sane, which baffled Cait and me. We decided that the settler side of the family were even madder and colder than our native British sides, from whom we'd also both descended; her through a Scottish father and me through an English one. Also, snobbery, that was woven into the fabric of our families. It meant we knew how to put up a formidable front, but it'd left us to do the hardest parts of life alone; like lawns, it was verboten to go to seed or weed in any obvious ways.

Cait returned to Edinburgh.

Till drifted back into the condo and set herself up in Ceci's room while Ceci was with Charlie. She ate most of Cait's quiches, backward and forward from the kitchen to the bedroom, bits of paper towel, a trail of crumbs. "Ohmygod, AF, this zucchini one is amazing. Okay, wait though. I need hot sauce. Where's the hot sauce, Ali?" Always on the phone, her computer, an iPad, juggling this account, arranging that other thing. Then I declared the condo a cellphone-free zone and after that Till rented a studio from a mutual

friend of ours, although she checked in with me most days to see that I was still alive and was still planning to be alive at day's end. Also, catching me out, "Ur texting me. Does this mean we are allowed to use our cellular devices in the condo again, Mein Führer Fuller?"

"*Ur* is my pet peeve," I texted back. "Also, grammatically incorrect as used here. And nein."

Then, my second cousin Harry and his seventeen-year-old daughter, Flora, came out from Yorkshire for five days. Until she opens her mouth and betrays an English accent, Flora appears to be the missing child in my fertility equation. She lands, in age, between Fi and Cecily. Also, Flora and Cecily look very related to each other; both have excellent profiles for a Roman coin. Harry's younger sister and I are fanana. Or, like the portrait of Dorian Gray, I am the southern-sunbaked, cigarettes-at-an-early-age, too-much-booze, civil-war-spooked version of Zoe. Both of Flora's brothers, Ollie and Robbie, could have been Fi's brothers. Meantime, Sarah looks less lost with two siblings trailing around after her, more accurately, one sibling, one siblingesque.

Three kids again. There's stability in threes, like legs of a stool.

And a whole little flock of us settling around the table for meals, I loved that.

Tripping over sleeping kids on the floor, resisting the urge to bend down and touch faces.

Reminding myself, too, that I am spread out in the blood of others, in the blood of people who sound like my father, or who look exactly like me time-lapsed-backward, or who might be the mirror image of my dead brothers. There are specks of me and therefore, most importantly, also of Fi and of my girls in all of them. Harry and Flora are proof that across the Atlantic, beyond the reach of our calamities there are echoes of us. Harry and I met only as adults, after my father had died, a handwritten letter, watery mauve ink on hotel stationery. "Dear Alexandra: You will not know who I am." Harry has small, nearly illegible writing. "But I'm afraid I've read all your books and have formed lots of preconceived notions about you."

Harry and my father share an English public school accent, the same shaggy eyebrows, thin lips, very blue eyes. Like my father did, Harry considers drinking alcohol his personal mission from God and a terrible hangover a holy event. "Don't interrupt me, I'm *in church*," my father would growl from the veranda on a Sunday morning, head in hands. "Bloody St. Paul's and all the bells are clanging; proper sermon on its way." Also, like my father, Harry speaks sometimes in riddles and shorthand and odd code. "Don't worry. Bit by bit, Bobo. A wind will pick up, and off you'll go. You won't be stuck in the doldrums forever. The sun will come out tomorrow." Harry will say nonsense like that.

"You sound like Tim," I'll say.

"Do I?" Harry will say, and I know he wants to know which bits in particular, *how* like Tim.

Harry and I love talking about our fathers' early lives. We know so little about them, really: the same nuggets of biography surfacing again and again for our inspection. Robert Wilmot, Harry's father, inherited a title and some money and stayed in England. Mostly, he drank and gambled; he had heaps of girlfriends. My father meantime buzzed frenetically—no title or money—around East and Southern Africa. I would say of him, too, that he gambled but not with money, that he loved my mother immoderately; and that he was a disciplined alcoholic. A proper blowout every fortnight or so, and then he'd be back to good behavior, pacing himself: one weak brandy before lunch, two watery whiskies after supper.

"We were always told that Tim Fuller had gone to Africa and lost it all," Harry once told me. "So, I thought he was rather dashing." Harry's father had been run over by a drunk driver in Scotland—ironically, awfully, as these things go— hurrying across the road to get a bottle of champagne to consummate his divorce from Harry's mother. Harry told me this very matter-of-factly, as if it were quite common for English fathers to die in this fashion. Harry had been seven when it happened, the thing that had changed his life. "Wilmot, your father is dead," the headmaster at his little prep school had said in early October 1974; the light outside—Abercromby Place, Edinburgh—was pewter yellow.

Fi

On their last full day, Sarah took Cecily and Flora into town for lunch, and Harry and I took a picnic into the back-country, not very far but far enough so that we were beyond the spot where most tourists start to feel the altitude and turn back. We sat by a lake, propped up against our rucksacks, faces lifted to the sun. I'd brought a thermos of fennel tea to share, an old marmalade jar with whisky in it for Harry, boiled eggs, carrots, cheese, nuts, dried fruit. "Oh my God, my heart aches," I told Harry. "For real, it hurts. I keep hoping perhaps I'll just keel over of a heart attack, and then this'll be done."

"Oh gosh," Harry said. "That sounds very um . . . I don't know, Bobo. You're very un-British, you know."

"Thank you," I said.

After that there was a long pause, and then Harry started back up with, "I'll tell you something quite interesting though, Bobo . . ." Harry's fallback conversation subjects are the Phoenicians, their navigational systems, and our mostly drunk or hard-drinking mutual great aunts, although to be fair, a couple of them also ended up teetotal Christian Scientists. I dozed off in the sun listening to Harry's blameless drivel. He can turn anything into a Melvyn Bragg–sounding *In Our Time* BBC Radio 4 history podcast, soothing. Our paternal grandmothers had been identical twins; Pammy (his) and Boofy (mine), real names Pamela and Ruth, the unwanted fifth and sixth daughters of Sebastian Henry Garrard.

"There but for the grace of a single split zygote go I."
Harry and I say this to each other. Pammy and Boofy, shockingly identical in the earliest photograph I've seen of them, dressed fanana in Edwardian frocks. Robert and Tim, their sons, born within months of each other, they're fanana too, both sporting foppish haircuts, rakish grins. In the only surviving photo I have of my father with Harry's father, they're both about eighteen, restless over an outdoor tea; the sky looks gray, low, and cold. Harry claims he can see the need to bolt the confines of an English upbringing in my father's eyes, even from the distance of that single photo, all those years ago.

Then Harry and Flora returned to Yorkshire.

I felt more alone than ever, such hunger for family, for un-aloneness.

I stuck Post-it notes up on the mirror, on the door, above the kettle. "We DO make it."

How did I know we'd make it? I don't know; I didn't know. People do, though—under much worse conditions, no hot running water, not enough food, no privacy. I thought of women grieving in prison. Women grieving in refugee camps. Women grieving in shelters. I had a place to live, close and caring friends, two beloved cousins, food, deskwork when I could get to it; I had a grief uncomplicated by the violence and pestilences of our age. Perspective is an important antidote to self-pity. Still, when our

closest friends and cousins were gone, and it was just us on our own, we regressed, we shrank, our grief overwhelmed us. All of us trying to feel our way back to the last time we'd felt safe—or safer.

Cecily slept in my bed again, fitfully, like a sickly infant, quiet, her appetite and her curiosity quelled. She went through the motions though; she'd do things with us, go to the river with her friends, but I could see how much it hurt her to be alive, how hard it was for her to comprehend such an enormous and enduring pain. Sarah slept in Cecily's bedroom, or out on the porch on the sunbed, or at the houses of friends, or I don't know where she slept some nights. Once, early on, Sarah'd driven north to Montana for three days and had ridden her mountain bike up and down precipitous trails near no one or anything she knew—bear country, cliffs, poor cell reception—until there'd been *only* bruises. Grief of this nature, it unhooks all systems at once for weeks, months.

"My darling," I'd texted Sarah, thinking of broken legs, a broken neck, her broken heart; I'd never felt so helpless, so desperate to say the correct thing, so wildly deregulated myself, so incapable. "Your only job is to survive this moment." But I couldn't have survived it for her; I couldn't even have told her how to survive it. "Just / sit there right now," the Persian poet Hafiz wrote more than six centuries ago. "Don't do a thing. Just rest / For your / separation

from God / is the hardest work in this world. / Let me bring you trays of food, and something that / you like to drink." Oh, my girls, trays and trays of food. I'd tried to cushion the blow; but I was becoming all ribs and veins and bones myself, grief eaten. It's unimaginable, even as you're putting on the kettle: rice, teff, spinach, ghee, turmeric.

No wonder no one can tell you how to do it, your own grief, the grief of your children, the grief of the communities he'd belonged to. Plus, whole days, gauzy with pain, terrible images of Fi as I'd last seen him, intruding like snippets from a nightmare. Meantime, I do remember that all day and all night, all day and all night, my mind had raced—plotting, scheming—running various scenarios for our escape. Clearly, no one—no friend, no family, no benign stranger, no miracle worker—was coming to lift this weight off us, these bulldozers, these tomb boulders. It was up to us, up to me to find my way out, to melt, thaw, and resolve.

"This is quite the trial," I'd said, panting.

My friend Terry—also a writer, a desert dweller from Utah, eroded to near silence by grief of her own—lay on the sunbed on the porch with me. She'd brought gifts: feathers, tea, flowers, candles. Her brother had killed himself around the same time that Fi'd died. Another brother taken three years earlier, cancer. A third weakened with desert lung. Her magnificent father, suddenly frail. This landscape eating her men, ours. Now, we were like climbing partners bivouacked

on a ledge between belays, the summit still invisibly distant in the clouds above our heads, the way back cliffed out, nowhere to go but up.

"It's hard," she agreed.

Also, all the blessings and instructions we were receiving along the way, the ancestors showering us with clues. An abundance of them, an embarrassment, their degree of difficulty ridiculously easy once we'd agreed to notice they were there—they don't, at first, make it any easier. Birds mated in Terry's hair, literally. We got messages from the moon. Rocks stopped us in our tracks and gave us their secrets. White and black butterflies smothered our feet, our heads. You begin to notice the signs, Terry and I agreed, but you'd rather have your loved one back than all the blessings and instructions in the universe. To begin with, you'd rather a brother or a son than an ancestor.

Tea, we decided.

Rooibos, whole milk, honey.

It's what I give to my children, after a shock.

We'd been given sherry for shock when we were children—the 70s and 80s. In Kenya, in the 50s, my mother's ayah had rubbed opium on her gums. My grandmother had been given knockout drops in the 20s. Generations of shock, numbed. But the Afrikaans aunties in our community gave their children rooibos, whole milk, and honey when they were kicked in the face by a horse or stung by a scorp or trampled by a

cow. They had big arms, those women, wide laps. Tough, until you were really hurt, then they'd acquiesce, open their arms, and say, "Kom sit hier by my." They knew the proper cures for shock, I noticed, the way they rocked and rocked their rough, shoeless, wounded children then kicked them back outdoors for more.

iii

PREGNANT WITH FI, worse morning sickness than I'd had with Sarah, also insomnia, headaches, dizziness. For four months, I'd been pasted to the sofa in the cabin in the foothills of the Big Hole Mountains. Meantime, even the fairly distant neighbors' cooking, the fragrance in their laundry detergent, all car fumes, had made me queasy. Standing up, even sitting up, had made me faint. Lying down, an ice pack on my temples, watching a video cassette of *Mary Poppins* with Sarah, sucking on orange slices, I'd managed that for months. Also, *Joseph and the Amazing Technicolor Dreamcoat*, Donny Osmond in the starring role.

Take my word, it was red and yellow and green, that damned thing, and brown and scarlet and black and ochre and peach and ruby and olive. I'd been reduced to the sum of my biology. Lethargic, bloated, hollow eyed, ribs aching, back aching, pelvis aching. Useless, too, I could no more have written a sentence or picked up the phone or bagged a grocery than I could have rolled off the sofa and delivered 250 push-ups. Oranges in July, Valencia, barely in season. I

remember thinking, *This can't go on.* Let me count the ways it can't go on—and on.

It had gone on though, through October. Charlie left for a month to climb mountains in Uganda, the last of the glaciers in the Mountains of the Moon. How quickly we've messed this all up: everything melting, flooding, on fire, and me with another human on the way to add to the overload. Meantime, grapefruit and pomegranates—and still nausea, sleeplessness, and a blinding pain behind my eyes. By Christmas, Sarah had Donny Osmond's performance down to the last disturbing eyebrow twitch, sidling up to me: "Any Dream Will Do." Also, such a helpful toddler, she'd colored and glittered and glued and pretend read all her books to her stuffed duck, Ping. You think, I thought, *All this love, how will I have any love to spare for another child?*

But you do. I did.

When Fi'd arrived, love to burn.

And then, when Fi was eight, pregnant as a beetle with Cecily, I'd crawled into his bunk bed for books before sleep. We'd read the *Chronicles of Narnia, The Wind in the Willows,* and all of P. L. Travers's Mary Poppins stories during those nine months. "The same substance composes us—the tree overhead, the stone beneath us, the bird, the beast, the star—we are all one, all moving to the same end. Remember that when you no longer remember me, my child." You read those words to your child—I did—and you think, *They won't need this information until I am long gone.*

Fi

Meantime, Fi'd put his hands on my belly to feel the baby. From early, she'd been a restless one; we'd been able to see the shape of her foot pressing out of my stomach, her fist punching, the swell of her rump distending my ribs. I'd had heartburn with her, an aching spine, screaming hips. Sarah and Fi had been polite, space-aware fetuses by comparison. The youngest had taken all the room she'd needed, the tiny, powerful thing. Fi had cooed into my navel, like a pilot reassuring a fractious passenger. "Take it easy, relax. Enjoy the ride."

All *this* love, how will I have any love to spare for yet another child?

But mother love can't be measured in the usual ways: time, speed, distance to the moon and back. Mother love can't be measured at all. A vestment, then, mother love, slipped over our heads when we're not looking—so, *in*vested and also, forever altered. The moment our body undertakes to form and nurture another life: mother love. I can't speak to father love or what it is; vaguely, balls. All your vulnerability, all your potency, all your games, and all your game, in one sacred sack.

Sibling love is you fall, I catch you. I fall, you catch me.

Child love is memory working forward, perpetual curiosity.

"What's *life*?" Fi'd wanted to know.

"You're doing it," I'd said.

"But who started it?" he'd asked.

<p style="text-align:center">✳ ✳ ✳</p>

These are the doldrums of grief, the bit where you're stuck and at the same time, you have to keep going, as if you need to churn the repeating nature of early grief into something solid and thereby escape, like a fly making an urn of cream into butter. "Are we sure about Till?" my friend Megan asked now; we were having tea on the porch. "Has she moved in?" She slid her sunglasses down her nose and looked at me. "No," I said. Megan tilted her head, skeptical; Harper did the same thing. "Maybe sometimes," I said. "On and off." I didn't say that Till was there because I had no family. My mother and sister's silences meantime grew only wider, weirder; Charlie flew out to Zambia and stayed with them, no one mentioning it to me, as if I had died and was no longer in the equation at all.

"I'm here!" I'd find myself screaming to the imaginary them, into the darkest part of night. I am here. Find me, come to me, someone *be* my person. There's shame there, I found, a deep, revealing shame to being cast up alone like this at a time like this without a sibling, a mother, a family of origin to help shoulder the burden. There's shame to being the one found tribeless during the most tribe-needing of times. Therefore, Till was here to administer to my early sorrow because a whole history of being an outsider with insider access had left me without that kind of unconditional backup in this moment.

Meantime, the girls, so whispering, like smoke. "They say the grief you feel is proportionate to the love you felt."

Someone had told me that in the grocery store parking lot. This grief would burn us to the ground then, a love so huge. St. John of the Cross knew: His fellow priests at Toledo, not Ohio, turned on him in 1577 and imprisoned him in a closet cell for months, crippled, in his own excrement, dysentery, lice, nothing but a tiny slit of window for light, rotting clothes. "I am dying of love, darling, what should I do?" he cried out to God at last. To which God responded, "Then die my sweetheart—just die. Die to all that is not us; what could be more beautiful?"

Die to all that is not us.

"I've got to get out of the valley," I told Till.

I needed to get into the mountains, deep into them, the big mountains south of us. It was not quite the middle of August by then; Fi'd been dead for five weeks, and there was nowhere that I could look that didn't remind me of him, gone. Every time I ventured out, my heart ambushed. A half-glance of someone nearly like him walking into his favorite lunch spot. An old green station wagon rounding the corner, like the one he'd driven. His initials on the rock above the traffic light on High School Road, spray-painted, the tradition in our town, our dead children commemorated in this way.

You don't think it'll happen to you.

And, even when it has happened, you think, *Not my boy.*

Please, not my boy's initials up there, not CFR: Charles Fuller Ross.

His school to the west, his grave to the north, his birth bed to the east, his deathbed to the south, his initials up there in front of me. I died and died right through green, amber, red, green, amber, cars honking. Weight pouring off me—torrents, down, down, down. And the world shrinking, shrinking, as it does for the dying. No news. I cared not for Brexit, Trumpism, the midterms.

A harbor was needed, a refuge. Two years before Fi'd died, I'd bought a sheep wagon. They're not for sheep, these wagons, but rather for the solitary shepherds who care for sheep in the high alpine meadows of Wyoming and Idaho. Sheep are temperamental, always sick, always falling prey; they need constant observation. Most of the shepherds are Peruvian out here, patient, accustomed to steep slopes and extreme mountain weather, baking sun, blizzards, wind. Rifles in a scabbard across their saddles, they ride tough Bureau of Land Management mustangs roped in off the Red Desert.

Horseback riding in the Idaho mountains, I'd come across the shepherds a few times; their horses swishing their tails, belly deep in rich summer grass, horseflies, deerflies. I'd seen their sheep wagons dragged up high, too, smoke chugging from their little stovepipes. They're everything you need in one tiny room, a sheep wagon: sixteen feet long, eight feet wide. So, when the glassblower had started to express the need for more distance, I'd bought a sheep wagon for myself. It had a queen-size bed, a pullout table, a tiny woodstove. I'd pinned up reproductions of Nicholas Roerich's Himalayan

paintings and a quote by the thirteenth-century Sufi mystic Jalaludin Rumi that I'd written out as an inspirational instruction, cavalierly, in retrospect.

"Bismillah your old self to find your real name."

I'd stocked it with tea, milk, honey, the sheep wagon. As the glassblower's irritation with me grew, I spent more and more time in there; writing, sleeping, meditating. Sometimes, quite often—women's friendships strengthen at such times—Megan had teetered across the meadow from her yurt to visit me in her Lycra workout pants and Elton John sunglasses, Harper like an enthusiastic apricot-colored cheerleader. We'd agonized and meditated together. Mostly I'd agonized, and Megan had rolled her eyes at me. Our Bitch and Sit, we'd called it. "At least you don't have cancer, and your children are healthy." Megan has never forgotten saying that to me.

If only.

If only I'd known. You never know what's coming; the whole wild ride is a mystery. I couldn't have predicted that the sheep wagon would be the only thing I could tow out of the life I'd made with the glassblower. But with nowhere to put it, I'd asked an old friend—who also happened to be an old friend of Till's—if I could park it in her yard, and then Till had needed a place to stay so I'd said, "Sure she can stay in the shwagon," as we'd called it. Like that this story goes, one coincidence following another, ending up with Till towing the shwagon into the mountains now,

my grief sanctuary on wheels, my mobile refuge. Till, my bespoke ferrywoman over all the five rivers of Hades, rocking the boat.

Zugunruhe is a German word meaning migration anxiety— wildebeest, for example, certain birds.

Divine discontent, sacred restlessness. Move or die.

THE BIG FIRE
AND
THE LITTLE
PHOENIX

i

I T'S A LOT HARDER than Elizabeth Bishop makes it sound, the art of losing. Or Margaret Wise Brown. She makes it sound like a lullaby. Matter-of-factly, you will say goodnight to mittens, then kittens, clocks, socks, stars, air, noises everywhere. I try to see every full moon. In the condo, if I stand in the loft against the little window, I can look east toward the moonrise. Also, almost directly toward the glassblower, in his yurt, our old yurt. On a mild night, not too windy, he'd be sitting in front of a contained little fire drinking a beer. The past is a different country. The future's too painful to imagine. The moon moves at walking pace, one step at a time.

The moon belongs not to time, but to Time.

The Lakota know this: thirteen moons in a year, not twelve.

Therefore, the second full moon after Fi's death, Till towed my sheep wagon for me in her diesel pickup—better torque, much better towing capacity—far up into the mountains southeast of the condo, dragged it really, as high as we

could go and as far, before roads ran out. I followed behind in my 1999 GMC Sierra, single cab, roll-down windows, bed stacked with firewood, a heavy splitting maul, an old mountain bike, a camping stove, an outdoor folding table. Till had announced she could continue to work remotely. She could drive twenty miles from the mountains to the nearest gas station—fuel, internet, junk food—work there all day, and drive back at night just to check on me.

"If you want to stay in town, I'll be fine alone," I'd said.

Till had said, "Yeah, no. Nope, you won't."

"Really," I'd said.

But I knew I couldn't be left alone, any more than a thirteenth-century anchorite could be holed up in a cell within the walls of a monastery for years, decades, her whole life, no caretakers. The English anchoress of the Middle Ages, Julian of Norwich, for example, is said to have had several maidservants—food delivered, waste removed, reading material supplied. Julian of Norwich, who'd survived more than one plague, her communities wiped out—also, probably, the death of her husband and all or most of her children—and whose writings are the first in English by a woman and who'd concluded against all apparent evidence, in her *Revelations of Divine Love*: "But all shall be well, and all shall be well, and all manner of things shall be well."

My sister-cuz, Cait, and I say it to each other sometimes, "But all shall be well"; it's the "but" that gives that sentence its power, we agree. "And, all manner of things," we'll

remind one another, "all manner of things." Till pulled up in a huge meadow that stretches out beneath Wyoming's highest peaks, if the gods had a cirque. In the otherwise empty meadow, there was already a sheep wagon parked in its northern end—an old one with a dented aluminum cover, a black stovepipe chugging smoke. There were two Peruvian shepherds tending to their camp. Grazing in the meadow there was a herd of about forty horses; end of season, saddle sore and stiff, the shepherds would have shipped the sheep by now.

Till waved to the shepherds, "Hi. Hola! How's it going? Qué pasa?"

"No," I said.

So, Till backed up and drove to the southern end of the meadow. "Here?"

"No," I said again. After that, "Closer to the creek." Then, "No, wait." And, "Maybe back to the forest, there." "Okay, but now we're right next to them, again. How about if you just . . . ?" Directing Till in circles until finally she became unhinged and drove madly around the meadow, knocking the sheep wagon's stove-pipe crooked on a pine tree, buckling its footrest on a rock. I yelled at her to stop, and she yelled back at me that she wouldn't stop until I was happy. Then she stopped anyway, abruptly, in the middle of the meadow, got out of her pickup, unhitched the sheep wagon, and said that this would have to be the spot because she realized I'd never be happy.

"Okay. Alright," I said. "But we need to turn it around, so the window's facing east."

"Are you shitting me?" she said.

"Yes, no. No, I'm not. I need to watch the moon rise," I said.

Regulations: I'd warned Till I'd be running my grief camp along the lines of a boarding school schedule. A half hour of chapel—morning and night we'd had back then in Zimbabwe—an hour on Sunday; our uniforms had scratched like sackcloth over our sunburns. And bells, all my formative years. A bell to awaken, after that, twenty-four bells until the bell for lights out. "I've never seen a wild thing sorry for itself," D. H. Lawrence wrote in his shortest-ever poem. I'd stuck a copy of it on my dorm room wall as a reminder to not indulge in self-pity, until I realized I'd seen plenty of wild things sorry for themselves, huddled, broken winged, dejected.

Perhaps D. H. Lawrence hadn't seen enough wild things.

You can do both, I'd always told my children: You can feel sorry for yourself *and* not whine about it. Future-you will thank now-you for not giving up even when you feel like it. Suffer, but don't add to your suffering with a whole performance. Write a timetable, stick to it. "Our routes," I'd told the kids when they were small. "Bath, books, bed." Routine first, because routine is a way to get traction, if nothing else, when all else fails or has failed: handhold, toehold, step. "It's a question of discipline . . . When you've finished washing

and dressing each morning, you must tend your planet." I'd written that out for all my children, from *The Little Prince*.

That's the great thing about parenting, one of them, all the stuff I wish I'd known; I could learn it and teach it at the same time.

All the stuff I'd needed to know, Post-it notes, I put them everywhere.

"I write because I have the authority from life to do so." Bessie Head said that, lost her mind, too.

Now, I told Till, she could camp no closer than a quarter mile away. I needed to write—bills to pay, lives to support. Till counternegotiated until at last I conceded. She could come for early morning tea and meditation—Tea and Spirituality, we called it—and she could come for supper. But she had to camp out of sight and out of mind the rest of the time. "Also, you can't," I told her, "beg to be around me and then sulk because I'm ignoring you or I'm crying or I don't want to be fed or spoken to."

"I know," Till said.

But she couldn't have known, because I couldn't have known.

You can't know what the death of a child will do to you if it does not kill you. All parents who hear of Fi's death have told me this: *I wouldn't survive the death of my child*, as if my child's death must therefore have been a lesser death than the death of their child would be. Or me, as if I must be a less grief-stricken parent than they would be, if it happened

to them. I tell them that I didn't survive and also that I did. Both things happened. Fi died, and everything that I'd believed until then blinked out with him, myself included. A fuse blown. Death after death, on the spot, like holiday lights tripping: *blink, blink, flicker-blink*.

It can sound grim, and it can sound like a dance in the rain, a song in the shower, all those bumper stickers. It's true, live that razor-sharp narrow way of dying and dying to each moment, and it's bliss, supposedly, even when you're smashed to pieces on the wave's crest, drowned in the shower, blinded by the light at the end of the tunnel you're always hearing about. "What doesn't transmit light creates its own darkness," wrote Marcus Aurelius. I have a worn copy of *Meditations*; a puppy had teethed on its corners, one of the two corgis we'd had when Sarah and Fi were little. They were supposed to help keep ground squirrels out of my garden. Instead, they'd ganged up on me, mostly.

Same, I'd come to feel, with the Stoics, so fish eyed and distant.

"If you've seen the present, then you've seen everything." Aurelius again.

And at the same time, I was aware—awfully—of this other insensible truth. I would have to live in the expectation of my daughters' futures. I'd have to survive these deaths: Fi's and mine, Stoicism in action, not theory. All this death, this death talk, this acceptance of death, it was going to take some digging, some unlearning, some poking around in the

shadows, by feel. Find death before death finds you; that's the core spiritual instruction at the heart of all religions. Monk me up, therefore; nun me down. Die to everything that is not love; is this love?

Is this?

How about this?

The way to know love is that, unlike evil, it cannot change, only deepen.

> 4:00–5:30 a.m.: Build fire, tea and chocolate, meditate one hour.
>
> 5:30–6:00 a.m.: Push-ups, sit-ups.
>
> 6:00 a.m.–Noon: Write.
>
> Noon–2:00 p.m.: Heat soup, eat, ride bike.
>
> 2:00–3:00 p.m.: Bathe, wash clothes and dishes.
>
> 3:00–5:00 p.m.: Write.
>
> 5:00–7:00 p.m.: Build fire, make rice, heat soup, eat.
>
> 7:00–8:00 p.m.: Meditate.
>
> 8:00–8:30 p.m.: Brush teeth, read, lights out.

Day after day, day after day.

Night after night, night after night. The little woodstove roaring, Till complaining after supper, how cold it was in her tent, how spacious the bed in here, how toasty the little woodstove. Me, throwing her out at 8:00 p.m. "Good night, Till. No, no, no. I don't care. No." Then, night after night,

the moon and I, alone together, scouring the skies for Fi, slowly, our sweep, from east to west, methodical, a fraction of a degree south each night, and her light fuller, too, beaming. Just me and the moon, looking for my boy, like a survivor of some vast, celestial landslide picking through the endless rubble. I wept effortlessly through all of it. If I slept, I don't remember; my pillow was soaked with tears by morning, though.

For two weeks, I did that.

Then, for two weeks, I drove the two hours back into town, picked up Cecily from Charlie's, ran to the grocery store, the farmer's market, cooked, did laundry. I mothered, and in the small hours, before Ceci woke up, I wrote and I grieved. Sarah went back to the coffee shop as a barista. I don't know how she did it, her whole childhood walking in. *So sorry*, old family friends, neighbors, people who'd known Fi his whole life, their whole lives, *so sorry, so sorry*. But Sarah found it, if not soothing, at least a familiar routine—this order, that order, people wanting the same thing every day— and she also saw that unless she stepped out of the habit of two mochas and a cappuccino with a shot of espresso on the side soon, she might slide into it forever.

"I don't know who I am without him," she said. "He was . . . I can't . . . We were . . ." I knew; I'd always known because I'd stitched their hearts together with my own hands, unbreakable threads. To Sarah, he'd been the OG other half, the perfect twin to her soul, the answer, the

question, all of it. Partly—almost wholly—because of the rupture from my siblings, the lifetime of pain it'd been, I'd soldered my children to one another. Joan and I agreed we could both understand why Fi might have had to die and why Charlie and I might have had to suffer, but not the girls. They didn't need this suffering, this early, this hard.

In the end, weeks after Fi'd died, Sarah surprised us all—and herself—by applying to be a legal assistant at a local law firm. That job would start in the fall, a few months into the future, our unimaginable future. Which is to say, the Sarah who would *never* have worked in a law firm or taken the bar—the Sarah who was likely on her way to graduate school in South America—was another Sarah, a pre-Fi-dying Sarah. Also, she'd *met* someone; they were dating, she reluctantly admitted. He was, is, remains, a physicist turned cider maker, also mad about cycling; but her heart was too smashed by Fi's death for love, she insisted. "I might have to break up with him already. I really hate his shoes," she said. "And his socks. Also, *all* I do is cry about Fi and he's very . . . Well, I'll bring him to supper. He's very *not* us."

"By which you mean . . . ?"

"You can never tell what he's thinking," Sarah said. "And he's impossible to shame."

Me, praying: *let love begin to mend Sarah's heart.* And Cecily, back to tennis, back to lacrosse, getting ready to go back to school. Sometimes, though, she said she didn't feel real,

as if Fi's death had made a lie out of her very existence. She kept drifting away from herself, she said. "I'm scared it'll be me next. What if I die in my sleep?" She'd looked her symptoms up on the internet, and she said she thought she was dissociating. We played Bananagrams, we did art projects, we lit candles and took long baths, we made trays of tea. We did the things you do in a regular, living body. We found therapists for Sarah and Cecily, we listened to podcasts, we read books, we prayed. We also never stopped knowing how much pain we were in.

We began every meal with a reading from David Whyte's *Consolations*.

When we'd read through that, we started up with *Love Poems from God*.

"Accustom yourself continually to make many acts of love, for they enkindle and melt the soul," St. Teresa of Ávila said that. The condo, like a hushed hospital, a hospice: a place where death was being confronted, the hard truth of it, and also the work of enkindling the soul, re-enkindling. Then while Cecily was with Charlie for two weeks, I fled gratefully back into the high mountains, to the sheep wagon, to the tending of my sacred anguish, my constant dying, my work: up before dawn, meditate, write. Like that, back and forth, I made myself a container. Scraping and scouring what I could of the grief while it was fresh, before it hardened against my insides, the beginnings of a shell.

Fi

Meantime, Till fading in and out—more or less helpful, more or less unhinged. I know we fought, the same circular argument. I wanted less of her; she wanted more of me. I always won, partly because of the dead son card. It trumps everything. We must also have had plenty of quiet meals together, meditations. But one of the medicinal properties of routine is that it causes time to bleed, and in so bleeding, the particulars of that time blur. One night, in the sheep wagon, I dreamed of Fi in this way: baby, ancestor, baby, ancestor. Every time I reached out for his baby hands, his ancestor arms wrapped around me.

Hands of longing, arms of love.

There's no going back, no stuffing this baby back in the womb.

Love is the answer; turn to the arms of love. Tall order though.

ii

THE FIRST OF SEPTEMBER, the Peruvian shepherds left the meadow taking their herd of horses with them in two stock trailers. Naturally, Till had befriended the shepherds, joining them for coffee and condensed milk every morning after she'd had Tea and Spirituality with me. They'd left her with boxes of picarone mix and their addresses in Peru. They had sisters and mothers, they'd said. She didn't have to decide which of them she wanted to marry until she got there. I could see what they could see: Till has something of Faye Dunaway's Bonnie about her, the blond curls, a halo of them. She's devastating, backlit. Also, the baby-blue eyes.

"I told them to warn their mothers I'm an awful cook," she said.

"That's the warning you thought you should come with?" I said.

"Well, what warning would you come with?" Till asked.

Bow season started; archers showed up, solitary, camouflaged, deliberately quiet. Then it was open season, and the

riflemen arrived. The meadow filled with RVs, four-wheelers, generators, gun oil, propane, chainsaws. When Till wasn't at the gas station on the internet eating junk food, she was making the rounds, introducing herself. Rednecks were her tribe, herself a Vermont redneck by birth, she said: granola, knitting, hunting, drinking, small-engine socialism.

"The force that through the green fuse drives the flower / Drives my green age; that blasts the roots of trees / Is my destroyer." Dylan Thomas wrote that poem at nineteen. That's a lot to know at such a young age, the circular nature of everything, especially when you're born into a culture—broadly speaking—that chops time into currency and mistakes formulas for faith. What of the ineffable? The part of me that still arose to be fed, the part of me that demanded I nourish my life's force, the part of me that is also a part of God and therefore unquenchable, inextinguishable, infinitely curious.

My vertebra and hips began to hurt, poking against my skin; by mid-September, I'd dropped from my usual 125 pounds to 110 pounds, 105 pounds. Down, down, down, 100 pounds, as if draining. I brought the bathroom scales back with me from the condo. In the two months since Fi died, I'd lost the same amount of weight as I had the first two months of his life. Maybe that's all it was, yet another way the beginning and the end were fanana. "Jesus, Ali," Till said, the only person ever to call me Ali, as if in recognition of my abbreviated self. "I think we draw a hard line under that hundo."

"Under that what?"

"*Hundo*, short for a hundred."

"How is hundo short for a hundred? Both have two syllables."

"No, they don't. A. Hun. Dred," Till said. "That's three syllables."

"Oh, you're right."

Like that, chattering mindlessly, a Sunday morning, Till and I had taken cushions down to the creek; we'd wrapped ourselves in blankets. My day of rest; meditation foregone, no sit-ups or push-ups or rules. I didn't write on Sundays. Instead, I dawdled, I wrote letters to Sarah and Ceci, I drew them pictures. I sat in the sun and drank tea. I let my mind rest and wander. I watched summer come to an end. Ice laced the edges of the creek in the morning; the nights were freezing harder. The skies filled and clattered with the last of the migrating birds, swirling, gathering pace. Also, wildfire smoke, more each day, thicker and denser—the whole of the west was on fire, it seemed, California, Oregon, Utah, Idaho, the rest of Wyoming.

I lay on the rock, the creek bubbling, life, life, life.

The sun glowed weakly through the wildfire smoke; the sky turned pale yolk.

Till emptied the wicker basket, food from all her new hunting friends. "There," she said. "That is bison and bacon quiche from Shirley and Sean, and the elk sausage is made by Ron from Rock Springs." Sean and Shirley, Till told me,

were the ones who had the huge RV, which they'd parked up where the Peruvians had been, the largest patch of flat ground. They'd laid out a green carpet in front of their RV like a small lawn, a grill, outdoor furniture, a generator. They were from Riverton. They'd been coming here for hunting season for thirty-five years, since they were first married, and had never seen it so dry, so hot. Also, the elk were still up high—even higher—no snow to push them into the timber at lower elevations.

Ron, from Rock Springs, he'd shown up late on the first day of the general season with a little old camper that he'd parked at the end of the road. He'd been coming here even longer than Sean and Shirley, Till told me. I'd heard him coughing and hacking—I'd long ago outlawed phlegm clearing in my vicinity after both Fi and Tenzing had taken it up, age about eleven—as he poked across the meadow like an elderly stork, but I never saw him go out hunting. Most of the time, Ron sat on a lawn chair about equidistant from Sean and Shirley's RV and my sheep wagon with a rifle across his lap, binoculars, and what looked like night vision goggles around his neck. "He's a trucker," Till said. "Been married so many times, it's like he's Liz Taylor, he told me."

Back to the condo for two weeks, it was getting harder to leave my deep mountain grief for the busy valley world, like breaking the sound barrier each time. I was there enough for Cecily; I must have been. As the youngest, she's an outspoken

child. She'd have let me know if I'd failed her as a parent. "You are the best *human* mother I know of," she'd written to me on Mother's Day, age ten. When pressed, she'd said she'd made the distinction to leave room for the possibility of a superior *animal* mother. A really good whale mother for example, just imagine having that on your side. And there are well-documented cases of grizzlies being *the* mamas. I know I fed her well; it's instinctive, under duress, for me to feed a child.

"Don't just stand there, *do* something," my Dad would have said.

You're less likely to end up bosbefok if you keep busy; the Devil finds work for idle hands.

Then, Sarah's twenty-fifth birthday, September 15.

Who could celebrate? The year had stolen away the one thing, the one thing. Oh, the *one* thing, her one person. It's hard to not think in absolutes: All or nothing, dead or alive. Charlie was planning to throw a party for Sarah, for Cecily, for their friends, for our friends, for us; I couldn't go. I couldn't have gone. I couldn't leave this meadow where I was actively grieving my child's death any more than I could have risen from a bed in which I'd been birthing him. I'd said, "I'll ruin it for everyone. Oh God, I am so sorry, Sares. I'm not fit for human consumption." I couldn't say, I'm both midlabor and middeath, but that's how it felt.

"I know," Sarah said. I knew that she knew, she of all people.

Fi

We had talked then about how hard it was to tiptoe around the Fi-shaped holes in both our lives. It was all either of us could think about, and yet we were unusually careful, circumspect with each other. We'd say, "I'm going to mention something about Fi, is that okay?" We did not spring memories of Fi upon one another, we didn't share photos of him that other people had sent to us, we did not tell one another how much we missed him. Nor did we catalogue for one another the specific travails of our grief, although Sarah had started to write about it for an online magazine: "Trying to talk about Fi is like trying to describe my own heartbeat or skeletal system—the invisible infrastructures of my life—ripped out."

"I don't have to be with you to be with you," I'd told my children before leaving on assignment. For six or eight weeks at a go, far-off places with sketchy cell coverage, different time zones, different times. Like a deployment or a mission, you don't get to choose when; that's up to the editor, the photographer, never up to me. "We're all going to bed under the same moon," I'd reminded the kids before leaving for Kenya, Madagascar, Ethiopia, a wind-shredded beach on the Última Esperanza Sound in Chile. I'd missed birthdays, holidays, Holy Days; *oh my God*, mothers in the post office, the coffee shop, school pickup had been impressed I'd seized so many days. "Who'll take care of them?"

"Oh, they'll be alright," I'd say. "They've got assault rifles."
Or the dog, I'd say. Each other.

Sarah would glower at me from the back seat afterward. "No one thinks your jokes are funny."

"I do," I'd say. Anyway, I'd felt compelled to address the implications of the question. Mostly I'd reminded Sarah that mothers should not exist in a fiction of pope-like infallibility, Hallmark perfect 100 percent of the time. That is not the perfect mother. Mother love is always selfless, I'd said, but it's not always self-sacrificial. Mothers can miss birthdays, fathers can make dinner, children can pack their own school lunches. No one dies, everyone lives more fully in their own shoulds and their own should nots. I'd been so cavalier, so certain I'd have the rest of their lives, mine, to fix whatever I'd broken in them, and still I find forgiveness is essential to healing. Starting with self-forgiveness, notwithstanding my inner stenographer, perpetually reminding me how unworthy I am of clemency.

They say immolation is the most excruciating way to go. The air so thick with smoke it tasted bitter.

The night of Sarah's twenty-fifth birthday in western Wyoming, then: a small but waxing gibbous moon setting early in the north-northwest behind dark wildfire plumes, with gray tendrils like shawls across her face. I crawled up into bed and turned to face the little window; the moon disappeared soon after, bled out, set. I didn't sleep much. Instead, I kept vigil mostly over Sarah, over my memories of Sarah: Sarah's birth, her babyhood, oh, her sweet plump

thighs. Sarah had been the happiest of my babies. She'd gurgled; everything had delighted her. She'd had rosebud lips and curly golden hair and the most enormous violet-blue eyes. The Buddha baby, my friend Mary had called her; we'd raised babies together in the mountains, black bears, deep snow. Mary had taught me how to ski and to cook; I'd taught her how to be cavalier with a baby, strap it to you and go.

At dawn, I lit a candle and said goodbye to all that.

The comfort of an infant on my shoulder, the perfect weight, that milky smell, bird noises.

You can't carry that around forever; infant becomes child, adolescent, adult, ancestor.

I got up, stoked the fire in the little stove, put on the kettle. I threw a coat over my pajamas and went down to the creek with towel and toothbrush—a strange, shrouded dawn. Also, I noticed a weird white glow on the southwest horizon; it looked like a nuclear bomb was going off. Then I saw a green Forest Service pickup bouncing up the road, making a beeline for Till's pickup and after that, the same green pickup heading back toward town, engine whining. Till arrived for Tea and Spirituality breathless with the news: a new fire. According to her Forest Service friend Craig, a couple of hunters had reported it in the early hours, so fast-moving, their only recourse had been to lie face down in a creek and let it overtake them. They'd been medevacked to Utah: burns unit, lungs near melted, the whole thing.

On average, a wildfire can move fourteen or fifteen miles a day, much slower than a human or a horse.

There are no averages anymore, though; this fire was ripping through averages.

All that day and the next, the new fire grew, it raged, it changed the weather, then it *became* the weather. Within three days, ash rained from a cloudless steel-gray sky. Daylight palled behind pillars of smoke, the wind took on a sun-smothered chill, and the fire had a name, the Roosevelt Fire, already looking to be one of the biggest wildfires in Wyoming's history. One of the most aggressive, too, it had shut off the roads to the west and north. Blowing cinders, falling trees, and towering flames were reported across three counties. Half a dozen helicopters, several air tankers, a thousand firefighters were assigned to the blaze. Till kept me updated via Ron, Sean, Shirley, and Craig.

The flames came closer each day: forty miles closer, then thirty miles.

And every morning at 4:00 a.m., nothing else to be done, I awoke.

Tea, chocolate, meditation. The smoke jumpers and helicopters began at 6:00 a.m., *thwack, thwack*. You can't hear that sound and not think, *Combat*. I did. You see those little bodies like clothespins suspended beneath billowing canopies, drifting down into the flames and you think, *This is war*. Then one morning, evacuation orders came, and that, too, reminded me of war's sudden changes of course. The hunters

began breaking down their camps in a parched mountain meadow; it was like decamping from a pitched battle that hadn't happened. I began weeping then. "I can't go back yet," I told Till.

It's not only that I was not ready to leave this smoke-swirling wilderness—so still and stilling—it was also that I *couldn't* yet leave. I hadn't done yet what I'd come here to do, whatever that was, a goalless goal. If I'd had these words then, I'd have said that this place, of all places, this burning paradise beneath the bloodred moon enabled the wildest of my grief. In this wasted, smoky, shrouded haven, I could bismillah my old self. I could protest and writhe and weep; under this veiled sun, I could endure the death of Fi's earthly mother. I could do the big deaths here, the hardest of the work; I could accept he was gone.

At the thought of the condo, the white walls, the beige carpet, panic closed in on me.

"Someone will call the cops," I said. Running amok, I pictured myself in the common area between the condos where the dog owners congregated morning and evening with mutt mitts and leashes, me in an old sweater, bits of myself sloughing off. "They'll try to put me on pharmaceuticals," I said. I mistrusted the world with its blunt instruments. The human world, I mean—the world of getting and perfecting and producing—had no language for this letting, undoing, molting. I'd have been misunderstood. The natural world was doing it beautifully all the time:

dying, rotting, regenerating. Here I was in keeping with the natural order.

I begged Till. There had to be another place I could stay in the mountains. What about farther east? Just until the first snow, I said. As soon as there were two inches of snow on the ground, I promised I'd leave; but if I went back now, mid-stride, mid-death, mid–whatever this was . . . I didn't know what would happen. Perhaps nothing. Perhaps I could go on grieving in the condo, in the town where he'd been born and had died. Perhaps I could have soldiered on in some conventional way, but it didn't feel like I could, and with no one else to speak for me, I spoke for myself. "If I go back too soon, I'll be like my mother, this grief stuck inside me forever, and I can't do that to the girls or myself or anyone."

"And if you burn up in the fire?" Till asked.

"Then I overshot the mark."

There was a long silence. "Okay," Till said. Then she did her Faye Dunaway thing, backlit. "Because I think I have already found a place." She'd anticipated this moment, prepared for it, run around, asked about alternatives to our complete evacuation from the area. "Craig says we might be able to wangle a couple more weeks out here; well, not *here* here, but around here . . ." Craig knew this, and Craig knew that. And yes, she said, as it happened, there was one camping spot left in this whole area that Craig said was still open.

Also, her other new besties—Sean and Shirley, Ron—they knew the way to that camping spot. It was a favorite among

locals who wanted to hide away for a dirty summer weekend, down the mountain a bit, tucked up a canyon, alongside a creek. It abutted a small pine-scrubbed hill, boulders, sagebrush meadow. Ron left twenty gallons of drinking water with us and a heavy-duty flashlight, something you could wave a train down with, he said, if you needed. Then Sean—with metal cutters and screws—fixed my unstable chimney and the step that Till had broken. Shirley, meantime, back and forth from their trailer with cookies, pastries, lasagna, meat loaf, cans, tubs, tubes. "Lucky you're also not vegetarian . . . or whatever," Shirley said.

Then everyone left, hurrying to beat the road closures: just Till and I remaining. I made her park her pickup on the other side of the sagebrush meadow, out of sight. At dawn, I warned her, the routine would begin again, the sacred humdrum, the way monks and nuns do a lifetime of matins and vigils and lauds and Lectio Divina, vespers. 4:00 a.m., stoking the fire, tea, meditation. Sit-ups, push-ups. Write. Only, instead of bike riding through the meadow at noon, I now walked up the creek a couple of miles in the thick smoke—fast, lungs burning. A little great horned owl followed me upstream between the overhanging trees—a juvenile, flitting and flapping like an oversized moth.

Back home, where I grew up, owls represent death; they're feared, mythologized, and persecuted, a bit like wolves are in the States. "Hello," I said to the owl. The owl was a tubby little specimen, horned certainly, but not yet great. *Hoo-ho-ho,*

it replied reproachfully. After that, all day—and as far as I can tell, most of the night—the owl didn't leave my vicinity. Till took photos of it; she took photos of it all. No doubt we looked haunted. My skin on bones as I bent over the basin in the sheep wagon to bathe; the flames from the fires visible on the horizon, the owl perched, sometimes flying, always near me, like a sorceress's pet. The sheep wagon, the kettle's whistle, the long, slow, chilly surrender to what is.

"You are so weak. Give up to grace." Rumi said that, too, danced it, maddened with God.

"You're trying to live your life in open scaffolding."

Everything liminal and yet also familiar, because the end of the world has always looked something like this to someone. Such surreal, silent picnics we had in that eerie smokescape, Till and me tucking into Shirley's food: hot dogs, relish, fish-eye salad, apple pie, cottage cheese, pickles. I could feel the weight coming back on my face a little, my breasts, my stomach. Till broke curfew and appeared not only for tea and supper, but also breakfast and lunch. She made flash cards, three, all the words you need. MAY I SPEAK? YES. NO. I took the NO flash card and poked it through the zipper on my coat. "So that's a no?" Till said. "Just to confirm?"

I nodded.

The fire changed direction, away from us, and raged on. I burned up, too, fanana: smoke, ashes. Then one day I realized

Fi

I'd burned up as much as was possible—or safe—all in one go. You can only burn up so much before you're as dead as you're going to get in this lifetime. Which is to say in the course of a great grief, if you don't die enough at once, you end up zombie dead, unrealized grief stuck inside; but if you die too much at once, you end up *dead* dead. I knew I couldn't stay here stirring the ashes of this grief until all my sadness and grief and grievances were cold to the touch.

"Drown, stir, feel." There are posters.

To prevent wildfires, you are supposed to put your hand in the ashes of your campfire.

Otherwise, Fi and me, forever, in this smoke-filled dome of exquisite suffering.

Just Fi and me, so agonizingly cozy, I wasn't ready to share him, ancestor him. The world wouldn't understand, wouldn't know how to handle him—or me. I hadn't wanted to share my babies with anyone else either, certain that only I could care for them, protect them, soothe them, also greedy for all the unconditional, perfect love, the godly bond. "Mind his head!" I could barely stand to watch anyone else with their rickety little necks, their jerking matchstick limbs. "That's okay, I'll take the baby," I'd say the moment there was an excuse to scoop the thing back. Even Charlie, he'd held them like a football, as if about to punt, casually. "No," I'd say. "Let me."

You can't imagine, I couldn't, the drug of an infant stitching itself unblinkingly back into you.

There's a point though; seasons aren't a choice we make. The Moons of Change, the Lakota called the moons of fall. Canwapek asna wi, moon when the wind shakes off leaves. You can't stop life from getting sucked back into the universe. The aspen groves naked now, pink-silver branches ready for the negative 40 or 60 degrees it'd reach in the old days for two weeks at a time. It'd killed off bark beetles, that marrow-freezing cold; now, with temperatures of only 20 below, whole forests turned dead and flammable, less a cycle of life than a spin. Was time speeding up? If I was going to find infinity, I was going to have to break time however breakneck fast it was going.

Or, I knew if I were going to find Fi, I'd have to stop time somehow.

And I'd have to grasp time's hands with both of mine, catch seconds in my teeth. I'd have to seize all the days.

I'd have to let go of certainty and float, like Sandra Bullock in *Gravity*. No calendar, no clock. Instead, seasons and tides and physics. Then, on October 2, 2018, it snowed, a small flurry, barely enough to cover the ground but enough to quench the Roosevelt Fire. More than 61,000 acres blackened—and steam, great clouds of it—slush on fire, embers under ice. The smoke cleared, and suddenly the Wyoming fire season was over, a chilly blanket of snow across the state. Till told me that Craig had told her that the smoke jumpers were already moving on to the next biggest regional fires.

Fi

New Mexico, Nevada, Texas.

And I—like something out of a medieval ritual—feeling myself to be carrying more than just the grief of my own heart. Now also, I am the new mother of a young ancestor. I awoke before dawn, as usual, on the morning of October 3. As usual, I put on the kettle and sat with the stove door open, warming my hands and feet. Then Till, of course, at the door, knocking, knocking. "Ali, Ali! It's cold. It's snowing out here. Holy shit, it's cold, let me in." After that, Till in front of the fire, nose like a baby mouse. You can't help yourself; I couldn't. I kissed the top of her head, her blond curls damp with melting snow. "Thank you," I said.

"Ohmygod, yes, thank *me*," Till agreed.

"I'm packed up," I said. I'd stayed up late lining a little box with satin cut from the edge of a throw blanket into which I'd put rosehips, one of my favorite photos of Fi, also the words to the old love song I'd sung to Fi since his incubator days. That had been Fi's introduction to music fresh out the womb: me, off-key, doing my best Karen Carpenter. Had I known Fi would be leaving before me, I'd have played him instead Johannes Brahms's Symphony No. 4 in E Minor. That's the whole of life, the whole of life's instruction caught in the opening thirteen minutes—allegro non troppo—fast but not too fast.

"I've got something I need to do," I told Till. "Then we can leave."

"Can I . . . ?"

"No," I said.

So, as the sun crested the horizon, right at dawn, I walked alone to the creek and sent the human representation of my son's earthly being away, downstream. A realm beyond me, the unsettled white settler, releasing a homing pigeon into the universe. "I'm letting you go," I told Fi. "Wherever it is you're needed, go there." With which I went to my knees, struck down. "I'll find you, my boy. Don't worry. Don't wait for me. I'll catch up." Allegro non troppo, and I tried to feel the difference, the letting go of Fi's humanness into whatever comes next.

It's not so easy, the feeling of it all: letting go of a body, forever, no turning back.

Cold snow under my knees; it melted pools through my jeans. Tears coursed my cheeks; my throat ached. It was hard to get comfortable, to unstick what was stuck, a lifetime of clinging, holding. This wasn't a picturesque grief, not a Modigliani portrait. I was uncomfortable, the way you are in labor. I squatted; I threw back my head. A wounded cry left my mouth. That's how I let go of Fi's body, his ashes; it sounds wild, but in the wild—even the ruined, smoke-stained, besmirched wild—our wildest selves are home. In the wild, we can put down our streetwise minds and become our wildwise bodies.

Because, left to its own devices, the body understands death the way it understands birth and sex and nursing. Fi, therefore, like a cool flame, in and out of the world, too fast

for me but exactly the right speed for God. The owl swung up the creek then in front of me and wobbled ridiculously, comically, pointedly on the very top of a young fir. "Thank you," I sobbed at the owl. "Thank you, little phoenix." The owl looked at me squarely, alarmed, from atop its precarious perch, with its penetrating yellow eyes. Fi'd looked at me that way sometimes. He'd seemed also to have arrived wiser than I, his mother. *What are you doing?* He'd sometimes had that expression on his face.

"I love you," I said to the space, to the owl, to the creek. The little owl gave me one more look of alarmed disapprobation, as if it had come at a cost to play its part in this beautiful drama. "Thank you, little phoenix," I said again; and then I shook my head, smiled, *of course*. Fi is present in all things now; if only I stay vigilant, open, there he is. After he died, the girls and I spent days thinking of all the ways he'd put the Fi into everything good: *fine, finesse, infinite*. It could only be that he'd put the Fi in phoenix, this wobbly little companion. Such intensity, such alertness, it was going to take some doing to stay here—in this sense of Fi but also in the world.

One foot here with my daughters: lacrosse tournaments, oil changes, taxes.

One foot also *here* with Fi, my young ancestor: Brahms's fourth, sunsets, the moon.

It was going to take practice, I could tell, a lifetime of practice, all the time I had left; but I'd keep my word. *Wherever*

you go, my love will follow, I'd told my babies, I'd reminded my toddlers, my children, my teens. *Even if I die, I'll never leave you,* I'd told them. Somehow, I would be Fi's mother and at the same time my daughters' mother, and I'd also mother myself. But the rituals and roadmaps for how to do that— how to be a trinity in one without sounding insane or going insane—didn't exist, at least not in my Southern African white-settler world. And yet we've all been here before; we've all been everyone. This is far from the first time someone's done something ancient for the first time.

And then, the last few things packed up, the sheep wagon hitched, we drove out; everything about me had changed on a cellular level. Ashes to ashes, Fi, and me. Dead to everything that had once been the mother and the son, the mother of a son, son of a mother. Also, alive. One tiny germ of us, alive. It was the luz, my luz, Fi's luz, the luz from which all life would be re-created in the end. It's a mere speck, and it's also everything that ever was and ever will be alive forever and ever. This is me then, coming down from the mountain, marinated in tears, swept up by the moon, smoked through by wildfire, but not alone. Never alone.

This is me, and my young ancestor.

GRIEF GETS DRUNK
AND STARTS
A DUMPSTER FIRE

i

THE WAY YOU DO when you're pregnant or with babies and people ask, *How far along, how old?*

To begin with, I counted every day, then every week, and after that, months.

August, September, October 8: one trimester of grief.

Out of the fire I'd come, a young ancestor accompanying me everywhere, like a pirate with a parrot on her shoulder—battle weary, battle tested. But being alone in the mountains with a young ancestor isn't the same as being in the world with one, the world with all its stuff and its clocks. Also, we all know grief isn't linear; it's a braid and a spiral and a knot. Barring a bolt of heavenly illumination—a cockroach on your foot, say, like what happened to the Californian New Age guru, Byron Katie—a good grief ensures you sort painstakingly through all your pain, untangle every thread, before it'll let you go.

A good grief will dissolve you, bones and marrow, everything but the luz.

Dissolve and dissolve, until you are the solution to any problem you could encounter.

Meantime, you can't imagine the impurities being thrown up and out.

Or just when you've had enough—I'd had more than enough—grief gets drunk and starts a dumpster fire. And there's no point arguing. There's no point trying to shift responsibility. There's no point saying, *This wasn't my garbage, this isn't my fire, these aren't my ancient raging sorrows.* Great greasy plumes of smoldering old, if there's an odor to grief, it's that. As if every toxic, synthetic thing about me had ignited. Friends drifted away; there were ruptures. Grief is a dreary spectator sport—fun, then not.

Or it's like a caterpillar—I can see why this metaphor gets trotted out over and over in the grief literature—has gone into the pupa stage and stayed there. Because the death of a child will make mush of you; and then there you are, helplessly metamorphizing. People who don't know any better will tell you to go back to normal, but you can never go back to being a caterpillar, nor would you want to. Instead, however, you have to become a whole other animal and learn to fly. And you have to do all of this while feeling so sad, so forlorn, so abandoned by the very God who is, at that moment, making a moth of you.

As a child, I'd opened more than one cocoon; curiosity made me a killer, but what had been dying?

Fi

Meantime, my waking thought is, *Fi is gone. Where is the village to raise my daughters; what will happen to them if I can't find my way?* It's worse in town, in the condo, my restlessness, my panic. Only the wild—even the scorched, diminished, smoke-hazed wild—seems conducive to my unwieldy grief. Grand enough to *be* the grief, to soak up the grief, to reflect it back at me, my feelings as thunder, wind, wildfire. In the mountains, I'd understood the warp and weft of my grief; I'd accepted its weather. In the mountains my grief was shouted back at me with majesty, in the oldest, most sovereign sense of that word.

In the mountains, I'd been able to see that Fi hadn't left; he'd just changed places. The threads that had made him human had simply been unpicked from the middle of our lives and restitched elsewhere. In the mountains I'd *understood* Fi was a little Fi-nix, a drop of golden sun. And maybe I'd even understood my new place in that picture too, a frayed, flawed, and fraught mother, bringing coherence to one tiny part of the vast and fleeting human story of which my girls were still a part and Fi was still a part. Up in the mountains, in vague wordless ways, I'd seen it all and I could accept it all. I could even see how to unstitch my boy from me, me from him. Just the weft, not the warp.

But all that wisdom and discernment—a lot of it— disappeared in the rearview mirror of my 1999 GMC. In town, in the condo, my emerging acceptance of Fi's death,

his perfect departure—I'd dared say that aloud in the mountains—knotted back into thick steel cords of existential loneliness that felt like they might kill me. Or, three months into it, if grief were a mountain, then I'd climbed and gained altitude and perspective only to find myself stranded on a false summit somewhere in the boulder fields, dangling from ropes around my neck. People told me now that I *must* get over it. They insisted my girls needed me. Fi'd have wanted me to be happy, they said, the same people who'd told me the death of their own child would have killed them.

Taking his name off my dental insurance: ring, hang up, ring, hang up. I'd sobbed and sobbed.

Sending out death certificates to the bank to prove: he's dead.

I could hardly set foot in the middle school to pick up Cecily.

I'd wept in the arms of an Idaho Falls mom of many in front of the balsamic vinegar display at the Natural Grocers on Seventeenth Street. But I also did Pilates every day, saw a chiropractor weekly, made teeth-cleaning appointments for me and Cecily, haircuts, pedicures, fresh food. I did the things that you do to care for a body—and for bodies in your charge—hoping that a kind of mundane normalcy would return, a way to cope. Although if you'd asked me then, three months into this grief, I'd have said I *was* coping, going brokenheartedly through the motions. How caught up with time we are; the death of a child will show you. How

much we want to shove time forward, take it back, use it to give our lives order and certainty.

Not this amorphous, weightless, timeless uncertainty.

"How long will we need to feel this sad?" Cecily asked. "Will I be this sad forever?"

"Definitely not," I said.

"Then how long?" Cecily demanded.

Forty days and forty nights, the official period of mourning. I'd looked it up; given how common death is, a hundred percent chance of it happening to everyone, you'd think it'd have been a fruitful search. It wasn't, at least not if you're a cuckoo hatchling of the southern cradle, loosely tethered by the Commonwealth, the Church of England, and by knowing which, if there are a few to choose from, is the correct utensil with which to eat your bouilleture d'anguilles. Do you harpoon them with fish knife and fork or just seize them with your fingers; eels slither around. I could almost hear my mother groaning, all those hours, both of us poring over *The Official Sloane Ranger Handbook* trying to cram some refinement into me before a visit to the UK the year I'd turned fourteen. Fish knives? "Sloanes make a joke about not owning these. The Georgians didn't . . ."

Sloane Rangers were supposed to giggle in bed, not cry at funerals. "Kill salmon. Put the 'Great' into Britain and the 'Hooray' into Henry. Drink seriously." It had said so, right on the cover. If anything, I'd been a bit overschooled.

In the end, the best I could tell Cecily was that I'd found the period of mourning in the Christian tradition is forty days. In Eastern Orthodox Christian traditions, I should clarify, the soul of the deceased passes for forty days through a series of aerial tollhouses during which they can repent for all the usual sins—sloth, sodomy, gluttony—before ascending to heaven. During this period, the deceased's loved ones are supposed to mourn. It didn't seem long enough; Cecily and I both agreed. We were more than twice past forty days and not nearly past our grief.

Never, forever, always.

In German there's a word: *Eigenzeit*, meaning, roughly, the time needed for a thing to happen is intrinsic to the thing that's happening. The time it takes for a mango to ripen, for example, or for a broken heart to heal, or for a river to reach the sea, is the time it takes for those things to happen, but you can't put an exact number on it. Then I heard Shankar Vedantam, host of *Hidden Brain* on NPR, interviewing a New Zealand psychologist and researcher, Lucy Hone, who had counseled people suffering from grief and PTSD after the Christchurch earthquakes of 2010–2011. Subsequently, terribly, ironically, Lucy herself then lost a young daughter in a car crash. As a mother, she'd grieved. As a researcher, she'd observed herself. She told Shankar that about five years is what it takes to get over the death of a child.

Still nothing on *how* to grieve, though, and what exactly is this thing I am doing. Also, why.

What is the mouthfeel of grief; what signifies grief's lifting?

And what does it mean to begin the process of a great grief at twelve, at twenty-five, at forty-nine?

Why are we not told and told to be prepared; why are we not made to repeat it to ourselves every morning, a drill? What starts will end: labor, infancy, a lifespan. Death will come to us all—and nearly always before we're ready. I knew this. I'd known it as long as I'd known anything. Why, then, hadn't I treated every moment of his life when I'd had it with sacred awe? Why hadn't I done this and why hadn't I done that? *Why, oh why*, we'd sung on family car trips when we'd crossed state lines, top of our lungs, *did I ever leave Wyoming?* Why don't bishops, priests, and curates have a formula?

Here it is, the calendar of your grief, complete.

A year after a child's death, say, a liturgically sanctioned ceremony, some community event.

It could be small, just to signify you're still here, alive, a sprig of evergreen, a bonfire.

Maybe the griever can be carried through the congregation in an egg, like Lady Gaga—"Be merciful to me, O Lord, for I am in distress; my eyes grow weak with sorrow, my soul and body with grief"—and then hatch before the altar. That was the closest I could come to a settler version of the Wiping of the Tears ceremonies I had seen on the Pine Ridge Indian Reservation that summer out there on assignment for *National Geographic*. It was the summer of my

divorce; I'd stayed alone in an old Indian boarding school adjacent to the cemetery where Chief Red Cloud is buried, although I'd never felt alone.

Out there, the hot humid nights had been filled with ghosts and ancestors. I'd seen it all with my own eyes: spirits, Big Foot, and a talking cottonwood tree, stuff I couldn't afterward fact-check. I'd driven around with a tribal cop who'd kept itching his Sun Dance scars under his bulletproof vest. His head had been shaved for a recently departed uncle, also a nephew, a cousin, a brother. Then the cop had told me that in Lakota tradition, when a loved one dies, there is wailing, cutting of hair, crying. The period of mourning is thirteen moons. After that: drumming, dancing, smudging, praying, regalia, horses. Tears are wiped, and the mourners are welcomed back into the circle of life.

You don't have to believe Mitákuye Oyás'iŋ to feel the power of a community who does: I did.

In Lakota tradition, the ancestors are always with us. In my Anglican tradition, we are the quick on one side and the dead on the other. Nothing about how to have an ancestor, let alone lots of them. Nothing about how to grieve the dead into an exalted place in our hearts, spirits upheld. In my old Book of Common Prayer—inherited from my drunk English identical twin grandmother, poor thing, her handwriting already displaying the propensity for tremens all the way back in 1917 when she was just seven—there is an Order for the Visitation of the Sick and then, on the next

page, an Order for the Burial of the Dead. There is nothing about an Order for the Period of Mourning though.

Therefore, in my tradition the grieving period for a child is indefinite. I'd panicked, imagining this grief forever. No way out because there was no way in. The poverty of my Episcopalian tradition around mourning and grief filled me with hopelessness. In time, hopelessness begat anger and anger—for reasons of convenience, I now see—landed not on the archbishop of Canterbury, to whom I might have at least written a letter expressing my disappointment in the church, but on Old Ostrich Knees. They warn you about the anger stage of grief; everyone does. But they don't tell you your anger will be an indiscriminate rage in search of any old reason, any old target.

"You'll never get over it," Old Ostrich Knees had said to me, just a few weeks after Fi'd died. "I know it's not what anyone wants to hear, and it's hard for me to say this," she'd carried on easily, "but I figured you can handle the truth." My spirits had sagged, but my inner stenographer had sat up and taken notes, filing them under *response pending*. Now, I had a recurring fantasy: a long, boring dinner party—I hate dinner parties, even in fantasy—in which Old Ostrich Knees is trapped next to me so I can tell her exactly what I think of her. Starting with the hors d'oeuvre, entrée, dessert—I'd order lemon meringue pie and decaf—and keep her trapped until I'd unloaded all my griefs and grievances.

Boom!

Whatever you're thinking about the most: *that* is your higher power. I'd once heard that said on one of my many recovery podcasts to which I am productively, if unevenly, addicted, and it had stuck with me: an elegant, undeniable truth. By this sobering definition, Old Ostrich Knees *was* my higher power. I thought about her nonstop; more accurately she was one of my lower powers, a drag, a deadweight that I hauled around with me all day, on my walks, while tending my perfect daughters, while cooking and cleaning and meditating, while resting my head on my pillow at night, while grieving my dead son. Rehashing this scenario and that, how dare she, how could she, who would have said as she had said?

"A book," Franz Kafka said, "must be an axe to the frozen sea inside us." I am, therefore, an axe-grinder, sharpening any edge that gets close to me. Historically, I bring my fights into the open. I prefer plenty of light. I welcome spectators and umpires and observers. I tossed and turned imagining the scenario in which this fight might be instigated. I'd be so ready; she'd better be on her toes. But ruminate as I might, there was nothing to bring to Old Ostrich Knees; I had no real quarrel with her. I was a shadow, swiping at vapors. Still, I awoke with inexplicable unresolved hatred crouching on my chest, cylindrical, escalating, looking for ways to attach blame to her for my terrible feelings of painful anger.

Anger because everything about my spiritual life, until now, was proving to be susceptible to fakery and quackery

and questions. Anger because no one else would transmute my suffering; it was mine, alone, all mine. Anger, because, if nothing else, a child in the ground will show you exactly where you are and who—the strength of your faith, the depth of your traditions, the caliber of your resilience, the support of your family, the truth of your God, the nature of your thinking—and I'd been found wanting, disordered, ill prepared. Anger because I was beginning to believe Old Ostrich Knees had been right; I'd never get over this. And also, she'd been wrong; she should never have told me I could handle knowing such a terrible thing. I couldn't. I can't. I don't want to. I won't.

Anger, growing, growing: cumulus clouds.

Then, thunder, lightning, very, very frightening.

Tears, raging, crying, lamenting, heartache, accusing, blaming, shaming. That's how these cycles of grief build and build. In time, peppermint oil, a hot bath, tea—like a migraine or a terrible bout of food poisoning—the storm passes. Then, shakily, wearily, insanity subsides; a kind of banal ache, a welcome relief, takes its place. And now, a moment to breathe. And in that breath, you can see, I can see: all hatred is self-hatred. It isn't well-intended Old Ostrich Knees with her borrowed spiritual traditions that I hate at all. It's myself, my own spiritual inadequacies, my own little Buddha statues, my Mexican Milagros, my half-baked n'anga rituals, my spiritually dry little Book of Common Prayer.

Intense, well-intended, interfering me: I am those things that I hate.

Blame, that's the pivot point in any cycle of grief, one of them.

That'll set you right back to where you once were; blame is the *for* in "forever."

Except one day, out of the seeming blue, my body interceded, and I had to stop the mind games. One moment, I was bent over my grief—utterly engrossed by it—sorting through my warries and stories, the next I was suddenly involuntarily stuck like a cocktail shrimp on a toothpick, sharp pains down the leg, up the neck, along the arms. I had to implore people—Till, of course, but others, too—to drive me around, bring me food, wash my hair.

Imaging showed discs squeezed out between a couple of vertebrae, also, scoliosis, some bone on bone, and my pelvis had tipped, like a swing that's been tied up for the winter. There was more; there is more. My backbone had been quietly accumulating its own stories and warries for decades while I had been ignoring it, mostly, but I am never more bored than when people tell me their medical histories, especially at dinner parties. I yawn and circle a wineglass with a wet finger. Who honestly cares. I wished now I'd paid more attention, taken notes even. I wish I'd jotted down the names of surgeons, preferred nurses, best hospitals.

Fi

I did the Western medical rounds. I came, I saw, I hobbled away in panic, my father's warnings about doctors and hospitals ringing in my head. Also, I am not that late middle-aged woman with a cane in the waiting room, so thin, carrying her spine on her shoulder like a spare cushion. Caught out by myself in the mirror, the way sometimes you see a photograph of yourself, I did, and thought, *Oh wow, okay, that's what I look like now.* Steroids and steroid packs and ablations and insertions and an ambulatory pain pump. Also, pharmaceuticals, a shelfful. I eschewed it all; I turned inward and fell silent. *Help me,* I told Fi in desperate prayer. *If you relieve me of this pain, I will read Eckhart Tolle's* The Power of Now, *all of it, no skipping parts, no giving up.*

"Grief," I type into the search bar, PTSD, help, spine pain, healing, therapy.

In this way, I find someone in Taos, New Mexico, who is not the first naturopath or bodyworker I call, nor the first person I see, but by the time I've been driven to Taos—the glassblower does the driving; our subsequent attempt to get back together is a spectacular failure—Tiffany Jama is my last option. Mostly, the pain has beaten me; it's almost a relief, how very beaten I am. "Either you have to fix me, or I'll have to die here," I tell Tiffany. She slips a clean apron over her head—a Frida Kahlo print, I note—and ties it in back. "Worse than childbirth," I pant. "Oh fuck. Jesus, fuck." I lurch toward her massage table and land in her arms. It

takes both the glassblower and Tiffany to heft me up onto her table; pain rips through me, and I scream as if being quartered.

"Hmmm," Tiffany says. She's like a tree. She's even tree-shaped: rooted, powerful slim trunk, a crown of dark curls. There's Ojibwe on her mother's side, I found out much later. You can see it in her cheekbones, also in the way she keeps going back to what's sustainable in a body, what's whole, wholesome, a whole world broken, and in need of skillful ways, care, repair. She also encourages the participation of the healee, of me. I'm not just supposed to lie there helplessly. "Okay, let's see now," Tiffany says. "Oh! I see. I see. Ah, I see." Like that she assesses, as if she's reading a scan, but instead of staring at a screen or an X-ray, she's staring at me, into me, through me. "Well okay, that makes sense," she says.

Then, at least in my memory, she rolls up her sleeves, but maybe not. She's not here to mess around though, or to chit-chat, or to listen to me tell stories about what has actually happened to my back and what I think has happened to my back, the symbolic blah blah of it all. Me neither, for once. I can't talk; I can't really even breathe comfortably. I don't need her to know how witty I am. I don't need to impress her with my dexterous conversation. I don't even need to know why I am kinked up like this. I can offer no defense, no offense, no kidding; I just want help getting out of my

body, out of this pain, this all-controlling abstraction. "Oh God. Fuck. Jesus. Help."

Like that, I blaspheme and I beg.

"Hmmm," Tiffany says, looking at the way I squirm and curl on her table, like a fortune teller fish. "Is it tender right here?" she says—it's not really a question—pressing her fingers gingerly into the concrete column of my right psoas. I howl. "And how about right here?" Tiffany says. Patiently, persistently, she presses, finding where I've twisted myself around my own spine, a strangler fig of sinew, all the years of reinforcing old patterns, old beliefs, old injuries. And patiently, persistently, Tiffany releases the bottlenecks of bone and muscle and tissue with the tips of her fingers or the palms of her hand, then with her elbows, her knees if she has to, sometimes a knee *and* an elbow.

"Let go," she reminds me. "See if you can let go."

I've returned to Tiffany often since that first visit, driving mostly, slowly, with and without the help of friends, down the Rocky Mountains, hundreds of hours of healing. This spine is a dynamic thing, a weathercock. Years into it, I find out that she got her start as a myofascial release therapist long before she knew those words—or most words—working the war out of her father's body, a Vietnam veteran. She's been soothing and smoothing and healing bodies since she could toddle. "Stand on my back, Tiff," her father would say, her little feet walking up and down a spine all locked up with

unfinished shock. She could feel the healing happening—her father's dis-ease easing—under the soles of her feet. We all shove our pain somewhere we think we can deal with it later. Hopefully never.

Tiffany heals with her eyes closed, as if remembering.

From time to time, however, she steps back from the massage table, opens her eyes, and looks at the body in front of her, then puts her finger right on something crushed, compressed, concussed. Is it tender right here? What about here? Ah, okay, so then, here . . . There's no hiding from her. It's all in there, the story of my life. Sometimes, if you were to look in on a session, it's just an hour of Tiffany gently allowing the tissue more spaciousness, fluids washing up and down my spine. Sometimes what comes up for healing is impressive, dramatic. I roar and involuntarily ping right off her table, levitate, or slide off headfirst. It feels like a therapeutic flashback, a controlled explosion. "Just let what happens happen," Tiffany reminds me, clearing furniture, making space. Also, she reminds me, "Breathe and let go."

"Oh my God, that fucking hurts," I say. "Fuck. Ow! Ouch!"

Tiffany says, "See if you can be more specific about the sensation you're calling pain." The mot juste, it turns out, matters as much here as it does everywhere. In the beginning was the word, and the word was God. It's that holy. Is it tingling, numb, sharp, old, sticky, emotional, hiding,

personal, inherited? Once I get the hang of it—months, it takes, hundreds of hours of bodywork—I can mot juste my way around like the verbal equivalent of one of those charts you see at a decent old-fashioned butcher's: shoulder, loin, belly, leg, neck. For example, I can feel where I store all my F-words: my fight, flight, and freeze, all in that right quad. Plus Fi, I've stored so much of my panic and anguish and agony about him in there, too.

Parts come apart.

Slowly but surely.

Parts came apart and then together.

Until I started working with Tiffany, I'd always acted as if—believed as if—I'm not a whole but rather bits and pieces. As if only a part of me had been there when Olivia'd drowned, and only a part of me'd had ringside seats to a small Southern African war, and a part of me was feeling always homesick for Zimbabwe, and a part of me is a mother, and a part of me misses a mother. But of course, all of me had played into all the ways I'd hurt and learned and loved and worked. And all that time, the congenitally curved, horse-damaged spine—like a vine, throwing out tendrils—had attached to bladder, bowels, uterus.

Tiffany calmly ignores my howling and goes into the hips, the pelvic floor, the jaw; everything is connected. Like that song we sang in school, the thigh bone really is connected to the hip bone, and from there to the backbone and from there to all the unfelt feelings, the unexpressed fears, the

unspeakable and unspoken truths. As the recipient of the work, I'd have said it's surgery of both body and of being. But it's surgery via someone's elbow, knee, or thumb, so very slow. Sometimes, Tiffany will be digging into a tender spot and I'll get the unmistakable scent of blood or of rain or of red dust, like those long roads of my childhood, as if clay from my oldest being is being re-formed.

"We don't need a miracle, just a millimeter," Tiffany says.

It's mine to unravel, mine to untwist, mine to surrender.

Mine, this undoing a lifetime of bracing and exuberance and speed and trauma and fight and flight and fixing twisted through my spine, crooking my hips. This rebirth is not a metaphor. Also, like labor, it's a painful necessity if I'm not to stagnate forever, to die in this child death. And Tiffany can only assist; no one can heal for you. But it's a lot in there, I'm finding, layers of skin to shed, lots of flesh to overhaul, piles of old bones to grind, not just losing Fi but the pain of losing Fi attached to every other pain in the universe, mine, not mine, microscopic and immense. I drink gallons of herbal tea, more gallons of water. A lifetime of cells, old daughter cells, like old drunks—passing down the warries and stories of myself to myself, stale with retelling—out they flush.

Born again, each new daughter cell, into a freshly replenished space.

Alone, in the condo, after treatment, easing my spine over balls and rollers the way Tiffany has shown me, I put

my mind not just into the pain but, as she's suggested, into the spaces around the pain. "If we got rid of all the empty space inside our bodies, we'd each be able to fit into a particle of dust," Fi 'd once told us. Be like the presenters at BBC's Radio 4 when you're at a meal, I'd told the kids: educate, entertain, inform. I'd offered prizes for especially interesting, lively conversation, extra points if the conversation was so dazzling or witty or incisive that someone had to be patted on the back. "And that's because our bodies are 99.999 percent space," he'd continued. "We're mostly not here."

I'm 99.999 percent space I told myself now.

I'm mostly not here.

My ex-mother-in-law used to say you can get accustomed to anything, given time. If I could turn back time, I'd spend more time listening to her, the most self-contained woman I've ever known, heroically uncomplaining. She lost a baby herself, a daughter, back in the 1950s. Now, I can't ask her how she'd survived that loss. Bridges burned, also she's over ninety now. But she'd told me once—and it stuck with me obviously—she'd taken refuge in the basement after her baby Cathy died: ironing, laundering, smoking. "Cigarettes were my best friend," she'd said.

She laughed so easily, took herself so lightly, my ex-mother-in-law. I'm sure she still does.

Too late, I'm in awe.

Other than smoking in the basement, how did she keep going—three young boys, a daughter dead, a baby on the way, her whole universe ended, her Philadelphia Main Line family the emotional equivalent of the martinis they preferred, icy and dry, never shaken nor stirred? She'd held it together though, seamlessly, generations of backbone and tongue biting, I imagine. She took her surviving children horseback riding and rafting and skiing; she did the church flowers. She grieved her dead child in a way that had been comfortable for everyone else. Somehow, it hadn't killed her. She was always so elegant and athletic. A smoker's cough is all, sometimes I'd walk in on her holding herself up over the kitchen sink, gasping.

I'd pretend to not notice.

She'd pretend to not notice me not noticing.

In some ways, I could see the value in all the not noticing— but not *enough* value.

In Chinese medicine, lungs are associated with grief. I know this because of Megan. She's always interrupting my stories to say things like, "Oh, ah-ha, lungs are associated with grief in traditional Chinese medicine, just so you know. Carry on." Anger with the liver, fear with the kidneys, worry with the spleen, joy with the heart. Where would we ever find joy? How could I find joy for my daughters? There's no way they're getting over this either; they'll never laugh again. It didn't matter how much time passed or how much grieving we did, there'd be more.

Fi

Tear out our hearts and search each chamber for joy; you'll find none.

"Darling, oh my darling, no, no, no." This was Embeth, of course, always right there, fairy godmothering me out of the mental ditches I kept putting myself in. Also, her clipped South African tones, so final, so authoritative: very hard to argue with. "No darling, no. The girls will laugh again, I promise. You too. But right now, oh. Right now . . . Oh, my darling Bobo, you all need the ocean. It'll bring you back to life." It had brought her back to life, she said, after the cancer. Her living death, her dying life, saying goodbye, goodbye to everything she had loved and that had loved her back. "You must take our cottage on the island for as long as you need, all of you. Please, Bobo. Please."

The way a seed husk needs to be rubbed by damp soil to excite the germ of life, Embeth said, that's what the girls and I needed. Something about the salt water and the perfect temperature and the tides, she said. After her surgeries and chemotherapy, so tiny in her wheelchair, poisoned, bald, hacked to pieces, she'd taken herself off to her seaside cottage on one of Hawaii's islands and stayed there weeks, months, unbending, healing. "It's amniotic," she said, inside the ocean—and out. The humidity, the warm rain, the fertile, red mud. "It brought me back from the literal dead. I swear, Bobo. I promise you, darling."

Till started to yelp, "Ohmygod, ohmygod. I've always wanted to go to Hawaii."

"Till!" I said. "Shhhh." Then into the phone, "Till's here. She says hi."

"Till must go, too," Embeth said. "Would that be helpful? Whatever you need."

"Yes!" Till shouted. "Yes, yes, yes!"

You could hear the surf from the bedrooms, Embeth was saying, the tide washing in and out; it lulled. Plus, she was saying, she'd stock the pantry for us: milk, eggs, tea, the basics, farmers' market lychees, pineapples, rice, fresh seafood, what else did I like, what would the girls like, what did Till eat? "Take the car," Embeth said. "Use the paddleboards, drag the deckchairs down to the beach." Till was online, booking air tickets with my credit card before we'd even hung up. "One day, you will all laugh again," Embeth said. "I promise one day, you will. But the sea will take care of you until then. The place is yours for as long as you need. Heal, heal, heal."

We hung up.

Till was leapfrogging up and down the carpet, sprinkling the contents of my wallet: health insurance card, library card, museum membership, bagel bucks. "We can fly through Salt Lake City to Los Angeles, then Los Angeles, Lihue. Ohmygod, please can I come. Say yes, Ali!" As a toddler, Till had told me, she'd had to be restrained with a harness. Her mother had despaired, especially in shops, airports, and amusement parks. "Bring me," Till said, boing, boing.

Fi

"Please, bring me. Please, please, please. Bring me, bring me, bring me. Bring me, pleeeeease, bring me."

"No," I said. "Just me and the girls."

"But," Till argued, "I can drive and shop and help you in the shallow end."

"No," I said. "No. Good God, please no."

"And riptides, they're so common. I'll be the girls' lifeguard," she said.

"Oh God," I said. "Okay. You can come."

"Sweet!" Till danced around the loft. "Aloha, mahalo." The next morning, she went into her storage locker and dug out a bikini she'd last worn in college in her early twenties, back when she'd fronted for a band: vocals, lead guitarist, cocaine, pills, booze. "I mean this in the least romantic way possible," she said. The elastic around the edges of her bikini had frilled and frayed; she sashayed up and down the loft. Two and a half steps, turn, two and a half steps, turn. "You need me, Ali. Someone has to take care of you, keep an eye on the girls. You're an accident waiting to happen."

"I know," I said.

Packing though, busy hands, making a list, already there was the sensation I was regaining a germ of lost hope, which is to say, the anticipation of being in a fresh place. New eyes, new ears, new tastes, the old is so very old suddenly. So, I'd tell grieving parents if they can—in a perfect world, generous friends, bereavement leave, decent daycare, a living

wage—within three or four months, plan to get away. Go somewhere people don't know you. Go somewhere people won't look the other way to avoid seeing your stricken face, where people won't cry at you, where people won't say things at you about your dead child.

Go there.

Get away from the epicenter of your pain. Go where your grief Geiger counter doesn't start clicking and purring every time you round the corner. Of course, wherever you go, your grief will go with you, the way a toddler must or an elderly dog. So, pack up its sunhat, its beach toys, its incontinence pills and take it with you. Because, it turns out, even grief—that most tireless and timeless and persistent of all our teachers—needs a vacation from time to time.

GRIEF TAKES
A BEACH VACATION

i

THE WHOLE WAY to Hawaii from the Northern Rockies, the girls read their books, held hands; they kept offering each other their snacks, I noticed, treats, as if cajoling one another along one pretzel, one peanut at a time. I tried to not think about the fact that Fi had never flown over the Pacific. I'd so much rather him instead of me, out to these iconic islands. Long after the deal had been sealed—Fi's body incinerated. Take me, instead.

Take me, return him to flesh.

I'd told my children over and over, "You are an eternal mini tribe of three, and nothing—not my death, not Daddy's, not the end of the world—can change that." And they'd trusted me and had thrown themselves into their sibling contracts wholeheartedly: handmade cards, secret languages, inside jokes. They'd taken it in turns putting their foreheads together: "I'm thinking of a number, what is it?" "I have an image in my head of either a castle, a tree, or a tiger, which one?" But I hadn't calculated into the formula the death of

one of my children, and now they'd never trust anything I told them again.

"He's our ancestor now," I told them. "He's everywhere now."

Our young ancestor: feel him in the wind and the sun and the trees, feel him there. He speaks through hummingbirds and eagles and butterflies. But I hardly believed it myself. How could I when only three months and nine days earlier, I'd have bet the whole world on my living, breathing son? Still, I didn't—if I gave it too much thought—believe in human flight, and here we were doing it, a bunch of physically unremarkable humans, effortlessly suspended over the Pacific Ocean in a great, unflapping tube of fossil-fueled metal.

We landed late, rented a ride from the airport, settled into the cottage.

Embeth had seen to it somehow from the distance of thousands of miles not only a fully stocked pantry but also vases of fresh flowers in our bedrooms, bowls of fruit in the kitchen, baskets of snacks, the beds made up with fluffy linens, a ready-made meal in the fridge, our favorite teas. We took a sunset walk, the surf hissed at our feet, we took off our shoes, toes in sand, ankles in water. Cecily did one handstand on the beach, then another, and then a cartwheel, two. Fi had died right in the middle of that stage: Cecily on her hands, Cecily on her head. He'd died and Cecily had

stopped eyeing all carpets and patches of grass and sand for a landing spot.

"That's the first time since . . ." Sarah said.

"Look!" Cecily shouted. "Momma, Sarah, look!"

Long legs, a sheet of blond hair, long legs, a sheet of blond hair: flip-flop, flip-flop.

The sun sank into the sea. Till reached for her camera—*snap-snap-snap*—and for a moment, a thrum of normalcy settled in my chest. These landmark moments, these holidays, these pictures of Cecily, growing, growing up—cartwheels on a beach—they'd become less bitter over time, sweeter. In fact, that photo is in a silver frame by my bed now. From what I can see, it's all ease and joy and light. It's as if her brother had Ceci by the ankles, lifting her across the pale gray sand. A baby-soft pink sky. A new happy memory. A miracle.

All miracles, *snap-snap-snap*: Till caught all of us midflight.

But up must come down, in must go out, day must turn night. Even fun depends on fun coming to an end. I tried to grasp these things out of my mind and put them into my body. That's a mind in pain, looking everywhere for a loophole, asking questions of everything. Demanding answers all the time. A sunset on a beach was not just a sunset on a beach. It couldn't be: Fi had died, and now a sunset had to mean something. The sunset had to mean something, the sea had to mean something, the sand had to mean something.

You can wear out yourself—and everyone else. I reminded myself, kept reminding myself, this one little death was not my whole community being murdered or threatened with murder. It wasn't my whole world ended, not really. Then is not now. Facts, not feelings. So, okay. You try to talk yourself through like this; I did. Breathe. Transcend. Enlighten. This grief wasn't a yoga retreat though, nor a primal healing workshop, alternate nostril breathing. This was the test of a lifetime. Grieve well and constructively and fast, but also do not bypass any bits. Therefore, in all things, grief.

Or let me say this: to begin with, in all things, grief, even on vacation.

Then, in time, in all things, grief *and* praise: Sarah and I had started to talk about the need for grief and praise to coexist. I'm not sure where this idea came from. Sarah may have read something; for the first month after Fi died, she scoured the internet for ways out of our pain. But for both of us, for most of the time, these words were just words, sometimes of encouragement, often of solidarity, but they were not ways. This was the way, for us, for now; until the way changed again, then there'd be another way until at last we would realize that we either *were* the way, or we were in the way. There is no other way.

The next morning, a little pale and unsteady from the travel, we took baskets down to the beach and set ourselves up like English tourists, towels, sandwiches, books, umbrellas,

cushions, buckets, spades. By evening—the sea, the sun, the rain—sandy, burned, soaked, we had exchanged our pale unsteadiness for pink exhaustion. We collapsed on Embeth's sofas, covered ourselves in her soft throws, ate supper on our laps, watched gentle British television starring understated people in beige overcoats.

Days melted into each other the way they do in the tropics. The girls' appetites for food returned. Our fourth or fifth day on the island, a hamper arrived from the mainland, a gift from Embeth, filled with the treats of my childhood. Or, rather, filled with the treats from the books of my childhood: like we were having tea at the vicarage in an English detective story, or as if we were Enid Blyton's Famous Five out on the moors again, glutting on fruitcake, scotch eggs, sausage pie.

"Darling Bo," Embeth had written in thick blue ink on creamy linen stationery. "Treats for you, and the girls, with all my love. Please overeat, honestly my darling, you must gorge, stuff yourself to the gills. I'll send more if you get through this lot. Or anything you like—anything you feel like at all—I can have it shipped to you overnight. I promise, nothing would make me happier than if you gained five pounds an hour. The almonds are my favorite, I'm addicted to the toffee, the fruit cake is divine. Smother everything in butter. Please put on some weight. I love you, Em."

A whole family in one body, Embeth manages to encompass sister, mother, aunts, great-aunts, extended everyone,

the family I am missing. Embeth is my ideal family in a familial vein, the extravagances, I mean, of another generation, of another time, unleashed on me now when I most need it. My English grandmother—the drunk one, dead before I was born—had been famous for her picnics, her sumptuous hamper baskets. When not able to get to Piccadilly herself, she had Fortnum & Mason send the necessary victuals—foie gras, potted lobster—to her cottage in Blair Atholl, Scotland. That's the family lore, hard to unstick fact from fiction.

This was during the London Blitz when she'd been evacuated up north with my toddler father, my infant uncle, a nanny, a cook, the groom; also, the pony, a horse, two dogs, six chickens, and the wine cellar. They'd had to drink gin for breakfast, no orange juice. Rations, obviously, Nazis. "What a long war this is." My grandmother would look around, nothing to do but ignore the baby, darn socks, and make parcels for the troops and POWs. No fires until December, coal by coal. "So boring. Let's have a picnic at the loch if we're going to freeze to death anyway. We can look for falcons." And the nanny, Noo, in her crisp, starched linens packing the hamper, the groom bringing around the car; petrol had been very hard to find so the roads were nice and empty, what a gas.

I could get lost there sometimes if I was lucky. On sleepless nights, when the grief had worn me down, I could pretend I was my lovely drunk English grandmother up in

Scotland during the war having picnics in November on Loch Tay. Flat out on her back on a tartan rug in head-to-toe Burberry, staring up at the drizzling sky and saying, occasionally, "Ooh, woosh, look. I saw one. Is that one? Is that a peregrine, do you think?" While all around the world mayhem reigned, and her baby cooed at the nanny and her toddler son ran around with nets and rods and wrist catapults. My grandmother never got over the freedom of those days, picnics and birdwatching; also dead by the time she was fifty-five, throat cancer, all those cigarettes washed down by all that gin.

All the ease in the world, I'm saying, it doesn't always make it any easier. My grandmother'd had money and breeding and whatever luxuries had been available at the time, at any price. She'd had two sons, a chilly but dutiful career navy husband, titled in-laws with a massive estate in Yorkshire, hunting, shooting, fishing, fancy balls, and still a catastrophic drinking problem. Even ease takes discipline is the point; you have to participate in your own life, survive enthusiastically whatever happens, or you'll never rise again. Discipline is borrowed backbone: I'd have been sunk, drunk, gone under without it.

Discipline is the only gift you can give your future self. *Six months from now,* I told myself morning after morning, *future-me will thank present-me for getting out of bed now, right now.* Therefore, I awoke in the dark and wrote till after dawn, three hours. Then meditation, breakfast, down to the beach.

Umbrellas blowing up and down, me, paddling in tidal pools, beachcombing, reading while Till and the girls swam and surfed and shrieked. In the afternoons, I wrote again, another three hours. In the evening, we prepared sunset picnics and played board games and read love poems aloud to each other.

"And if you love"—St. John of the Cross—"if you really love, our guns will wilt."

Then early to bed, early to rise: all over again.

"Are you trying to heal us or kill us?" Till asked. She showed me her sand flea bites and her sunburn. "I can't believe you're making me sleep downstairs on the porch. No one else has to sleep outside. Look at my spots." I looked. Till's porcelain skin had turned into pale pink sandpaper, like what you might imagine would happen to a lizard in a microwave, I told her, or maybe a gecko, but anyway, nothing aloe vera wouldn't solve. "And my rashes," she said.

"You'll be fine," I said.

Till shook her head. "I have *heatstroke*," she wailed. "Why can't I sleep up here, with you?"

"Because I don't want you to," I said. "There's calamine lotion in my sponge bag."

The girls and I rarely need calamine lotion; but still, I go everywhere with it, out of habit, for Fi, the most prickly heat prone of our children. I heard Till in the bathroom rifling through my things; she emerged with a chalky-pink mask covering her salmon-pink skin, the same bottle he'd last touched. I couldn't bear to think when that had been.

"I hope you're happy," Till said. "Well, you look happy," Till said. "Okay," she said. "I'm leaving now." She flounced off. It sounded as if she were kicking her head down the stairs in front of her. "Happy?" she sang back up to me.

I wasn't happy. I was grieving.

I was bereft beyond words, but I also had calamine lotion for anyone who might need it. I wrote six hours a day. I ate regular meals—or tried to. I talked to my friends on the phone. I meditated and sunbathed and prayed, and I bossed everyone about. I set the schedules for mealtimes and bedtimes and who should bathe first and who should bathe last and who should wash their hair. "I know I seem as if I'm doing well enough. That's the goal," I told Till. But inside, not so deep down, I despaired; I despaired that we'd ever feel really okay. "I'm dying inside. This is so hard, so all-consuming, so all I can do. You don't see it."

"I *do* see it," Till said, but Till didn't know me well enough to know where to look.

Meantime, we resembled an ordinarily unhappy middle-class family on vacation, quite modern, two mothers, one old and one young: Portia and Ellen. Our eyes a bit puffy, our default expressions a bit wounded, as if we'd all drunk too much and had subsequently argued until the small hours about things we'd never have had time to fight about on the mainland. Our tenderness and watchfulness of each other, though, that was something we had in common with families with small babies, babies either eating sand or charging

toward the waves. "Where's the baby?" That terrible moment when everyone within hearing freezes and slowly looks around, where is the baby?

Where *is* that damn baby?

Oh my God, where's the baby?!

Phew, *there's* the baby. Suddenly we're all smiling at each other, fucking little baby.

And then, the girls laughed.

I marked the date: October 20, 2018. Three months and a dozen days after their brother had upped and gone away in such a confusing, difficult, seemingly final way—loud, uproarious laughter. As if the sea and the sand and the sunsets and the extravagant Embeth nourishment and the long walks on the beach had undone a curse. From my room above their room, I heard first Sarah then Cecily laugh. A loud, unmistakable volley of delighted hilarity—volleys and volleys, like laughter had been trapped inside them these last terrible months and had simply needed a good enough excuse to come bursting out.

I guessed Ceci had said something funny; she had. Sarah can also remember the moment, but she can't now remember what the comment was that set her off. She said she remembered feeling relieved, too, that Ceci was laughing. I know I texted Embeth right away: "You've done it. We've done it. They've done it. I just heard the girls BELLY laugh from downstairs. Thank you. I love you." I couldn't stop

laugh-crying myself. The girls had laughed again—really laughed. I sent Embeth all the emojis: Cartwheel emoji, rainbow emoji, unicorn emoji, laugh-crying emoji. Healing and also growth.

Growth away from him and what he'd have said and done and given and been, in any situation. And growth toward what we'd say and do and give and be without him. But no growth is easy. The first laugh—that first miraculous laugh—it was a reprieve and a step but also a shock of something like betrayal. As if we'd acknowledged in some terrible way that we could live without him. We could laugh without him. So, too, the puppy Fi wouldn't have a hand in choosing. On our way back from Hawaii, giddy with sun and rest and chock-full of Embeth's food and nurture, my book nearly written, I'd finally conceded; the last of the Corgis had died the year my father'd died, the same year we'd put old Ghost down, the children's sweet, generous, solicitous pony.

"A puppy? Really?" Cecily said. "At last. Oh my goodness. Oh my gosh. Um, let me look."

Cecily logged on to Petfinder.com there and then, in the airport concourse. Or she opened her laptop and refreshed the page she'd been refreshing all week. "Ta-da," she said, seconds later. "The. One," she said, turning her computer screen for us to see. "And. Only. There!" The puppy was anxiously presenting a pleasing profile; he had very expressive ears. "Isn't he the most adorbs thing on the whole planet?" Cecily said. She looked beatific, like Piero della Francesca's

Pregnant Madonna, a small reproduction of which Terry had given me for Christmas one year. "Isn't he?" Cecily asked. "What do you think? Momma? Sarah?"

We said, "So cute."

And, "Oh my gosh, that face."

Together, "Those *ears!*"

Then Sarah and I had cried a little on the concourse, not at each other but looking away because crying is contagious and it can also be painful and hard to stop. The same thing had gone through both our minds, though. Fi wasn't there to say what he thought. How would we know without our usual quorum? It had always been me and the kids staring into a pile of puppies. Now, at the adoption center, though, the puppy in question served himself up onto Cecily's lap the way you read about, unprompted, one outsized paw at a time. He curled himself around himself like a snail, lifted one entreating eyebrow at her, and passed out.

"Oh Momma?" Cecily said. "Isn't he divine?"

"Extremely," I said. "But what about this other . . . Maybe you should look at . . . ?"

"No," Cecily was firm. Black-and-white drapery, mostly white—Great Dane, border collie, pointer, those breeds seemed evident—he flowed over our furniture in the condo, lots of loose, silky skin. "His name is Moss," Cecily announced. At night, he slept up against Cecily—the two of them like exhausted travelers, fallen into each other—therefore, in her own bed again for the first time since Fi'd

died. Her hand over his leg, his paw over her arm, face-to-face. All day they had minutes-long staring competitions. "The internet says it increases the puppy's dopamine and oxytocin," Cecily explained. "And mine."

I'd stared into the eyes of my contented babies in such a way.

Nurtured puppies and cherished babies, not yet worried and neurotic, a portal to the source.

Not dispelling the dark so much as guide dogging you through it, the most reliable of lamps.

BECOMING
MOTH

i

WE CAN'T, of course, do everything from beginning to end, alone.

"The essential American soul is hard, isolate, stoic, and a killer." D. H. Lawrence wrote that.

Help me. Those two little words nudge mountains, pivot lives, revolve the world.

Meantime, I kept stepping my way through my monumental grief as quickly as possible, step after step, like a sobering drunk in a hurry. Because even in a spiral, there are still *only* steps either up or down: first this one, then the next, no bypassing. In this way, without warning, it just arose one day, out of the blue, six months into our grief, in the coldest depth of the winter: depression. Elisabeth Kübler-Ross's stages of grief and dying have been disputed, discarded, overturned, and updated, but in my experience, they're broadly accurate. And I'd known them all—or I *thought* I'd known them all. But I did not, until six months after Fi died, experience true depression or the terror and aloneness of it, not mine but Sarah's and thereby worse by some incalculable degree.

Sarah's darkest month: January.

Depression fell on her like a lead blanket.

We've talked about it since and about the miracles that then ensued.

About how, so worried about Sarah, I'd wept openly and brokenly in the arms of a friend in the parking lot of the post office—not really even *my* friend. Actually, he was more a friend of the glassblower's, a hunter who then showed up the following day at the condo door with an icebox full of wild meat—antelope, deer, elk—and the phone number of a close friend of his who was on the board of a place, which was how Sarah and I ended up on an all-expenses-paid week at a nonprofit grief sanctuary in New Mexico in early February 2019. We kissed Cecily and puppy Moss goodbye at Charlie's and drove down together from Wyoming in the little car Sarah'd bought with the savings Fi left. He'd worked and saved since he was fourteen; so *Fi* of him, we'd agreed.

From the moment we started driving, there were eagles everywhere, just flapping around like huge chickens. "I guess this is what we're supposed to do," we said. The laughable number of eagles. Me laid out in the back seat with a blanket over my knees and yoga blocks propping up the spine, shouting sightings, "Look, another eagle," like my drunk grandmother spotting falcons. It all seemed very much in the flow of the universe, very supported by a favoring God.

Even when we took a wrong turn and ended up lost, without a GPS or a phone signal in the desert southeast

of Rock Springs, a kindly forest ranger manifested on an ATV and guided us out to the highway, past a herd of wild horses frolicking and tousling like they would if this were a movie featuring Tim McGraw. Also, more golden eagles, plus a light snowstorm, a rainbow, blue sky. "Well, I guess we're doing the right thing," we told each other. You take the exquisite agony of these signs for granted. The magic of the freshly dead in our lives, undeniable when it's happened to you—or is happening to you—but it's never enough. Never enough to assuage the grief or the terrible longing or the desire to be back in the proximity of the dearly departed.

Sarah's deep, hard, seemingly immovable dark was understandable. Her grief was so cellular; she and Fi had been so bonded, so trauma bonded. Sarah and Fi age about eight and eleven, legs in corkscrews around each other watching Bizet's *Carmen*, starring Julia Migenes Johnson and Plácido Domingo. I'd put on the video cassette for them one rainy afternoon and then disappeared into my office to write. It had traumatized Fi, they told me afterward. The graphic bullfighting scene at the opening of Rosi's production'd proved to be too much, especially so soon after falling in love with *The Story of Ferdinand*. That, and the repeat showings of other babysitting videos I'd bought for them at Teton County Library discard sales: *Antonia's Line*; *The Adventures of Priscilla, Queen of the Desert*; and the *Reduced Shakespeare Company's Complete Works of Shakespeare (abridged)*.

"Cut the crap, Hamlet! My biological clock is ticking and I want babies NOW!"

That had taken some explaining when I'd drifted back into the bedroom to check on them eventually, always distracted by my work, always distracted by the unhappy marriage, always distracted by my own agenda. It hadn't always been easy, Sarah needed to let me know now; it was coming up for her in this grief, the mother wound and other wounds. I knew what she meant. Grief isn't neat; it doesn't cordon itself off. Grief is messy, and it's sans frontiers. Sarah told me the marriage, the long cold war between me and Charlie, the unsaid, the said, the fights, the times I left—or tried to leave—only to come back again, and again; those things had wounded the whole family. And Sarah, the eldest, taking the hardest hits, being parentified by us both. Also, her grief now, Fi forever gone, the one who understood best what it had meant to be raised by us, Ceci protected by stage and age.

It's well-appointed, the Golden Willow Retreat, expansive, yet homey, atop a mesa, down a red dirt road. Sarah and I had a spacious room each within an adobe ranch house, tastefully furnished, terra-cotta floor tiles, south-facing windows, thriving geraniums. Each room had an enormous pine bed, a thick wool rug, an armchair, a reading lamp, a desk, a door leading out to a stone patio, and beyond that, benches in a desert garden. We ate brown rice, steamed vegetables, lentils, beans, fresh fruit, salads, granola, flax, nuts. We undertook individual counseling and family counseling. We learned

techniques for self-soothing, self-inquiry, self-repair; we meditated and walked. Sarah journaled.

I didn't journal. I hate journaling.

Instead, I sat out in a basket chair in the cold winter sun and drank fennel and dandelion tea and wrote all three children letter after letter after letter, all the ways I could think I might have hurt them, the myriad ways. My inherited ways; our anti-love culture, except if someone like Frank Sinatra or John Denver has anything to do with it. I wrote until my eyes were raw from crying, burning the letters; that was the whole exercise. Then I wrote a letter to my mother asking her what can separate a parent from a child? Let me count the ways, I wrote in response to myself: work, war, addiction, grief, drama. You start to see. I did, of course. I'm much like my mother, in predictable ways. But unlike my mother and I, Sarah and I trust each other to work it out, and out and out; we're in this for life, so we'll always be working it out.

We did yoga and breath work and Reiki.

And we cried. But at night, we laughed uproariously, inapposite contradictory joy.

Also, we listened to Byron Katie's *Loving What Is: Four Questions That Can Change Your Life.*

New Mexico's one of those places like Switzerland; it's a magnet for people on their last legs. D. H. Lawrence and his wife, Frieda, for example, they'd come here—not to the Golden Willow Retreat in Arroyo Hondo exactly but to a ranch close by—from England, hoping to alleviate the

symptoms of Lawrence's tuberculosis, one of the thousands of so-called lungers who flocked to New Mexico in the 1920s for the dry, clean air, the enchanting light, the promise of healing. "It has snowed," Lawrence wrote in an essay from that time, "and the nearly full moon blazes wolf-like . . ." It didn't cure his TB, but this wild old place liberated him, he said, from the shackles of his domineered, damp, poor childhood.

And it feels true, the high desert of northern New Mexico wheedles its healing into you, ancient and knowing, spines, prickles, needles. And what an astringent antiseptic the wind is: scouring, persistent, impartial. Also, the way the sun and the earth dance together, you can see for yourself how it is, not one or the other but both: shadow, light, shadow, light. The land doesn't hide from it. "I was born . . . where the wind blew free and there was nothing to break the light of the sun. I was born where there were no enclosures," so said Geronimo, the nineteenth-century Apache leader, American Indian holdout, family man, legendary warrior. "We had no churches, no religious organizations, no sabbath day, no holidays, and yet we worshiped," he said.

Geronimo was born in 1829 near the headwaters of the Gila River in northwestern Mexico. He had nine wives and many children, not at the same time. Most of his wives were killed in raids or died in epidemics, most of his children, also. Geronimo lived and fought all over New Mexico and the borderlands south of here. He died in the hospital at Fort Sill, Oklahoma, a prisoner of war, in 1909. A life like

Homer had written it. It is said that after he saw the bodies of his first wife, his first three children, and his mother killed by Mexican troops in their Apache camp outside Janos in 1851, Geronimo did not speak for days. It's estimated he killed thousands of Mexicans in revenge, hundreds of settlers, scalped little girls.

"Sing, o Muse, of the wrath of Achilles," thus begins Homer's *Iliad*.

Epic, no doubt. It's going to take some doing, this repair.

"Are you having fun?" Harry asks. I call him midweek.

"Well, it's a grief sanctuary," I say. "So, it's like that."

"Oh right," Harry says. "What time is it there? Good weather?"

"The idea," I say, reading from my notes, "is to emerge from this process as the essential self, nothing extra, nothing indispensable."

"The essential what?" Harry says. "You're going to have to shout, I'm afraid. I'm on the train up from London."

"The essential self," I shout. "Simple, unpretentious, and whole."

"Well, you've got the 'old' part down," Harry says.

"*Whole*," I shriek. "As in foods, like the grocery store, you wanker."

"Oh," Harry says. "Look, if I lose you, there's a tunnel . . ."

When Harry calls back, I ask if he's heard of Kintsugi, the Zen Buddhist approach to repair, no attempt to disguise the

✶

damage. Instead of discarding a smashed bowl, it is repaired using lacquer inflected with the most precious gold available. Fault lines are not only strengthened but also emphasized, embellished, adorned. "Cait sent me a card about it and I found a book in the grief library here. Isn't that a lovely idea?" I ask. "By the time I am done getting through all this, my heart will be pure gold." There is a long silence. "Have you gone away?" I ask Harry. "Are you still there?"

"No," Harry says. "No, I'm just thinking." Which means he's been looking out the train window at the English countryside whipping past, keeping an eye open for foxes, and paying no attention to me. I launch into one of my lectures. I tell Harry: Life needs grief the way music needs silence and love needs forgiveness. Grief is the glue for our brokenness. Without it, we're fragile and prebroken; we're eggshells. Then I accuse Harry of not listening again; one has to, habitually. "No, no, no. I'm following along, Bobo," Harry says. "Crack on. Crack on. I'm just . . . If I lose you . . . I could have sworn there's a tunnel here somewhere."

At the end of Grief Camp, Sarah and I call it, we make a vow that there's no going back to the ways we were before Fi died, back when we were so unaware, and so unaware of being so unaware. "That would be a waste of the worst thing that's ever happened to us," Sarah says over our final breakfast. I shall miss Grief Camp; I shall miss the luxury of knowing that all I have to do between now and the next meal is grieve. I shall miss the hours of meals and talking

and walking with Sarah. I shall miss getting everything out, said, the intention to heal, to let love back in. "Let's say grace." Sarah and I clink our orange juice glasses together. "Grace," we say.

Sarah returned to her life, to her boyfriend, to her job as an assistant to a partner at a local law firm. She started to train for spring and summer bike races, started to return to herself more fully. Cecily signed up to learn American Sign Language for college credit. She practiced on Moss; "I love you," she signed over and over. "You are a beautiful dog," she told him. Moss signed back with his eyes, full sentences in a single look. Meantime, up against the north-facing wind-protected foothills, the snowbanks rotted and turned the road to rivulets. In the condo, thick ice slid off the roof and piled against the windows letting in only blueish-white igloo light.

My book finally in, deadline met, I found myself spending a whole morning online searching real estate listings, then the whole of the next morning. "It's too small for Moss in the condo, and I can't breathe," I tell Harry. "I need a bolt hole far from the madding crowd." Harry tells me that as an alternative to reading about all my childhood trauma, he is reading a book about the history of the British East India Company. "You what?" I say scrolling. And there it is: four acres, three of those flat, not in a subdivision. Neither suspiciously cheap nor outrageously expensive: forty-three

miles from the condo, thirty-five miles from Yellowstone or, roughly, the distance a wolf can travel in a day, in the foothills of a diminutive western range of the Northern Rockies. Still fluffy with snow. My tiny broken tangle of wild, my homeopathic dose of source love.

The next morning, I drive from the condo to the property to meet with a realtor; from door to door, it takes exactly an hour, not more or less. There's a *Fi*-nesse to that unequivocal sixty minutes; I make note. The property has a disintegrating cow barn, a tattered barbed wire fence, a creek, and an uninterrupted view of the sky. Enormous boulders along the western edge of the meadow rise out of the snow like the sarsens of Stonehenge, anchor-holds. There's a meadow, an aspen forest, and in a young aspen tree on the westernmost edge of the meadow, a nest, made by last summer's robin.

"Yes," I say to the realtor. "Yes, yes, yes, please."

Ravens circle, gossiping, scolding. And, across the creek, over the road, a dairy farm; a small family affair, I can tell. I glimpse the farmer out feeding cows; white-haired, solicitous to his herd, moving very slowly, very quietly among them, like a faith healer, touching, blessing, running his hand along this one's back and along that one's flank. Mormon, I can tell by the order of her garden, the raspberry stakes like soldiers above the snow, bird feeders full, a barn cat sunbathing on a bale of golden barley. They look like the kind of neighbors you'd want to the north of you, in the high country: reliable, reverent, lots of tractors.

"I bought the place on the spot," I tell Harry.

Harry's appalled, "You did what? I hope you haggled a bit."

"Should I have?"

"Oh, Bobo, you're quite mad. Is there even a building parcel? Water? Electricity?"

"Um," I say.

"What worries me," Harry says slowly, cautiously, "well, I have several worries, really."

"Stop being so British," I interrupt him. "Come over in May and help me put up a yurt."

"Ah," Harry says. "Yes, I'm just looking at my calendar now, actually."

ii

IF A PLANT IS DYING, it needs four things; I heard this in a lecture by a naturopath online once.

Water, light, food, love. Also, dark, the naturopath didn't say. We need the dark. If not the dark, the dark and the depths. That's the role of grief. It is like an unwelcome, unplanned archaeological dig or a scuba dive—unguided—to any depths of your choosing. I have no direct experience of the ocean. Even a few minutes in open water—goggles, a snorkel, and flippers—is enough to make me squeal and doggy-paddle for the boat. The ocean depths terrify me for the same reason grief terrifies most of us. But there are riches to be found down there, in only the darkest, least-visited places.

Silence, for me, that's my least-visited place.

I chatter incessantly, mind chatter, radio chatter; silence is a practice, not a permanent state.

Silence calls to me now though, the way the wild had also called, and Tiffany, and the property.

Also, it had been dawning on me, slowly and painfully, that I couldn't simply magic an ancestor into existence for

myself just because I longed for my dead; that kind of thinking is doomed to end in emptiness, more separateness, madness. To have ancestors, to call upon them for guidance and abundance and healing is a serious undertaking. Also, in cultures where ancestors are venerated, there is thanks to be given, there are sacrifices to be made, rituals to be performed, rites of passage, nights of vigil. It's not hopeful, wishful thinking that'll get you an ancestor. It's something else.

Something more like I'd seen on the Pine Ridge Indian Reservation. The Sun Dance, that's an ancestor-thronged ceremony if I've ever heard of one. It's hidden from non-Indian view, partly because Native American spirituality was outlawed until 1975 and partly because of exactly this: me, a culturally orphaned white settler thirsty for the spiritual water that her own people keep trying to poison. THE INDIAN WARS ARE NOT OVER, NO ONE IS ILLEGAL ON STOLEN LAND, MMIW AWARENESS: I saw those T-shirts for sale at the annual Pine Ridge Wacipi but still I was invited to sweat and pray in purification ceremonies. Three inches of my hair accidentally singed off; even the easier aspects of Lakota spirituality are indiscriminate, hard, and holy.

So, March 3, 2019.

The first of Fi's birthdays after his death day.

We only have to do this once, I told the girls. There's only one first birthday. One first everything. How I'd loved the weeks around Fi's birthday. They had portended all things

spring: the return of redwing blackbirds to the willows, *trill, trill, kak, kak.* Also, the retreat of snow, the advance of black mud, tendrils of green along the verges, everything roaring like lions to be born. The girls did not want to mark Fi's birthday together, a birthday party without the birthday boy, the horror of having to celebrate someone no longer there.

We all scrambled to plan our ways out of the valley. Charlie made plans with Cecily; Sarah made plans with her boyfriend. It was in this way that I decided to spend the last part of February, first part of March in a former state mental hospital now converted into a free meditation center in Alberta, Canada: ten days of silence, fourteen hours of meditation a day, no talking, no eye contact, no eating after noon, no phones, no computers, no internet, also no writing, no reading, no singing, no sit-ups, no push-ups, no yoga. I would spend days observing myself acutely for signs that I was ready to emerge from the pupa.

It wasn't my first meditation retreat: Vipassana, very dry, very matter-of-fact. Don't take yourself so seriously you're reminded; just notice you're breathing. Nothing to it. I don't remember suggesting that Till come along; somehow though it was settled. She'd drive the diesel pickup sixteen hundred miles north across an international border in the stormiest part of late winter to not speak for ten days. And also, to just sit: respiration, respiration, this sensation, that sensation. "Are you sure?" Iris had said. "Oh Bobo, really? Ten days in a Canadian ashram, sitting cross-legged? You don't think

Till will go mad, do you? Just give me your coordinates, in case." There was a long pause, then, "And I love you, but this is some cold-adverse Zambian blood in my veins, and if you don't come back, I'm not heading up there until summer. So be prepared to be frozen in a ditch till next June."

By then, we weren't talking again, Till and I.

Maybe there'd been a row, another row. I don't remember now. Perhaps we'd realized we had a better chance at a working relationship if we didn't have much of a talking one. We agreed, therefore, to limit ourselves to three flash cards each for the two-day drive up the spine of the Northern Rockies, across to Canada at Sweetgrass, Montana, then east through Alberta: Okotoks and Drumheller to Youngstown. Say more with less re: the flash cards we agreed. Till's: GAS, BATHROOM BREAK, CAN WE LISTEN TO SOME-THING/ELSE? Mine: NO, a bolder, bigger **NO**, and finally, NO, FERFUCKSAKE, TILL, **NO**.

I'd brought two thermoses of tea and a picnic basket: apples, boiled eggs, nuts, roasted seaweed, dark chocolate, dried fruit, julienned fresh vegetables, biltong, goat cheese. First gas stop, Till added Cheetos, Reese's Peanut Butter Cups, Twix, Snickers. At the border, I had to throw out half of everything I'd brought; uninspected agricultural produce. Till whooped and hollered when we pulled away from the border; Cheetos-orange lips, greasy little crumbs everywhere. God, it was cold, howling; Till's heavy diesel pickup was shoved this way and that along the highway, side to side by

the wind. There were a couple of kids—early twenties, not wearing enough clothes—blown off the road in their little Toyota Camry, bald tires on ice.

"Ah, look at the children," Till said. "Like two little sardines in a tin."

"No," I said.

"Where's the love, Ali? They'll get eaten by polar bears."

"There aren't polar bears in Alberta," I said.

"You're such a know-it-all," Till said. "Anyway, I thought we aren't supposed to be talking."

I turned on the radio, lots of static. Canadian broadcasters are offensively inoffensive: "Mars is a toasty minus 15 centigrade today. Compare that to the minus 20 centigrade that Calgary has been seeing over the past week, not to mention the windchill making it feel closer to minus 40 centigrade, and you may start seeing Matt Damon's plight in *The Martian* as more of a tropical vacation." I stared out the window at the ice-deadened world blowing past us; you can't believe the shades of white, blinding, dizzying. I thought of all those women who'd raised babies out here, before electricity. Why did I think of them hanging up their laundry in this?

I bet their hands had been as raw and red as they would have been if they'd lived on Mars.

I bet they hadn't imagined their descendants in a Toyota Camry.

Blown off the road, how much can change in a few generations. How little.

Fi

✳ ✳ ✳

People—my exes, mostly—complain that I push everything to the edge. They're correct, but it's like complaining about the nature of a cliff. No edge, no cliff. These free meditation centers are not spa retreats. They're run by very strict vegans. At teatime on the first day, they warn you that what you are about to do is very hard, and this is your last chance to not do it. Then they take your car keys, your phone. After that, you vow to keep noble silence. Also, you vow to not kill anyone or have sex with anyone—including yourself—for the next ten days.

I'm immediately looking around. It happens every time: but if I *had* to kill someone, if I *had* to have sex with someone. The rooms are what they are: a bed, a light, a closet, a window. The meditation retreat had not only started out as a mental asylum but it had also had a brief stint as a nursing home. What a prison those lives must have been. A prison within a prison, the white outside blazing such bitter cold that it'd take you down before you could get to the main road. When we walked outside—we were allowed small daily excursions, a tiny figure eight outside the women's block—we had to cover up all bare skin.

Until 6:00 p.m. though, it was like the first night of term at boarding school, the nervous anticipation, figuring out who is who and what's what before the hammer comes down. The thirty or so women meditators gathered in the females'

dining hall helped themselves to food, simple—beans, rice, salad—trying to not bump into one another, smiling up from our plates. Most of the women were Till's age, teachers, nurses, an airline steward. Everyone quickly trying to do the math on one another. One of the nurses—cardiac ICU—flicked her finger between me and Till. "Are you two . . . ?"

"It's a long story," I said.

"Yes," Till said at the same time.

"Oh, no judgment here at all, ay," the cardiac nurse said, both hands up as if to show us, *Look, no guns.* "My second husband's a woman." And after that, we went around the table. What are you here for? And you? The cardiac nurse was here because she'd been waking up in the night, screaming and screaming. The truth is there's no fixing what comes into her care. The person who walks out is not the person who came in or went under. The air steward was here because she'd seen the worst of humanity, and then someone had left their feces on an airplane seat, an angry adult. It had broken her. And you?

Till said, "I'm with Ali here."

"Ali?"

I hesitated. "My son died seven and a half months ago. His birthday is in a week. He'd have been twenty-two. I'm here to observe that and to . . ." My words died. No one said anything after that, and although no one touched me—already observing the no-contact rule as if we'd been born to it—the women's bodies turned in around me, subtly,

Fi

instinctively, as if to fend off any more hurt, as if to protect the place of my tenderest wound, as if to shield and shelter our most vulnerable member. When the gong sounded to signal the beginning of noble silence, therefore, it met us where we were already: women in solidarity, sisters.

4:00 a.m.: Gong.

4:30–6:30 a.m.: Meditate.

6:30–8:00 a.m.: Breakfast, shower, any laundry that can be done in a sink and hung up in a closet.

8:00–11:00 a.m.: Meditate.

11:00 a.m.–Noon: Lunch.

Noon–1:00 p.m.: Rest, walk in tiny circles outside in temperatures colder than on Mars.

1:00–5:00 p.m.: Meditate.

5:00–6:00 p.m.: Tea.

6:00–7:00 p.m.: Weep, quickly, in a bathroom stall or in bed.

7:00–8:15 p.m.: Taped discourse by the late S. N. Goenka.

You become accustomed to the tuneless chanting in Pali. I did; I began to adore it, signaling the end of each hour-long meditation session as it does. On the videos, S. N. Goenka is always accompanied by his wife, E. D. Goenka. She just sits there looking benevolently bored. I'd hate my husband if I were her. "Pure love is just one way-traffic,"

S. N. Goenka says. "You give, you don't expect anything in return. You just give."

E. D. Goenka just gives.

8:15–9:00 p.m.: Meditate.

9:00 p.m.: Bed. The windows rattle all night. I don't sleep.

You learn if you sit for ten days in silence—observing first your respiration and then, head to toe, toe to head, every sensation in the body, down to the finest little wavelets, wavelets of sensation, sensation—that time is only as dense as the thoughts that you push through it. Or no thinking, no time, no time, no aggression. S. N. Goenka also looks plump and cheerful in these discourses, grandfatherly, not at all *Wild, Wild Country*. "When one experiences truth," he says, smiling, smiling, "the madness of finding fault with others disappears."

Meantime, over on the men's side of the meditation hall, there's someone in a tie-dyed undervest groaning as if birthing a cannonball. I can only hope he is. I hate men, I decide suddenly. God, I hate men, their gracelessness, their slowness, their lack of awareness. Men do not menstruate or give birth or worry about pregnancy; therefore, what do they know about being inside a body? The ICU nurse on the other hand, she *is* inside my kind of body. She's my kind of woman. We're supposed to wear clothes that in no way

cling to our form. They'd sent a checklist, loose yoga pants; but her form defies sackcloth.

My heart aches for Fi.

My heart *really* hurts, and my hips will never regain feeling. The ICU nurse has hips that resemble playful ferrets.

Like that: Jesus, only I would be avoiding my pain by thinking about hating men and having sex with a married woman at a silent meditation retreat these precious few days before my dead son's birthday. You learn that about yourself, again, the very basics. Meantime, across the meditation hall from me, in another section of the asylum, I later learned, Till'd been discovering that her sugar addiction was stronger than her need for sleep. Every night dressed in the free blankets they offered for indigent or ill-prepared meditators and for people like Till, she'd broken into the kitchen and wolfed down industrial portions of honey, peanut butter, blueberry granola. She'd chugged a couple of bottles of vanilla extract; by day four, she'd puffed up like a little Victorian heritage chicken.

"You look like hell," I mouthed.

"What?" she mouthed back.

"What have you done to yourself?" Still mouthing.

"I am going to die," Till mouthed but squeaking. "I've got to get out of here."

I mouthed back, "Oh, don't be fucking ridiculous." Except maybe I said it out loud.

Then the meditation teacher wafted over like a small hurricane—tall, blond, unanswerable—and told us to stop talking, and to not make eye contact, and to leave the common area, and to return to the meditation hall, and to our individual cushions, forthwith. I nearly kissed her. I loved the not having to think about how to end a conversation. I loved the having to do as you're told. I loved not having to worry about what to eat or even when to eat or to shower or to do laundry or to sleep. I loved the fact that if I were having a heart attack, I'd just drop wordlessly dead.

I loved being just another body, null and void.

Not to say it didn't hurt.

It hurt; it hurt: to sit for fourteen hours a day and observe, observe, this feeling and that feeling. "The sharp knife"— as the Band Perry sings—"of a short life." It slices and plunges—a life cut short does—depths I'd never have fathomed had not Fi died. And my daughters, their innocence cut short. I agonized for them; to the marrow it went. But a wall of women behind me, a wall in front of me, we sat as one, breathed as one: a wave of women, stillness, strength, fortitude. I could have sat there indefinitely dying—my little imaginary heart attacks, my little imaginary trysts—women all around me, holding me with their breath.

Breath.

Breath.

Breath.

* * *

Fi

Before Fi died, I'd thought in threes—each of my children, in each of my thoughts—all of the time: three plates on the table, three Christmas stockings on the chimney place. I never plant only one tree, always three. For months and months after he died, however, I'd thought mostly only of Fi or of myself in relation to who I'd be without him. Or I'd thought not of Fi but of the pain of losing Fi, which is another way of saying I'd thought only of myself, the girls coming in and out like static on a radio tuned in to something else, also urgent but to which I'd had a hard time listening.

Fi's birthday: 238 days and nights without a son.

On that morning, I awoke before dawn and put my meditation cushion at the end of my bed up close to the window. When the gong went for the morning sit—*click-clack, shuffle-shuffle*, everyone on my floor off to the hall, I'd learned my fellow meditators by gait and by sigh and by smell— I stayed in my room to watch the sun rise. But first, stars blinking out and the sky turning pale yellow, then pink, then indigo blue, all the pastel colors of a baby's nursery. I scraped the shape of a heart with my thumbnail into the ice that had formed on the inside of the window, then his initials: CFR.

Beneath that, his dates: 3.3.97–7.8.18.

At 6:30 a.m. another gong sounded: breakfast, laundry, showering.

Then at a little before 8:00 a.m.—the sun pulsing weakly over the horizon—from my window, overlooking the snowy

little yard, I saw first the ICU nurse, then Till running out the building, down the steps: ice, slip, slide. They ran to the thick blanket of unblemished snow beneath my window, looked up at me, and then abruptly, in sync, fell backward, arms outspread, legs in a V, together, V, together. By the time the female meditation teacher had spun outside after them and ordered the women back into their halls, it was too late: there were two perfect snow angels beneath my window.

In one, Till had written FI; in the other she had written AF, kicking the letters into the snow with the heel of her winter boot. I couldn't hear what else was going on out there—the wind, for one thing, worrying the window panes—but the meditation teacher was hurrying and herding them back inside, and they were two huddled, frozen, jumping figures, steaming blurs. Just before the door closed though, Till turned, the ICU nurse, too, and blew me kisses and kisses. "Thank you," I said into the ensuing silence, just the windows, *rattle, rattle*. "Thank you for coming," I told the pink sky. "Thank you for being," I told the two snow angels.

Going, going.

Gong.

iii

A T BREAKFAST on the tenth day, noble silence ended. In the women's dining hall, chatter erupted like the release of so many birds. Did you see this, feel that, hear the next thing? Can you believe this fucking cold? Did you think you were dying? How much did your heart hurt? Did it? Grief, we decided, our as-yet-unmet grief is what we'd all encountered, like Achilles at the end of the *Iliad* when—after sulking for ninety percent of Homer's epic poem, followed by a killing spree that might be better described as an overkilling spree—he finally breaks down and weeps in the arms of his slaughtered Trojan opponent's father, the end. Best to know your Greek myths and thereby avoid becoming one.

It wasn't Achilles' heel that got him, at least not in the *Iliad*; it was his refusal to break down.

I squeezed the skin over my heart: it was still there, the pain, but less acute.

The ICU cardiac nurse said that grief can stress the muscles of the heart so much it can feel like a heart attack;

it even has a name, broken heart syndrome she said. But it wasn't like I'd die from it or anything. The ICU nurse smiled, her eyes so clear after ten days of this sensation, that sensation, I could die from that, too. I left the asylum with her address in Calgary, a bed for me there anytime. Heart advice, she'd be there for that; her wife would love me, too. Till left the asylum with the name and the contact information of the tall blond meditation teacher, super vegan. "Ingrid's the *best*," Till said. "I think I'm going to become a Buddhist nun."

"No sex," I said.

"No sex," Till agreed breezily.

After ten days of being still, it felt giddying, as it always should, to be racing along on icy roads at sixty miles an hour, warm, a roaring diesel engine and thick rubber tires. Alberta stretched out all around us. Power lines the size of a man's torso, pylons big as dinosaurs, bigger, all the way back to the US border and down into Montana. Canada emptying itself, the States, sucking, sucking. It was hard to imagine people here, bands, tribes—also, bison. There's nothing lonelier than a landscape without its ancestors: "Cry, the beloved country, for the unborn child that is the inheritor of our fear." The South African Alan Paton wrote that, but he sang it for us all.

"Do you think you'll ever have sex again?" Till asked.

"Of course, I will," I said. "Sure. One of these days, maybe. But first I've got to . . ." I looked at Till, thinking

stalled out, as if I were reading road signs through a fog or a blizzard. "But first . . . I think . . ." I started to cry, fat tears, ripe tears. "I think I'm finally just starting to feel my way out of wherever I've been, so I guess not right now. But oh my God, it just feels good to be, to be . . . Just to be." Or, if death is dark, confining, and silent, then the call to light is like trumpets sounding, rams' horns blowing. "Oh God," I said, wiping my cheeks. The worst of the work of this grief—the slog, the mission—was over. "I'm a moth," I said to Till. "Watch, I'll eat holes in all the cashmere sweaters Embeth keeps buying me."

"Jeez," Till said. "Don't do that, Ali."

I looked out the window: power line, pylon, power line, pylon. Sheets and sheets of wind-stirred snow, flurries and tunnels and whales. There was once a time my grief seemed huge, uncrossable, unfriendly, and as if it would kill me. But the truth is, now I can see, my grief is mine, only mine, mine alone. Beyond my skin, no grief: just Alberta. Beautiful, bounteous, boundless Alberta, rich dark soil. Also, moths don't argue the case against their transformation; that's what I've never seen a wild creature do. They just transform, perfectly.

"I think I'm going to be a Buddhist nun, *and* a dog trainer," Till said. "What do you think, Ali?"

I poured us each another cup of tea from the thermos. "Amazing," I said.

"I don't mind being a vegan. I was vegan for years."

At the Del Bonita Canada–US border crossing, no one around: you could see for miles, nothing. It was like Mongolia, I imagine. Actually, it was very similar to a border crossing I'd made once between Chile and Argentina, guanacos all over the place. I started telling Till about it as we slowed down wondering where to park, what to do, no sign of life. That border crossing in Patagonia had also been a lonely little station, barbed wire, vast grasslands as far as the eye could see, distant snowy peaks, an assignment following Patagonian cowboys who were, themselves, following feral bulls.

Forty dogs, twenty horses, nine humans on a mission along sea cliffs, through dense forests, the wind blowing the waterfalls up like pale silk scarves. At one point we'd run out of food; the dogs had started to eat our saddles. The Chilean photographer had teased me for looking like frightened poultry most of the time. "You are actually *chicken*," he had laughed in his adorable Chilean accent; he had been quite correct. Terrified 150 percent of the time, I told Till, and I'd wanted to do it all over again the moment it was over. Till parked next to the little building—beige siding, I think, green metal roof, unremarkable—and we got our passports.

"Hi America, we're home!" Till said, getting out of the pickup. "Yoo-hoo."

I peered through the windscreen, all that space, no sign of life—human or otherwise—for miles. I got out of the pickup, too, stretched, then peered around the building a bit;

there was an empty chain-link kennel. I remember thinking, *Poor dog, I hope he gets a warm bed at night and a good meaty bone.* "Is there even anyone here?" Till asked. "Isn't there supposed to be someone to check our passports or whatever? Do you think we can just pee right here?" Windswept nothingness, rocks, no trees. "It looks like the party already came and went."

"No kidding," I said.

So, we were very surprised by what happened next; the door to the little border post building blew open and a US Homeland Security officer came running out as if he'd just realized his desk was about to blow up. He had terrible skin, I noticed right away. It was hard to look at him and not think: oatmeal, ice packs, tea tree oil. "Get back in your vehicle," he screamed. His skin shone irritably in the merciless high-altitude sun, the scouring wind. "Do you know who I am? Do you know who I am? Do. You. Even. Know. Who. I. Am?"

"Do I?" I said, frowning, edging back toward the pickup. "Should I?"

"No," Till said.

"We don't," I said.

The officer whipped out his Glock 19, snappy cartridge, high muzzle energy, competitive price point. "Get back in the vehicle. Do you know how much trouble you could be in right now?" Till and I shut our doors. "Do you know who I am?" he asked again, putting his piece away; he was

right up against my window now. I couldn't remember from cop movies if I was supposed to wind it up or down, and it changes from country to country. In Zimbabwe, definitely down. Here, though, these were power windows, and it didn't seem like turning the key was a good idea.

"Um," I said uncertainly. I looked at Till. "Does he really want us to tell him who he is?"

Till had both hands on the steering wheel, eyes down, lips zipped. I turned back to the man and squinted at his badge; this is exactly the time bifocals would have been better than grocery-store cheaters. Instead, I had to press my nose against my window to read the little letters on his nametag. "Clayborne," I said helpfully, really annunciating, so he could hear me through the glass. "You're Mr. Clayborne." But I knew, even as it was coming out of my mouth, it didn't sound correct, of course, not official enough. "Er, Sergeant. Constable. Officer. *Officer* Clayborne," I said.

"Officer Clayborne," Officer Clayborne agreed. "I am a United States officer of the law." Then Officer Clayborne made us step back out of the pickup while he searched it. "Meditation retreat," he said. "What do you even do there? You know it ain't legal to bring weed into the States. Do you? Hm? Cannabis? Right? Pot. Right? Do you *know* the marijuana laws?" Then, suddenly, he really started freaking out. "Oh, oh-kay. Now we're onto something. Yep, yep, yep, what do we have here?" he asked. He pressed his cheek up

against the levers that pushed the passenger seat forward, back—*zoom-zeem-zoom*—groping.

"Oh, what do we have here?" Officer Clayborne emerged, victorious, with a frozen, wrinkly apple in hand. He peeled off its sticker, reading. "Fuji," he said, looking up at me. "Did you know," he asked, "the damage you could have done to the US apple industry with this? Do you know what your thoughtless actions are doing to the working people of this country? Protecting Americans, that's why we have borders. Did you think about that? This apple is not an American apple."

"Um, no," I said. "Actually, it is. *Fiji* is a tropical island in the south Pacific Ocean . . ."

"Oh jeez," Till said.

"Sugarcane and copra, I imagine, tourists. Not apples, though," I said.

"Oh boy," Till said.

"Do you know how much trouble you could be in right now?" Officer Clayborne asked again, slower this time. "Would you like to wait for the K-9 Unit?" He glanced over his shoulder at the empty chain-link kennel. I felt a little less kindly toward its imaginary inhabitant than I had just minutes earlier. "I can have a unit here in oh, six hours. I can wait all day. Can you wait all day? It looks like you want to wait. Don't you?" Did we? We didn't think so, but then you sound like a human trafficker, don't you? I mean

if you don't want to wait for the K-9 Unit, such impressive, sleek, obedient dogs.

"Mm," I said noncommittally, looking into the middle distance. "Holy 'roid rage," I said as we drove away. Just as inexplicably as he'd started it, Officer Clayborne had suddenly relinquished his inquisition. Till said nothing. "Wasn't he the worst?" I asked. Till said that no, he wasn't the worst. I was the worst, honestly. What the fuck was I thinking? Had I really needed to give Officer Clayborne a lesson on international trade and the chief export crops of a tropical island? And what was with my accent going from Zimbabwe American to pure Downton Abbey all of a sudden?

"Linguistic convergence," I said. "It's a survival technique."

"Apparently not," Till said.

"Well, it got me this far," I said.

We both started laughing then and didn't stop until we got to Cut Bank, Montana, thirty miles south of the border. We stopped for diesel and to shake it off, not all the lessons, though, not the baby Jesus out with the bathwater. You see, in this way, a child dies—your child, mine—and you think, I thought, *I'll never care about anything else ever again*. Not really. But unbidden, other things shoulder their way into your grief-saturated world; and coincidentally, you shoulder your way out of it. Apples roll under seats, you drink tea, and your bladder fills. You register injustice, you feel outrage, you find yourself at a border post looking for the bathroom. You're ridiculous and human and insufficient, but

you're back in play. Relief filled my chest, blew it open like the steel bands on an oak casket had been snapped.

Air sucked in, and in, and in.

Deep breaths, all the way in and all the way out.

For days now, for most of the hours of the last ten days, I'd been not just a grieving mother and the mother of griev- ing daughters but also this other thing, these many other things. I'd been, too, a Vipassana meditator, a ritual maker, and an apple smuggler. I'd been a participant in the human drama, a witness to the militarization of our constitutional federal republic. I'd been a provocateur and a know-it-all. I'd cared again about something beyond my tiny little world of all-consuming grief. And magically, as in a fairy story, that care had freed me; unselfish, sisterly, motherly attention.

Care received, care given.

Who needs a guru?

Caregivers are the unsung liberators.

Or kindness had been the necessary atmospheric change I'd needed, the world tipped just right, rains pending, the cocoon sighing open. I'd done my time in the churning, yearning, lonely dark. I could tell that at eight months, I was close to gestation. In the eight months leading up to my concentrated silence, intense grieving had reduced and essentialized me. And at the same time, without me notic- ing the exact moment, care had cracked the place between my grief world and the whole rest of the universe. If I chose—a shoulder shrug, a few flaps—I was free, freed,

floating through clouds on downy wings; all manner of things will be well.

This heartbreak, that story, this warrie, that one.

I have found my way, sweet merciful Lord. I've found my way.

TWICE TIMES
THEN IS STILL NOW

I N EARLY MAY, the snow that had covered the four acres I'd bought in the middle of my darkest winter melted as if a giant torch had been taken to it. "Oh God," Harry said. "You literally bought the place without being able to see the ground, didn't you?" First the boulders and the sunlit meadow emerged and, finally, the north-facing shelf on the south side of the property. The creek bubbled, then thundered. The little road onto the property thawed; I towed in the sheep wagon and parked it up against the creek. I moved into it when I wasn't in the condo with Cecily. Little stove roaring, door open, fly screen down, cold breeze, frogs pinging.

If sans famille had been the haunting that had accompanied my grief; this was the antidote, surely. I couldn't ever be lonely here, all this life tumbling around me. Mule deer yearlings, they're as awkward as any teen, two of them poking their heads in the door of the sheep wagon one morning. Ravens love-chuckling to one another in the dairy farmer's hay barns north of the creek. Sandhill cranes clattering

overhead, the return spring migration, such elegant creatures, earth colored, *krrr-krrr, krrr-krrr*. Like bald eagles and trumpeter swans, they mate for life, and like almost everything else in the Intermountain West, there's a season to shoot them.

Then, sometimes, you hear just one calling: no reply, just *krrr-krrr*.

But they don't stop calling is the point.

You can only do your side of the song; I can only do mine.

In late May, the meadow came up thistles. I planted three cinquefoil, one for each of my dead siblings, and daisies for Vanessa who'd never see this place, and Austrian pines for my mother who'd also never see it, and cottonwoods, maples, and rosebushes for my ancestors. Against the yurt's platform, I planted sage, mint, strawberries. I started hop vines and a Virginia creeper, and I sowed grass seed where there was any bare ground. By early June, it was nearly all done, a ragged start to a meadow garden, a place to plant apple trees.

In the first week of July, I trailered Sunday over to the property from Joan's; for the first time since Fi'd died, I felt I could look after a horse again. Once—a decade ago, longer—it had seemed to me that Sunday and I would always be able to go as fast as we liked for as long as we wanted. An Arabian with a deep chest and strong legs could endure and endure. Now, she and I walked together slowly, both a bit lame, shoulder to shoulder, through the meadow, me pulling up thistles, Sunday eating the thistles, green juice

running down her chin. Sometimes, I put a head-collar on, scrambled onto her bareback, and we sauntered up the road past the dairy farm and into forest; often we came across a small group of elk broken off from the herd of about eighty that make this range their home.

Also, moose, skunks, bluebirds, night hawks, garter snakes, a black bear, a porcupine.

"Fi?" I asked them all; I'll never stop asking. "Is that you, Fi?"

Moss gamboled and hopped at our feet.

Meantime with the help of Till, carpenter friends, a neighbor with a backhoe: first pylons, then a deck, then the yurt, board after board, fastener after fastener. I got sunburned and sore, on my knees, crouched over my power drill; *zeep-zoop; zeep-zoop; zeep-zoop.* At night, I bathed in buckets of creek water heated over my camp stove. Then I sat with my headlamp on and I tweezed thorns and splinters and slithers from my fingers and feet. "I'm like the literal Christ." I showed Ricky on FaceTime. "Look, stigmata."

"Oh my God," Ricky said. "You should start a cult."

"So should you," I said.

Then, we're back in on that subject, about who we once were and how far we've come and how far we have still to go. But I knew I'd reached a settling place. I could already see the time I'd sell the condo and be here on this property full-time, like being in the arms of a trusted old love. I'd generate my own electricity and write and pull up thistles.

I'd build Sunday a stall, and she'd live beneath me. I'd get one more puppy, a little friend for Moss. I'd put a shed in the cottonwoods as a bedroom for Sarah and Cecily. Step by step, word by word, I'd build the grief and joy sanctuary we've always needed, long before Fi died and brought us to our knees.

An aspen grove will grow up all around the yurt, its leaves green, yellow, red, dead.

The wind will rattle the canvas; the moon and sun will blaze through the dome.

And I will be as a mountain, slicing through the clouds; let the weather come, and come.

I will stand.

Sometimes I Go About Pitying Myself

Sometimes I go about pitying myself
and all the time
I am being carried on great winds across the sky.

<div align="right">Anonymous, Chippewa, nineteenth century</div>

Acknowledgments

THE AUTHOR wishes to acknowledge:
Jimmy and Cindy Bartz, Rebecca Beckett, Michael and Amy Bernstein and family, Joan Blatt, Christian Burch and John Frechette, Deborah Calmeyer and the Roar Africa family, Brot, Didi, Phoebe and Tenzing Coburn, Patty Cook, Rick Cosnett, Bill Clegg, Laura and Will Davenport, Embeth Davidzt and Jason Sloan, Pam Devore, Dick Dumais, Glug Duthie, Sara, Tim and Sam Dykema, Ann Godoff, Megan Griswold, David and Leslye Hardie, Lachlan Hardie, Bruce Hayse, Lela Hebard, Jane and Michael Horvitz and family, Lizzie Horvitz, Melanie Jackson, Tiffany Jama, Kelli Jones, Jo Anne and Terry Kay, Eric and Susan Kay, Christopher Lander, Brett McPeak, Iris and David Mwanza, Guy and Tracy Murray, Jorge Olivares and family, Julie Patnode and Keith Harding, Jim Little, Oliver Payne, Cait Pearce, Kathrine Polzin, Katie Pierce, Scotty Ratliff, Susan Rauch, Pam Reading, Cecily Ross, Charlie Ross, Sarah Ross, Elisabeth Schmitz, Kathryn Steele, Allyn Stewart, Jaclyn Taylor, Jeri Taylor, Deb and

Kevin Thebault, Hilda Tembo, Johnny Fat Bastard Vincent and Gretchen Vincent, Summer Winger, Terry Tempest and Brooke Williams, Kate Horvitz Trentscoste, Ted Wiard and the staff at Golden Willow retreat, Harry Wilmot, Clive Wood, and Lori Wynn.

Also, always the ancestors.